Irving Sandler

From
Avant-Garde
to Pluralism:
An On-The-Spot History

May 18, 2006

To Brioka C. Juschka,

with my very best!

Irving Sandler

Hard Press Editions
2006

From
Avant-Garde
to Pluralism:
An On-The-Spot History

Front cover image: © Fred W. McDarrah
Cover Design: Jonathan Gams

Printed in Canada

To Lucy for putting up with my inability to deal with email.

Table of Contents

Chapter 3—From the 1950s into the 1960s

Chapter 4—The Changing Art World

Introduction

Eleanor Heartney

The poet Frank O'Hara called Irving Sandler "the sweeper up after artists", an appellation that Sandler adopted as the title for his own memoirs. The phrase, characteristically unassuming and modest, points to the crucial role which Sandler played during the ground-breaking decades of the 1950s and 60s and still continues to perform today in the much changed art world of the early 21st Century. Another way Sandler has formulated his activity is to note he is the writer of "on the spot history". Either phrase emphasizes the crucial aspect of his lifelong work. Sandler works from the ground up, writing about the artists he knows, the developments he has experienced, the art world of which he is very much a part.

Criticism today is in a state of flux, even, some argue—crisis. In an era when paintings by living artists are routinely sold for hundreds of thousands of dollars, when museum boards are in mortal combat with each other for donors and their multi-million dollar collections, and when the gatekeepers of the art world come primarily from the class of art dealers and art collectors, is there still any relevance to the humble craft of criticism? Does anyone really care that beneath the deafening blare of the publicity machine, an unamplified voice may be urging a more nuanced and balanced view of the situation?

Sandler has wrestled with these questions and come to a certain amount of peace with them. In part this is because he can look back over a five-decade career that spans the first emergence of what would later be celebrated as the ground breaking New York School to the free-for-all which is the international art scene of today. He can remember the days when the entire New York art world comprised fifty individuals. He was there when his beloved Abstract Expressionist school was supplanted by Pop Art and Minimalism. He witnessed the invasion of the art world and the art works themselves by the proponents of post structural theory. (He recalls that it was "a bit like the Mafia. Here they were saying, 'I have a theory you can't refuse')." He recalls the emergence of the last of the genuine "isms" in the late 1980s and the subsequent explosion of pluralism which remains the

9

hallmark of art today. He has watched the audience for art explode, reaching proportions today which would simply have been unimaginable in the early days when artists saw themselves as a tiny embattled cadre and looked askance at anyone who had the temerity to actually make a sale.

The secret of Sandler's longevity as a critic can be traced to a decision he made back in the mid 1960s when what he dubbed the "New Cool Art" of minimalism, Pop art and photorealism began to usurp the privileged place of Abstract Expressionism. After struggling for several years with his role as standard bearer for the earlier movement, Sandler decided, in his words, "not to go sour." He realized there was no reason why art should stop with a certain group of artists or a certain development, and since then he has remained keenly aware of the twists and turns of contemporary art.

I first met Irving in early 80s, long after the publication of his seminal first book, "The Triumph of American Painting" and long after he could legitimately have decided to rest on his laurels. His energy amazed me, and continues to do so today. He can be found everywhere —at openings, at panels, at lectures, speaking to students and doing the Chelsea art crawl in a ritual which he humorously calls his "cardiovascular program." And always, he is asking "What have you seen that is marvelous?" "Which shows should I be sure not to miss?" His enthusiasm remains an inspiration to younger critics.

Today, Sandler is the author of * books. At age 80, he still has more on the way. While books like his monumental "Art of the Postmodern Era" (whose last chapter is included in this anthology) update the story to the moment when he sent off the manuscript to the publisher, he continues as well to look back to the artists whom he first championed and to rethink and reanalyze their place in history. He is the rare writer who bridges art criticism and art history, sometimes blurring the distinction between them through his ability to draw on his own memory as a primary source. And in fact, many of his most insightful writings come out of his personal knowledge of and relationship with individual artists.

Critics go into the business for many reasons. Some see themselves primarily as educators. Others wish to function as gatekeepers, or talent scouts, or arbitrars of taste. It is clear that for Sandler, criticism has always been essentially a labor of love. He loves artists, he loves art and this love has served him as a framework for understanding the world at large. He

notes that he always considered his primary audience to be artists. Even when writing for popular publications, especially during his tenure as critic for the New York Post from * to*, he has acted as an advocate - opening up avenues of understanding for complex and challenging art, helping readers understand why art is a vital part of their world.

The essays in this book were written between 1956 and 2006 and they deal with art that ranges from Abstract Expressionism to what is vaguely defined as Postmodernism. Together they provide a panoramic view of the art world of the last half century that is both sweeping in its breadth and highly personal in its take. History, we are reminded, is based on the experiences and understandings of astute observers. Here, as we read, we can see it being made, "on the spot".

Chapter One

Abstract Expressionism

I BEGAN MY CAREER IN THE ART WORLD AS AN ADVO-
CATE OF ABSTRACT EXPRESSIONISM. IT WAS MY
FIRST LOVE IN ART AND THE FOUNT OF ALL LATER
THINKING. THE FOLLOWING SHORT SURVEY WAS COM-
MISSIONED BY LONDON'S ROYAL ACADEMY OF ART FOR
A SHOW OF 20TH CENTURY AMERICAN ART. IT
FOCUSES ON THE TWO MAIN TENDENCIES OF ABSTRACT
EXPRESSIONISM: THE FIELD PAINTING OF JACKSON
POLLOCK, CLYFFORD STILL, MARK ROTHKO, AND
BARNETT NEWMAN, AND THE GESTURE PAINTING OF
WILLEM DE KOONING AND FRANZ KLINE. IN RE-
READING THIS ESSAY IT OCCURRED TO ME THAT I
SLIGHTED A CHANGE IN MOOD THAT TOOK PLACE IN
THEIR ABSTRACT WORK DURING THE LATE 1940s;
NAMELY, THE CHANGE FROM A DARK VISION THAT
SEEMED INFLUENCED BY WORLD WAR II, THE ATOMIC
BOMBING OF JAPAN, AND THE REVELATIONS OF THE
HOLOCAUST, TO A MORE POSITIVE ATTITUDE, ONE
THAT EMBODIED THEIR VISIONS OF THE AMERICAN
EXPERIENCE.

Abstract Expressionism: The Noise of Traffic on the Way to Walden Pond

1993

As the avant-garde of the 1940s, the Abstract Expressionists were spurned not only by the general public, but by the art-conscious audience as well. The artists were condemned to poverty and alienation. They were willing to suffer because they had a calling—to be the standard-bearers of the avant-garde, of all that was adventurous and provocative in the visual arts. Their collective sense of neglect and mission brought them together for mutual solace and support—at openings and other social events at meetings and notably at protests, the most notorious of which led to a photograph of some fifteen artists in *Life* magazine in 1951, the group portrait that has helped to determine our image of the Abstract Expressionists. In the face of a hostile public, the vanguard presented a common front.

However, there was no commonality in their styles. In fact, their work is distinguished by its individuality. No label can encompass a group as diverse as Jackson Pollock, Willem de Kooning, Mark Rothko, Franz Kline, Clyfford Still and Ad Reinhardt. Yet it is in the nature of art critics and historians to search for affinities and if possible to catagorize their subjects. Like many names applied to modern art movements—Cubism, for example, or Fauvism—Abstract Expressionism does not define the art subsumed under the label. The paintings of Pollock, Rothko, Still, Reinhardt and Barnett Newman are abstract but not expressionist. The name fits the style of de

15

Kooning better, but much of his work is figurative. Perhaps Abstract Expressionism can best be defined negatively, by what it was not, that is, by styles the artists rejected as outworn: Regionalism and Social Realism, popular in the economically depressed 1930s; Abstract Cubism, or geometric abstraction, the dominant avant-garde art of the 1930s; and Surrealism in its near-abstract manifestations, the advanced style of the early 1940s.

Above all, the Abstract Expressionists rejected the relational design of Cubism, whether of a Picasso or a Mondrian, that is, the tightly knit composition of varied, clearly defined, flat shapes contained within the picture limits. Instead, beginning in 1947, Pollock and Still, soon joined by Rothko and Newman, formulated a radically new conception of the picture—as an all-over, open field: an expansive linear mesh, as in Pollock's poured canvases, or an equally expansive field of colour areas, as in Still's, Rothko's and Newman's abstractions. Both kinds of field organization engaged the viewer with immediacy—suddenly, all at once, in a way very unlike Cubist compositional techniques, which induced the viewer to experience a picture from part to part to whole. It is significant that this innovative abstract image-the most radical formal invention of Abstract Expressionism-involved a total rejection of the Cubist inspired composition that had been absolutely central to modem art of the earlier twentieth century.

But Field painting was only one tendency within Abstract Expressionism, a major one to be sure. Another, variously labelled Gesture or Action or Painterly painting, was equally important. In fact, it numbered far more artists, foremost among them de Kooning and Kline. They continued to use Cubist composition as a stable infrastructure for their improvisational configurations of open brush-marks, but their images were too explosive or implosive to be characterized as Cubist. Indeed, their painting is marked by its gestural quality.

Recognizing that the labels Field and Gesture painting are more specific than Abstract Expressionism, art critics and historians have usually treated the new American painting as two tendencies rather than as an entity. Even so, both tendencies have been linked so repeatedly that the differences between them are often minimized. They should not be. Not only did Field and

Gesture painting differ formally, but the artists had different aesthetic and metaphysical outlooks, moved in different social circles, had different life-styles and were even separated geographically, most Gesture painters living in down-town Manhattan, most Field painters up-town.

De Kooning stressed the differences between himself and Still and Pollock. He recognized that they were the primary innovators of the new painting and the most radical of his colleagues. As he said of Pollock: "Every so often, a painter has to destroy painting. Cézanne did it. Picasso did it with Cubism. Then Pollock did it. He busted our idea of a picture all to hell. Then there could be new paintings again."[1] De Kooning believed that compared to Pollock's and Still's work his own was traditional. In interviews I had with him in 1957 and 1959 he characterized Still's and Pollock's abstraction as "American", embodying the image of the solitary pioneer who opened up the wild frontier to agrarian enterprise.[2] De Kooning neglected to mention that his own painting embodied the equally vital American urban experience. Nevertheless, his insight is crucial to the understanding of Pollock's and Still's work.

Still openly proclaimed that his art represented the New World, but he want-ed his message recognized globally. So did Pollock, who also acknowledged the Americanness of his work, if less stridently. De Kooning, Kline and most of the Gesture painters rarely referred to nationality, and for good reason. During the 1930s, at the beginning of their careers, the future Abstract Expressionists recognized that their art was derivative and provincial. They knew that it was not as provincial as the backward-looking, Marxist-orien-tated Social Protest and nationalistic Regionalist styles that they reviled as retrogressive and just plain bad, and this provided a solace of sorts. However, American avant-garde artists knew their work was not as original, vital and masterly, and thus major, as that being created in Paris, the city they acknowledged as the hub of world art.

At an ocean's remove from the centre, the best that vanguard artists could do was to emulate those modernist masters whom they admired, notably Picasso, Mondrian and Miró. The Americans set out to master modern art, and by the outbreak of the Second World War they had. Their outlook had

been anti-provincial and internationalist, and it would remain anti-provincial and internationalist; they would measure themselves by the highest and most advanced of global standards—such was the scope of their ambition—and this would lead them in time to achieve recognition abroad as well as at home.

Their internationalism was abetted by a fierce hatred of racist and xenophobic aesthetics, then promulgated most loathsomely in Hitler's Germany, which was growing in power and preparing for war. The vanguard paired Nazi blood-and-soil myths with the nationalistic rationale of the Regionalist painters. Thus, Regionalism was rejected not only because it was retrograde, but also for being chauvinistic. The Abstract Expressionists might not have been so reluctant to invoke the American dimension to their painting had they been able to distinguish between nationalism and national identity, the first a malevolent force that leads one people to hate and subjugate another, the second a people's positive awareness of shared qualities and aspirations. But no such frame of reference existed, as Isaiah Berlin has pointed out. Nationalism had dominated much of nineteenth-century Europe, and it continues to be a powerful political force in the world today, perhaps the most powerful force of all. Yet, as Berlin observed, no significant thinker, certainly none of the stature of a Freud or a Marx, has given it the attention it deserves.[3] It is telling that both Freud-and Marx played down the importance of both nationalism and national identity in human affairs, and their thinking was the most influential in the Abstract Expressionist era.

In the early 1940s Pollock, Rothko and other Abstract Expressionists turned to archaic myths and "primitive" art for inspiration. They used the Surrealist technique of automatism to recollect man's primordial past and reveal the archetypal symbols that "lived" in the collective unconscious, an approach influenced by C. G. Jung. These "Mythmakers", as Rothko called them in 1943, professed that their interest in primitive man was prompted by the Second World War. Rothko said that archaic art and mythology contained "eternal symbols...of man's primitive fears and motivations...And our modern psychology finds them persisting still in our dreams, our vernacular and our art, for all the changes in the outward conditions of life."[4]

In their statements the Mythmakers emphasized mythic and primitivistic content. It allowed them to repudiate geometric abstraction for what they considered its lack of content, while continuing to use abstract forms identified both with modernist art and much of "primitive" art. They also claimed that their content, because it was universal, was more relevant than the Marxist class struggle of Social Realism or Regionalist nationalism; supra-national content, moreover, emphatically opposed the xenophobia of Nazi aesthetics.

The Mythmakers were attracted to all "primitive" art, but they preferred its native American variants, notably Northwest Coast Indian, Eskimo and Pre-Columbian. Much of this indigenous art was available in New York, for example, at the Museum of the American Indian. In 1940 The Museum of Modern Art mounted Twenty Centuries of Mexican Art' and, in the following year, the largest and most far-ranging show in its history, "Indian Art of the United States". The museum stressed the universal aesthetic and human values of native American art. So did Rothko, Gottlieb, Newman and Pollock, who said, for example, that it possessed "the basic universality of all real art".[5]

The focus on Indian art was an early sign of American identity in the painting of the Mythmakers and their rejection of European culture. Later, in 1946, Newman claimed that the Mythmakers prized "the many primitive traditions" because they stood apart "as authentic aesthetic accomplishments that flourished without benefit of European history".[6] By identifying their modernist art with the indigenous art of the Americas, the Mythmakers were able to differentiate their painting from European art. The idea of creating a major American art of global stature was to grow even stronger in time.

The so-called mythic period in Abstract Expressionism lasted from roughly 1942 to 1947. Pollock improvised impulsive images that allude to mythic animal sexuality, Indian totems, primitive rites and Graeco-Roman legends —violent themes rendered tempestuously. Still juxtaposed horizontal, female, dark earth with vertical, male, light suns. Rothko employed automatism to invent human, animal, bird, fish, insect and plant hybrids engaged in cryptic re-enactments of ancient myths.

19

From the first, the Mythmakers sought to express a universal "Spirit of Myth, which is generic to all myths of all times," as Rothko wrote.[7] Around 1946 they found that their quasi-figurative imagery had become too commonplace to evoke visions of what Newman had begun to term "the sublime", Rothko "transcendental experience" and Still "exaltation". Mythmaking was transformed into a quest for "the Abstract Sublime", in Robert Rosenblum's words, and in Lawrence Alloway's, "the American Sublime".[8] This search for a timeless and universal imagery was to lead the Mythmakers into non-objectivity.

Pollock carried automatism into abstraction so extreme that it could no longer be categorized as Surrealist. He placed outsize canvases on the floor, and, moving around and at times on them, poured, dribbled and flung paint instead of applying it with the brush. The technique was derived from the divergent sources of Surrealist automatism and the sand painting rituals of Southwestern American Indians. The synthesis was unusual—a process that was identified, on the one hand, with an international modernist movement and, on the other, with a "primitive" art that was also American. Pouring pigment enabled Pollock to register his creative experience more directly than he could with the brush. His bodily movements needed scope, encouraging him to work on a large scale, to "literally be in the painting."[9] Sweeping, arm-long skeins of paint traject freely, like traces of energy, across the canvas. Interlaced in an all-over configuration, lacking focal points, the painting generates even more energy, a continuum so charged that it seems to expand beyond the picture limits, evoking an immediate sensation of boundlessness, a sensation intensified by the large size of the canvases.

Still, Rothko and Newman evolved styles as radical as Pollock's but focused on expression through colour. To maximize the visual—and emotional—impact of colour, they eliminated figuration and symbolism, simplified drawing and gesture suppressed the contrast of light and dark values, painted chromatic expanses that saturate the eye and enlarged the size of the canvas. Aiming for the visionary, they strove literally to engulf the viewer by creating a total chromatic environment.

Still painted open and expansive abstract fields composed of vertical paint-

encrusted areas whose contours were organic and flame-like, acting to unlock the picture space, causing it to expand up and outwards, conveying an immediate sensation of upward aspiration and boundlessness. Newman formulated an equally radical colour-field abstraction consisting of a single, almost matt colour cut by one or more narrow vertical bands of contrasting hues. No horizontals knit the verticals into a Cubist-like structure that might break the continuous field. Instead, the vertical stripes function as accents energizing the entire colour field, preventing it from becoming amorphous and inert. Rothko eliminated discrete contour lines, making the atmospheric surfaces of his abstractions continuous. His mature abstractions consist of a few softly painted and edged rectangles of luminous, airy colour, floated symmetrically one above the other on somewhat more opaque vertical fields. His aim was to release viewers from their everyday existence, causing them to rise above the self's habitual experience into a state of transcendence, a frame of mind in which spiritual awareness might occur.

It should be stressed that the ambition of the Mythmakers was to be universal, modernist, internationalist and original. But equally important, their work was informed by a national consciousness. The United States is distinguished by the diversity of its people, regions, economic classes, life-styles and so forth. And yet, despite this heterogeneity, there exists a common culture, the product of geography, language, laws, institutions, historical memories and beliefs, real and imagined, which generates a commitment to certain values, such as individualism and openness. Leo Marx succinctly characterized two main forces that shaped the consciousness of Americans in the title of his book *The Machine in the Garden: Technology and the Pastoral Ideal in America*, and I would add to technology the urbanization that accompanied it. The Field painters tended to evoke the rural experience, the Gesture painters the urban.

Marx said that all self-aware peoples possess a mental map and a national myth of origin.[10] The most important attribute of the mental map of Americans is boundlessness, the United States as a limitless expanse in which, as Gertrude Stein wrote, "there is more space where nobody is than where anybody is. This is what makes America what it is."[11] This vast landscape, stretching some three thousand miles from the Atlantic to the Pacific

oceans, is not merely a physical phenomenon but, as Barbara Novak pointed out, "a repository of national pride...even...a religious alternative."[12] The American national myth of origin, as Marx observed, is the transatlantic voyage of immigrants and, by extension, the journey into the uncharted West. In short, the myth is that of new beginnings, the escape from the Old World into a New World.[13] The outsize abstractions of Still, Pollock, Newman and Rothko appear to be shaped by the continental geography of the United States-not only its vast terrain, but also the stance of the people who tamed it. Still's work conveys a boundlessness and openness that calls to mind panoramic American prairies and plateau-awesome crags and fissures. Equally American were Still's statements presenting himself as a latter-day pioneer who discovered a New World in art-the mythic terrain of art replacing the mythic American West as the open frontier, a frontier in which a heroic Individual could achieve absolute liberation. "It was as a journey that one must make, walking straight and alone... Until one had crossed the darkened and wasted valleys and come at last into clear air and could stand on a high and limitless plain."[14]

Still's and Pollock's abstractions call to mind the American wilderness in its sublime vastness. But they also suggest the rural scene. Leo Marx has pointed out that the "line between the two is not sharp. Both the wild and the cultivated versions of the garden image embody something of that timeless impulse to cut loose from the constraints of a complex society."[15] Much as they seem to evoke nature as untamed, Pollock's and Still's abstractions also look agrarian, Pollock's reminiscent of grasslands, Still's of farmlands. Both Pollock and Still grew up on small Western farms. Still proudly recalled his farming experiences when "my arms have been bloody to the elbow shocking wheat."[16] His coarse, heavy pigment, trowelled on with palette knives, calls to mind earth. Pollock had also been a farm worker in his youth. His friend Tony Smith said: "I think that his feeling for the land had something to do with his painting canvases on the floor"[17]—the floor as a kind of surrogate earth. In an interview of 1944 Pollock said: "I have a definite feeling for the West: the vast horizontality of the land." After he moved East to Long Island, New York, he substituted the Atlantic Ocean for the Western plains of his youth.[18] Pollock's and Still's boyhood in the West shaped their

spatial imagination. Moving to New York, they carried their landscapes with them. But immersing themselves in modem art and culture, they created bold new abstract images of American space, in which there is an utterly convincing fit of form and content.

Rothko's abstractions are distinguished by their light, which becomes a metaphor for spiritual essence. Robert Rosenblum related Rothko's work to the landscapes that Martin J. Heade, John Kensett and other Luminists painted in the nineteenth century:

> Typically, a Luminist painting confronts us with an empty vista of nature (often a view of sea and sky from the shore's edge) that is more coloured light and atmosphere than terrestrial soil. [The] power of light slowly but inevitably ... pulverize[s] all of matter, as if the entire world would eventually be disintegrated by and absorbed in this primal source of energy and life. A surrogate religion is clearly a force here, too. [This] natural American light...can slowly lead us to the supernatural and the transcendental thought of [Ralph Waldo] Emerson and [Henry David] Thoreau, who also sought a mystic immersion in the powers of nature.

Rosenblum suggested that Luminism was of central importance in American visual and cultural traditions and that Rothko's art could "be seen as resurrecting, in an abstract mode, the Luminist tradition."[19] It is significant that Rothko's close friend, Newman, venerated the Transcendentalists, even choosing to spend his honeymoon on Walden Pond, where Thoreau had lived.

To sum up, the Field painters distilled American nature as they imagined it, abstracting its essential American quality and transforming it into mythic imagery. In a sense, they reinvented Regionalist painting, not as illustration but in the abstract forms of their own historical moment.[20] At the same time, their art commanded global attention, indeed it dominated avant-garde art in the post-war West. Or, as Pollock put it: "The important thing is that Cliff Still...and Rothko, and I—we've changed the nature of painting.[21]

In a real sense, the idea of an American wilderness, in which humankind cre-

ates a garden, turned out to be a myth. And the myth was long outdated. After all, the frontier had vanished by 1890. Nevertheless, its image lived on in the American imagination: a symbolic terrain, it evoked emotions, ideas and associations in the American psyche and continued to shape the very being of Americans-their psychology, thinking, behavior and even hopes. The Field painters invested the myth with new vitality.

Leo Marx posited a powerful counter-force in the American consciousness to the pastoral ideal, namely industrial power-the accompaniment of which was the city, a "man-made wilderness".[22] And in the twentieth century, the United States had become predominantly industrial and urban. De Kooning, quintessentially urban, was the most influential avant-garde artist in the 1950s. His work appealed to his colleagues because it was rooted in tradition, referring to human anatomy, Cubist design, drawings by Rembrandt and Rubens, and graffiti on tenement walls. It also appeared to be based on what Wassily Kandinsky called "inner necessity". Moreover, it seemed existential—the improvisational painterly images looked as if they were encountered in the anxious struggle of creation and thus embodied the artist's authentic being—at a time when Existentialist philosophy was in vogue.

Much as de Kooning acknowledged his debt to past art, he still sought to create a new urban art, that is, to express the restlessness, claustrophobia, density, rawness, violence and ambiguity, of the city. Indeed, de Kooning's painting of the late 1940s and 1950s felt like a walk down a Manhattan street.

Franz Kline's thrusting black-and-white swaths also allude to the ever-chang-ing city-to massive sections of partly demolished or constructed skyscrapers and bridges. But unlike de Kooning's images, which are compacted, ambigu-ous and anxious, Kline's are expansive, bold and exuberant. He once said: "Hell, half the world wants to be like Thoreau at Walden worrying about the noise of traffic on the way to Boston; the other half use up their lives being part of that noise. I like the second half. Right?"[23]

Notes

1. Quoted in Rudi Blesh, *Modern Art USA*, New York, 1956, pp- 253-4.

2. See Irving Sandler, "Conversations with de Kooning", *Art Journal*, vol. 48, no. 3, 1989, pp. 216-17.

3. Isaiah Berlin, "Nationalism," in idem, *Against the Current, Essays in the History of Ideas*, New York, 1980, PP- 333-55.

4. Adolph Gottlieb and Mark Rothko, *The Portrait and the Modern Artist*, mimeographed script of a radio broadcast, New York, 13 October 1943, n. p.

5. Jackson Pollock, "Jackson Pollock", *Arts and Architecture*, February 1944, p. 14.

6. Barnett Newman, *Northwest Coast Indian Painting*, exhibition catalogue, New York, Betty Parsons Gallery, 1946, n. p.

7. Mark Rothko, Statement, 1943, in Sidney Janis, *Abstract and Surrealist Art in America*, New York, 1944, p. 118.

8. See Robert Rosenblum, "The Abstract Sublime", *Artnews*, vol. 59, no. 10, February 1961, PP- 38-41, S6, 58, and Lawrence Alloway, "The American Sublime", *Living Arts*, June 1, 1963, p. 11-12.

9. Jackson Pollock, "My Painting", *Possibilities* I, Winter 1947/48, p. 79.

10. Leo Marx, "American Ideology of Space," lecture at The Museum of Modern Art, New York, 21 October 1988.

11. Gertrude Stein, *The Geographical History of America*, New York, 1973, p.p.- 53-4.

12. Barbara Novak, "Grand Opera and the Small Still Voice", *Art in America*, vol. 59, no. 7, 1971, p. 67.

13. Marx, op. cit It is noteworthy that Rothk had emigrated to the United States as a boy and had crossed the country to Portland, Oregon.

14. Clyfford Still, Letter to Gordon M. Smith, 1 January 1959, in *Paintings by Clyfford Still*, exhibition catalogue, Buffalo, Albright Art Gallery, 1959, n.p.

15. Leo Marx, *The Machine in the Garden: Technology and the Pastoral Ideal in America*, London, 1964, p.p.- 42-3.

16. Quoted in Dore Ashton, *The New York School: A Cultural Reckoning*, New York, 1972, p. 34.

17. Tony Smith, interviewed by Francine du Plessix and Cleve Gray, in "Who Was Jackson Pollock?", *Art in America*, vol. 55, no- 3, May/June 1967, p. 52 .

18. Jackson Pollock, "Responses to a Questionnaire", *Arts and Architecture*, February 1944, p. 14.

19. Robert Rosenblum, "Notes on Rothko and Tradition", in exhibition catalogue, London, Tate Gallery, 1987, p.p. 26-7.

20. Pollock had studied under Thomas Hart Benton, a leading Regionalist painter, and had begun his artistic career as a painter of American scenes. Although Pollock rejected his teacher"s tame realism, he retained the spirit of Regionalism.

21. Quoted in Selden Rodman, *Conversations with Artists*, New York, 1957, p. 84.

22. Marx, 1964, p. 358.

23. Quoted in Frank O"Hara, "Franz Kline Talking," *Evergreen Review*, Autumn 1958, reprinted in Frank O"Hara, *Standing Still and Walking in New York*, Bolinas, CA, 1975, p. 94.

WILLEM DE KOONING WAS REVERED BY DOWNTOWN
ARTISTS OF THE NEW YORK SCHOOL AND BY ME.
I WAS DEEPLY MOVED BY HIS PAINTINGS AND
INSIGHTS INTO ART. WHEN DE KOONING DIED,
I WAS APPALLED BY THE OBITUARIES. ASKED
BY ELIZABETH BAKER TO WRITE AN EULOGY IN
ART IN AMERICA, I WAS ABLE TO RECTIFY MAT-
TERS SOMEWHAT BY SPECIFYING WHY DE
KOONING WAS A GREAT ARTIST.

Willem de Kooning

1904-1997

Reams of trivia about de Kooning the drunk, womanizer, basket case, etc., have just about buried de Kooning the artist. Too bad, because for me and most avant-garde artists I knew in the 1950s he was <u>the</u> painter. He was so revered by the habitués of the Cedar Street Tavern and the Club that their conversation was studded with "me and Bill."

What was it about de Kooning that gripped us? His masterful painting and his deflection of the grand tradition of Western painting into a brand new style.

De Kooning once said that when he thought of art he found himself "always thinking of that part which is connected with the Renaissance. It is the vulgarity and fleshy part of it. . .the stuff people were made of." He also thought of the space the Renaissance painter measured out—a "large marvelous floor that he worked on." However, he would not accept the full-blown Renaissance figure and its ordered surround, and he kept fragmenting both, piecing them together and disassembling them again.

De Kooning was also in debt to Cubism, but he rejected the clear, fixed and stable composition of its synthetic phase. Just as he dismembered the figure,

he destabilized Cubist design, decomposing it into ceaselessly shift-
ing and interpenetrating forms. The imagery seemed to embody his
'way of living.' He was too 'nervous,' as he put it, too anxious, to
feel at ease in any fixed situation. Consequently the space he paint-
ed was disordered, disrupted and dislocated.

De Kooning's experience of New York in the '40s and '50s con-
tributed to his nervousness, much as he loved the city. His pictures
caught its complexity, hectic tempo and peculiar anxiety. Clogged
with paint-laden forms, they are raw and paroxysmal, evoking the
squalor and violence of street life. The Women of the early 1950s,
big-busted, with eyes crossed and teeth bared, both violent and
voluptuous, are equally urban in feeling-city-bred pinup girls.

His work is both a continuation and a challenge to the centuries-long tradi-
tion of Western painting. In taking the conventional human image and clas-
sicizing Cubist structure and melting both down, he expressed the anxiety of
living in the nuclear world.

De Kooning was the most influential painter of the late 1940s and 1950s.
His great rival, Jackson Pollock, was more famous, but young artists believed
that if they followed him they would only produce derivative Pollocks. De
Kooning's painting appealed to his fellow artists because it provided them
with rich possibilities, both avant-garde and traditional. He demonstrated
that painting could be ambiguous as well as clear, abstract and/or figurative,
and flat and/or in depth; that it could be made of Cubist inspired compact
relational design and/or of nonrelational open fields; that it could make ref-
erence to past art and/or be in reaction against it. He invented a visual "lan-
guage" with which other artists could write their own "sentences."

De Kooning was never able 'to sit in style," as he said. It made him uncom-
fortable. And his body of work from the very beginning is distinguished by
sharp changes and shifts from figuration to abstraction and back, from com-
pacted forms to open forms and so on. Perhaps the most radical and risky
change occurred in the 1970s, when he ripped out the structure, the back-
bone of his earlier work for which he was justly famous, and let the areas pig-

ment flop about, holding them in tension at the edge of pictorial chaos. This was the phase of his work prized by the generation of painters that emerged in the late 1970s and 1980s.

His abstractions of the 1980s marked another change. In them, de Kooning distilled what made de Kooning de Kooning, that is, he abstracted his artistic identity, based as it was on painterly drawing and the human anatomy. Turning away from the world and its anxieties and turmoil, he found within himself a realm of quiet, of serenity and of radiance.

Those who knew de Kooning all have a favorite story. Burgoyne Diller recalled that he tried to get him a commission to paint a mural for the 1939 World's Fair. The jurors turned him down, saying he couldn't draw. Diller got the bright idea of asking de Kooning to submit a portfolio of drawings he had made while a student in the Rotterdam Academy, drawings in which the charcoal was sharpened to a needle's point and just tickled on the paper. He got the commission.

De Kooning was a stunning conversationalist. He meant what he said and often said it with passion, but he could be very funny. Once, when invited to dinner by the Rockefellers, he greeted his hostess, "Gee, Mrs. Rockefeller, you look like a million bucks."

My own favorite story. In 1956, two friends and I made a film of de Kooning at work. We arrived at his studio late at night with our rented cameras, lights, etc., lugged them all up the three flights, set everything up laboriously, and then ordered him to paint. He had a marvelous picture in progress, and he painted on it in an "action" manner. Our camera followed his movements avidly, the flailing brush, the dancing feet. It couldn't be better as film. A few days later I met de Kooning on the street and asked how the painting was going. He said that he had junked it the moment we left. I asked why. "I lost it," he said. "I don't paint that way." Then why the charade? He answered, "You saw that chair in the back of the studio. Well, I spend most of my time sitting on it, studying the picture, and trying to figure out what to do next. You guys bring up all that equipment, what was I supposed to do, sit in a chair all night?" "But Bill," I said, "in the future, they'll look at our film and think that's how you painted." He laughed.

In this interview with Willem de Kooning,
he captures the sensibility of the
Depression thirties and war-torn forties
and reveals his situation as an artist,
and by extension, that of Modernist
artists during those decades.

Conversations with de Kooning

From 1956 to 1959, 1 was a sitter (with the title of Manager) at the Tanager Gallery, the first and best known of the artists' cooperatives on Tenth Street. De Kooning lived and worked next door and would drop into the gallery frequently. I also visited him in his studio, and on two occasions (April 25, 1957, and June 16, 1959) interviewed him "formally," taking down his remarks in longhand (in that pre-tape-recorder era).

Both times we talked at length about Clyfford Still. De Kooning believed that he had little in common with Still. In our 1957 interview, de Kooning referred to himself as a "conservative," pointing to the influence of European "fathers" of modernism on his art, although, he added, he was "grappling for a way to say something new." He remarked that in this he was like Arshile Gorky and Hans Hofmann. In 1959, de Kooning stressed even more strongly the differences between his painting and that of Still and Jackson Pollock, whose name he coupled with Still's: "They eat John Brown's body. They stand all alone in the wilderness-breast bared. This is an American idea.... I am a foreigner after all. I am different from them because I am interested in all of art. I feel myself more in tradition. I have this point of reference-my environment that I have to do something about. But the Metropolitan Museum is also part of my environment...I change the past."

My primary purpose in the 1959 interview was to find out about murals for the new French Line pier that Fernand Léger was to have executed in 1936 with the assistance of American artists on the Federal Art Project. De Kooning recalled: "Léger wanted to paint a mural here, even for free, to see what big murals would look like in America." Arrangements were made by Burgoyne Diller, the head of the Mural Division; he invited Léger, who as a foreigner could not be part of the Project, and assigned American artists on the Project to help him.

Léger strongly impressed de Kooning: "It was like meeting God. He looked like a longshoreman—a big man. His collar was frayed but clean. He didn't look like a great artist; there was nothing artistic about him." "There were seven other assistants: Harry Bowden, Byron Browne, Balcomb Greene, Paul Kelpe, Mercedes Matter, George McNeil, and José de Rivera. Mercedes interpreted. We all went to the French Line with Léger. He decided to take the outside of the pier where there was ironwork, and we would do the inside rooms; each of us was to have one panel. He sent us to the Museum of Natural History to get ideas about the sea. He told us to make a list of objects having to do with the sea-ordinary objects. We were to do our own designs, and he would criticize them and unify them. We really wouldn't be like assistants; he was very nice about this. He criticized us as if we were professionals. We were all working in the same room at 39th Street and Fifth Avenue. It was just like a shop. He seemed a little bored with our sketches, but he was surprised and favorably impressed to find so many New York artists—more than in Paris—who understood his work and were able to work with him.

"Léger had a fantastically original way of looking at the world; he was like a builder. He worked a slow line, which is so marvelous. He drew an anchor, a French flag, and an American flag and filled them in. He worked like a sign painter. He made lots of sketches, threw them around on the floor, and picked one out. The one he picked always clicked. Then he squared it off [to transfer it onto the wall.] At times he would use pigment right out of the tube; make a figure yellow, outline it in black. He would shade flat, just like a child. It was a very direct way of painting. There was no mystery in how he did it. Yet, when you saw it finished, you wondered why it worked so

terrifically. He would look at his work in a very relaxed way and say,'bon.'"
De Kooning then told the story of Léger at the Museum of Modern Art
looking back and forth at Picasso's Three Musicians and his own Three
Musicians and murmuring: "Pauvre Picasso." De Kooning concluded: "You
got the feeling from Léger that to be an artist was as good as being anything
else. This was a very healthy feeling. He gave me a feeling of confidence; he
does his painting, I do mine."

The French Line called off the mural project on its pier after only a few
weeks.

De Kooning also spoke of the Depression Thirties. "The Project was terribly
important. It gave us enough to live on and we could paint what we want-
ed. The Project was terrific largely because of Diller. I had to resign because
I was an alien, but even after the year I was on, I changed my attitude to art.
Instead of doing odd jobs and painting on the side, I painted and did odd
jobs on the side. The situation was the same but I had a different attitude. I
gave up the idea of first making a fortune and then painting in my old age.
. .There was a terrific amount of activity going on in the thirties. It was not
a dead period. You don't have to like the art to appreciate the excitement.
But many of the people were good artists-Graham, Davis, Gorky. We knew
one another. But we also respected American Scene and Social Realist artists.
Gorky and Soyer were good friends. I wasn't a member of the American
Abstract Artists, but I was with them. I disagreed with their narrowness,
their telling me not to do something. We fooled around with all kinds of
things and changed from style to style a lot. It was a great big hodge-podge."

About the forties, de Kooning recalled: "The Greek business of
[Aristodemos] Kaldis and [Landes] Lewitin gave me a pain. How could you
be Apollonian in 1940; you could only be pathetic.... We didn't talk about
personalities-only art. We were all poor and worried only about the work. It
used to be all artistic ideas. Art has now become something you can get some
thing out of." I asked about the influence of Existentialism; de Kooning
replied: "It was in the air. Without knowing too much about it, we were in
touch with the mood. I read the books, but if I hadn't I would probably be
the same kind of painter. I live in my world."

When I asked about the work he was doing then (1959), de Kooning spoke of Courbet." I like Courbet because he was so concrete. He was overcome with reality. The light on the floor makes a certain gray. The mystery in the world is to see something that is really there. I want to grab a piece of nature and make it as real as it actually is like in my Merritt Parkway picture. How the hell can you paint the Merritt Parkway-a ribbon of gray in green and it stretches for miles and miles. Then in the fall when the colors change, it's positively crazy. For years I had an idea of it, and then I painted it, and it is real. Hopper is the only American I know who could paint the Merritt Parkway." De Kooning drew me a sketch of a Hopper he saw in the Whitney Museum of a girl looking out of a window at a forest [Cape Cod Morning, 1950]. "The forest looks real, like a forest; like you turn on it and there it is; like you turn and actually see it."

DE KOONING'S RAW AND AGGRESSIVE PAINTINGS
SEEMED TO EMBODY WHAT AUDEN TERMED THE AGE
OF ANXIETY. THEY EXEMPLIFIED THE
EXPRESSIONIST TENDENCY IN ABSTRACT
EXPRESSIONISM. IN CONTRAST PHILIP
GUSTON'S PAINTING, WHICH WAS RESTRAINED
AND LYRICAL, CAME TO BE LABELED ABSTRACT
IMPRESSIONISM. AS THE FIFTIES PROGRESS,
GROWING NUMBERS OF YOUNGER ARTISTS LOOKED
TO GUSTON FOR INSPIRATION. MY ARTICLE
DEALS WITH HIS ABSTRACTIONS OF THE 1950S.
ALTHOUGH THEY WERE HIGHLY ESTEEMED THEN,
THEIR FAME HAS SINCE BEEN ECLIPSED BY PIC-
TURES GUSTON BEGAN TO PAINT IN THE LATE
1960S THAT WERE ON EXHIBIT IN 1970.

Guston

a long voyage home

*From Social Realism, through an influential
Abstract Impressionism, to his fluent new idiom,
runs this lyric painter's consistent adventure.*

Every event in the recent canvases of Philip Guston is offset by a count-er-event. The forms are quivering, about to shift, to establish new relations with other forms, yet they are irrevocably kneaded, rather than painted, together. What appears about to occur is the decisive resolution of what already has happened. The denouement comes as a shock. The viewer finds himself suspended in future, present and past. The pictures are simultaneously open and fixed, animate and inert, in flux and in stasis. A red area in *Poet* continues to elude the black claws that catch it; the claws themselves seem to want to probe for new forms to confine, or possibly to escape the role of captor altogether. The heaving black of *Close-up, 2* is tamed by its rectangular container. Color, full and sensuous, flares up in places to its highest, saturation, yet is restrained, even ascetic. It "partakes of layers of tones trapped under it."

Earlier works, painted before 1954, were more fragmented, less explicit. They were immersed in an ethereal light, an illimitable atmosphere that seemed to express a yearning for beauty. Since then, Guston has worked, in depth and has expanded the small shapes into larger and more complex areas. It is as if he has moved close to his forms; they are more intimate and burdensome—massive aggregates of impetuous details. The shapes have

opened up to the edges of the canvases. They do not displace the atmosphere but breathe it, allow it to sift in and between them, to grey their colors. The atmosphere in turn has partaken of the density of the forms; it becomes a solid smoke tinged with lyric accents. The palpability in recent works supplies the human balance, the substance of man, rich in feeling, pulsing in and with ether.

The disordered order found in these works is not premeditated, although it seems as if it ought to have been. Guston discovers structure in the process of painting, in the dramatic act of finding his self, not as he would like to appear in the world but as he actually is The pictures become, in T. Hess' words, "atlases of personality." But if the artist reveals and affirms himself in the transcendent moment, the moment is informed by the memory of past experiences.

During the thirties, a number of American-artists reacted against the prevailing American scene and Social Realist art. Some began to experiment with avant-garde European painting and sculpture. To escape political clichés, others turned to the art of the past. Many of those artists later called Abstract- Expressionists arrived at their styles partly through devouring large chunks of earlier art, achieving first what they would later discard. Philip Guston's painting developed along similar lines. Around 1930, while a high-school student in Los Angeles, he visited the Arensberg Collection where he was moved by the early canvases of de Chirico and Picasso. His own drawing from the model and an interest in the antecedents of Surrealism and Cubism led him to study' Renaissance art, a preoccupation which lasted for almost a decade. Guston's "realism" was rooted more in Mantegna, Masaccio, Piero and Uccello than in Depression ideologies, although a turn to mural painting was socially motivated. His involvement in the 'thirties was with the solution of space problems; this continued to absorb him after he joined the WPA mural project in 1935 and came to New York. At first, Guston treated space as a void in which to project solid forms. He then attempted to synchronize solids' and voids so that they operated in controlled depth and as a two-dimensional surface. Later, he adapted Cubism, trying to create a poetry of shifting planes.

When Guston completed his last WPA project, the Queensbridge housing mural, 1938-40, his private world had begun to open up. After leaving the project, in 1941 and accepting a teaching position at the State University of Iowa (Guston also taught at Washington University, St. Louis, from 1945-47), he returned to easel painting and developed sections of the Queensbridge mural in a series of "children" pictures. After years of working in mural mediums, he was stimulated afresh by the potentialities of oil paint, its suggestability and resistance. The "children" canvases were possibly remembered scenes from Guston's childhood, and symbolized adult conflicts. They remained steeped in art, displaying the marks of many past and present artists. However, he increasingly' used forms and colors as equivalents for emotions rather than to express subjects. Guston's work since this time has been the intensification of an inner search. In this sense, there are significant resemblances in the massing of shapes and in the treatment of space between *Martial Memory*, 1940-41 and *Fable*, 1956-57.

Guston had five years of "felt" painting, but the period from 1946 to 1947 was a troublesome one. In *Martial Memory*, he had attempted to make emotion into flesh via flesh, but each sortie into self revealed unforeseeable sentiments which at one point became too elusive to be recorded so indirectly. It was becoming necessary to feel, think and act concurrently. If the subject of the picture had initially been used to explore feeling, the exploration itself had become the method of finding the subject. The new forms that were struggling to emerge could no longer be related to the specific image. But Guston was reluctant to sacrifice every reference to the external world, and he continued to try to fuse the forms with the figures'. The "children" in pictures such as *Porch 2*, 1946-47 became flattened and attenuated; such canvases have a Surrealist "look." Guston was dissatisfied with these paintings; he still wasn't hitting directly enough. Toward the end of 1947, he eliminated the "children" and began to experiment with sections of his latest pictures, i.e., the lower part of *Porch, 2*, which somehow felt "right." Pictures like The Tormentors, 1947-48 reflected his turmoil in this period of transition. His disquiet was expressed in the smoldering reds and blacks, the constrained use of paint and the tendency to geometric rigidity. Although the flow of feeling was inhibited, a new immediacy was achieved. Guston felt that he was on the right path but needed more time to assimilate the changes

41

in his work. He destroyed most of his 1947-48 canvases and stopped painting.

Other artists in New York had been undergoing similar metamorphoses and encouraged one another. Guston came East again in 1947 and settled in 'Woodstock and New York. Searching for what Harold Rosenberg called "the true image of Identity," in Guston's words, the canvas had become "more of a mirror than a picture." Notions about what art should be were ignored; they could only define what one already knew. However, the muse of painting was enlisted in the search for the "Cosmic I." For those who had been making love to her so ardently, divorce was impossible. She could be a Termagant "the conceptual bitch"—but the precision of sensibility that she fostered was invaluable. The life of the painter was changed in the act of painting, but in its power to change life, art itself had become more vital.

If similarities exist among these painters, so-called Abstract-Expressionists, the distinctions are much more apparent. These stem from what Guston calls "the lonely part of the artist that does not live in the world of relationships." Identity is individual; the painter must emerge in his own colors. Guston's uniqueness is found in his preoccupation with paradox and in a blending of hypersensitivity and hypercultivation. His canvases are-not heroic or intimate; not mystical, symbolic or naturalistic; not violent or moody. They are rather a Kafkaesque probing of the nerve ends of feeling with the scalpel of art. Guston is like a neurosurgeon cutting into living tissue—his own. The simile is not meant to be morbid, but to convey the sense of risk and the seriousness of such an act—the anguish in the subtlest turn of knife (or brush). But if Guston must probe inchoate sentiments that can be caught only at the moment of sensing, he must also weld these unintegrated and often contrary feelings into the sum total that is his self. At this point the painter faces a paradox of being: the divergent emotions, ever unfolding and shifting, can never be bound into a transcendent whole. Still, the shattered fragments can be fixed on the picture plane, to be held in suspension at the outer limits of awareness where man makes known to himself what he is. And if the paradox cannot be resolved, it can be expressed through the opposites in painting. To maintain multiplicity is to insist upon our real beings—so interminable—but at least the finger is on the nerve. The order achieved cannot

be final; it is evocative of man's tragic yearning for oneness. Nevertheless, the paintings are unities, tentative triumphs. Guston's work suggests the possibility of another, more total, kind of order; yet the artist does not fear to leave the traces of all of the ragged processes through which he has traveled.

When Guston began to paint again in 1949, he tried first to close the gap between thinking and doing through the act of painting itself. He eliminated all impediments to immediacy—the residues of Cubist space, the strict delineation of shapes. During 1950-54, when the forms proved unwieldy, they were fragmented and dissolved, and emotion expressed directly in the flow and resistance of pigment, in the jostling of reds, pinks and oranges. Accuracy was achieved through erasures which remained as part of the image. In the resulting pictures-some consisting of spare, suspended forms, others of throbbing color clusters or meshes of pigment—the image was relocated. Thought and touch had merged; the paint itself became noun and verb.

Acutely alive to his psychic processes, Guston is more sharply aware of the still-hidden reality than of the revealed. While he starts his canvases with memories of former works or with projections of an ideal picture, in the act of painting esthetic assumptions become too predictable to encompass the incongruous stirrings, of his inner self. In each picture he begins to paint numberless possibilities which in turn organize resistant elements and are rejected. "I scrape out all that does not yet belong to me or that belongs too much." If conscious choice, mental gymnastics and rules are unacceptable, neither are the momentary offerings of the unconscious admissable. Guston refuses to push aside thought, memory or will; he refuses to lapse into an unconscious naturalism. Painting becomes a "tug-of-war between what you know and what you don't know between acceptance and non-acceptance, the moment and the pull of memory."

In the process of experiencing disorder, he does not permit himself to be submerged, nor does he escape by artifice. He assumes moral responsibility for his choices. His pictures are not accidental, indulgent or gratuitous, but issue from his will to create order.

Guston paints from area to area until the forms have battled with and par-

taken of one another until he has suffered them. He works in a condition of mounting "tension provoked by the contradictions...in painting." As the forms "shed their minor relations and confront each other more nakedly," he reaches "a state of 'unfreedom' where only certain things can happen, [where] unaccountably the unknown and free must appear." Culminating in a total vision—which is the earned moment—Guston breaks the shackles of past categories, and the urgencies within himself are free to find their own shape; the image begins, to "pull" for its own "light," "its sense of place." The paradoxes no longer withstand solution; the forms maintain their identity yet charge all other forms in a new, unpredicted way. The structure emerges only as an end result, the function of the equilibrium achieved. Guston says that, "what is seen and called a picture is what remains—an evidence." The painting crosses. "the narrow passage from a diagramming to that other state—a corporeality." It ceases to be the subjective extension of the artist and becomes a presence, a sudden onenes. that cannot be translated back into its parts.

When Guston confronts a finished canvas, he feels he has revealed an organism that has always existed. He is surprised both at its familiarity and at its newness. Surprise is the crucial element. It is not enough to say: "that expresses exactly how I feel"; he insists on being able to say: "I never knew I felt like that." Ultimately, each painting becomes a trap to be eluded; the unknown remains; the "drama of the process" must be repeated.

THIS ESSAY DEALS WITH THE THREE MAJOR
COLOR PRINCIPLES OF MODERNIST ART, THE
ROLE OF GAUGUIN AND MATISSE IN FORMULAT-
ING THEM, AND THE IDEAS OF THE THREE
AMERICAN MASTERS THEY INFLUENCED, NAMELY
HANS HOFMANN, JOSEF ALBERS AND MILTON
AVERY WHO HAVE MOST COGENTLY ARTICULAT-
ED THEM. THE ESSAY ALSO DEALS WIH MAJOR
OLDER ABSTRACT EXPRESSIONIST COLOR-FIELD
PAINTERS CLYFFORD STILL, MARK ROTHKO,
AND BARNETT NEWMAN; YOUNGER STAINED
COLOR-FIELD PAINTERS MORRIS LOUIS,
KENNETH NOLAND AND JULES OLITSKI, HARD-
EDGE PAINTERS ELLSWORTH KELLY AND AL
HELD; AND A NEW PERCEPTUAL REALIST ALEX
KATZ.

46

Expression Through Color

After Matisse

The use of color as the primary means in painting is peculiarly modern. It began with the Impressionists. Before Pissarro, Monet, Renoir, and their associates, artists based their painting primarily on drawing, notably contour, linear perspective, and shading from light to dark. Color was secondary, although many Pre-Impressionists were great colorists indeed. In their desire to simulate the movement of light in nature realistically, the Impressionists suppressed drawn line and modeling and employed dabs of pure color instead. This made their pictures look 'unfinished' to nineteenth-century eyes, and the Impressionists were scorned. But there was another underlying reason for the negative reaction: the Western sensibility seemed more disposed to drawing than to color, despite the associations of color with hedonism and decoration. This predilection may account for, or be the result of the vastly richer vocabulary that exists for drawing than for color. Even today, our art-school curricula reflect the disparity; the occasional course in color is a poor counterpart to Drawing I, II, and III, Two-Dimensional Design, Drawing from the Figure, Anatomical Drawing and so on.

The Post-Impressionists adopted Impressionist color but used it for different purposes. Cézanne made the dabs of paint volumetric, shaping mass and

47

space, and creating structure with them. Seurat turned them into points of color to produce optical vibrations. Van Gogh made high-keyed strokes stand for passion, and Gauguin expanded the dabs into planes of color with which he hoped to symbolize states of soul.

Gauguin was the first who thought of color as an autonomous pictorial element which could be expressive in itself or, as he remarked, if memory holds, which could be enjoyed as "sensations proceeding from its own nature, from its inner mysterious force." To him, shading greyed color, and complicated drawing and textures distracted attention from color and thus were 'alien' to it, blunting or dissipating its visual and symbolic force.

The suppression of modeling from light to dark causes a flattening of pictorial space. It is widely believed that, starting in the late nineteenth century, modern artists valued flatness because they wanted to assert the reality of the picture as a two-dimensional object. The claim is that to be modernist, a painting must be looked at rather than through to some subject. I have come to believe, however, that the urge to present the picture as object was not primary but secondary, that modern artists generally suppressed modeling and so flattened their images for the sake of expression through color.

Henri Matisse adopted and extended the color principles of the Post-Impressionists in a number of original and influential ways. He believed that colors had "the inherent power of affecting the feelings of those who look at them...A blue, for instance, accompanied by the shimmer of its complementaries, acts upon the inner sensibility like the sudden stroke of a gong. The same with red and yellow; the artist must be able to strike them when he needs to."[1] During his Fauve period, from roughly 1905 to 1907, he combined Cézanne's use of color to create volume with Van Gogh's expressionism. He painted directly with vivid hues and through the orchestration of color, as the Fauves liked to refer to their process; he tried to make every inch of surface equally intense, and in this manner to organize his pictures.

Hans Hofmann met Matisse during his Fauve period and was strongly impressed by his use of 'plastic' color. Hofmann (arguably the greatest teacher of art in this century) transmitted Matisse's ideas, elaborating them

in his own way to his American students, either in Munich between the end of World War I and 1931 or, after that year, in America, until 1958. Clement Greenberg claimed that "you could learn more about Matisse's color from Hofmann than from Matisse himself."[2] Hofmann's reputation as a master of Abstract Expressionism, beginning in the late forties, contributed to the influence of his teaching. So did the large number of his students (and their students) who became important teachers in their own right.

As Hofmann viewed it, the painter had to take into account, simultaneously, three interacting factors: nature, the inherent qualities of the medium, and the artist's psychological, spiritual, and imaginative feeling about both nature and the medium. The problem was to translate the volumes and voids of nature into planes of color in accord with the two-dimensional character of the painting medium. And then, the crucial action was to structure the color planes into 'complexes', whose every element was to be reinvested with a sense of 'plastic' space-depth or bulk—without sacrificing physical flatness. The suggestion of a third dimension was vital to Hofmann. It enabled painting to avoid becoming decoration, which would result if colors possessed only a surface dimension. But the kind of mass or space that Hofmann wanted to create was not a tangible pictorial property; instead, it was implied and, in this sense, was supra-material. In Hofmann's words, "The relation of two given realities always produces a higher, a purely spiritual third [which] manifests itself as pure effect."[3]

To achieve a simultaneous two- and three-dimensionality, Hofmann devised the technique of 'push and pull', his version of the Fauves' improvisational orchestration with color or, as he liked to put it, an answering of force with counterforce. Hofmann carried forming with color further than the Fauves had- into abstraction. His concern with the weightiness of color allowed him to use rich, tactile pigmentation. As Clement Greenberg remarked, Hofmann addressed his picture surface "as a responsive rather than inert object, and painting itself as an affair of prodding and pushing, scoring and marking, rather than of simply inscribing or covering. . .And it is thanks in part to Hofmann that the 'new' American painting in general is distinguished by a 'new' liveness of surface."[4] The way in which Hofmann related his colors had a source in Cubist design. Indeed, it was

49

his life-long ambition to synthesize the explosive color of Fauvism with the compacted composition of Cubism. However, the interaction of color, the building of structure with color, was primary to Hofmann. He spurned the filling in of linear diagrams with color that produces a 'bright' Cubism, with color subordinate to drawing.

Following the Fauve period, Matisse began to use flat areas of color, as had Gauguin. It was this aspect of Matisse's painting that most inspired Milton Avery. But Avery's vision of nature tended to be more sober and brooding than Matisse's, akin to that of Albert P. Ryder and Marsden Hartley—and in this respect, peculiarly American. Avery was esteemed as a painter in avant-garde circles earlier than Hofmann, who was better known as a teacher until well into the forties. During the thirties, a decade in which Cubism, both figurative like Picasso's and nonobjective like Mondrian's, was the major influence on American advanced art, it was Avery's canvases which were crucial in keeping Matisse's chromatic ideas alive in America.

Avery was the mentor of Mark Rothko and Barnett Newman but, in their own work, they carried Avery's and Matisse's color ideas into abstraction. Newman simplified drawing, gesture, and surface incident, enlarged the size of the canvas, and painted with a thin coat of a single color, energized and given scale by a few vertical bands or "zips" of other colors. Newman's zips function in much the same way as the studio paraphernalia in Matisse's *The Red Studio*. Rothko's pictures, composed of a few softly-edged rectangles placed symmetrically one above the other, are also simple in format and large in size, like Newman's. They differ in the elimination of line and in the application of paint in lightly brushed, stained and blotted touches of color that generate a glowing yet shadowy aura emanating from within the painting and suffusing the entire surface. Rothko and Newman wanted to create an overwhelming emotional impact with color, with fields of color that seem awesomely vast and boundless and, thus, suggestive of what Newman called the "sublime" and Rothko, "transcendental experience. "[5] Because neither Rothko nor Newman organized discrete forms of color into relational designs, as Hofmann did, their design has no reminders of Cubism. One perceives their abstractions not as structures to be experienced part to part to whole, but as fields, each graspable immediately and in its entirety. The color

fields are open and thus reminiscent of late Impressionism. Thinly applied pigment contributes to the openness; disembodied, the paintings appeal primarily to the eye, little to the touch.

There has been an inclination to think of the colorists of the forties and fifties as color-field painters. This characterization includes Rothko and Newman but not Hofmann. Yet Hofmann's approach—it might be termed 'relational plastic color' or 'painterly color'—is just as coloristic as that of color-field painting. In Greenberg's words, "Hofmann has come to require color to be saturated corporeally as well as optically," and this contributes to the presence of his pictures. [6] In contrast, Newman's and Rothko's thinly painted color, neither broken by assertive brushwork nor "by sharp differences of value or by more than a few incidents of drawing or design... breathes from the canvas with an enveloping effect, which is intensified by the largeness itself of the picture.'[7]

Impressed by Newman's and Rothko's enveloping color, Kenneth Noland, Jules Olitski and Morris Louis tried to augment the optical effect of their painting. They found that they could do so by staining thinned pigment into unprimed canvas. In this they took their cues from Helen Frankenthaler who had been influenced by Jackson Pollock. However, where Pollock relied mainly on dripped calligraphy, Frankenthaler, with an eye to Matisse, focused on the interaction of color areas, fluid and buoyant. Noland, Olitski, and Louis fused the liquid paint with the canvas, producing a unified field of fabric texture and light, akin to that of the Impressionists with their all-over brush dabs. But stained color also appears to be without physical substance, swiftly inundating the eye. It possesses a resonance that animates both colored and bare canvas alike, and its effect is hedonistic and decorative in the best sense of that word.

The painting of Frankenthaler, Louis, Noland, and Olitski had an effect on taste: it made decoration acceptable, indeed desirable, in art. During the heyday of Abstract Expressionism, vanguard artists valued rawness and crudeness because painting was thought to be—and often was-the result of a struggle to reveal emotion truthfully, no matter how ugly. "Beautiful",

"handsome", "tasteful", "decorative", "elegant" painting was suspect, dishonest. Critics made allowances for Matisse but not for other artists—until the advent of stained color-field abstraction. Color-field painting accounted for a change in the climate of opinion and the recognition of subsequent decorative painters inspired by Matisse, such as Joyce Kozloff, Robert Kushner, Kim MacConnel, Miriam Schapiro, and Robert Zakanitch, all of whom have proclaimed, without reservation, the decorativeness of their painting.

Louis, Noland, and Olitski were only indirectly indebted to Matisse. Al Held and Ellsworth Kelly, so-called hardedge painters, were directly influenced by him. Unlike Louis, Noland, and Olitski, they conceived of color as form rather than field. In the early and middle sixties, Held improvised with shapes derived from illustrations of Matisse's collages in the book, *Jazz,* but rarely ended up with images that looked like them. For the most part, be converted Matisse's free forms into rectangles, triangles, and circles, turning a sensual biomorphism into a strict geometry. Held's color also tended to be more strident than Matisse's, a kind of visual noise evocative of New York City. Like Matisse, Kelly reduced his images into large planes of color. He began his painting with drawing, with the shapes of color, signifying its primacy. As he said: "I work from drawings [which always comes first. There] have to be adjustments during the painting. Through the painting of it I find the color and I work the form and play with it and it adjusts itself."[8] When drawing is simplified to maximize the impact of color, it remains as important as ever; any lapse in the vitality of line is immediately apparent. Kelly ventured further than Matisse toward abstraction or, more accurately, near-abstraction, because his subjects are the silhouettes of ephemeral, natural phenomena such as shadows or the spaces between objects. Kelly's work also differs from Matisse's in its cooler, less sensuous color—this the sign of Kelly's artistic personality.

Inspired by Matisse, Avery, and Rothko (as were the stained-color-field and hard-edge painters) Alex Katz simplified and flattened his forms but, unlike their abstract images, his were portraits. To create a sense of the mass of a figure in space, he relied mainly on the drawing of his contours and the interaction of color. In his insistence on specific representation, Katz seems closest to Matisse's small pictures of the twenties, although he is more literal.

However, in their large size, Katz's canvases after 1962 relate more to Matisse's 'abstract' works of the teens. Katz's development of the 'big' representational picture, which could compete in presence with the huge abstractions of his contemporaries, was a major contribution to the New Realism of the sixties.

Matisse started to assemble collages from painted paper in 1950, after the age of eighty. In the collages, he reduced his subjects-dancers, bathers, nudes, flowers-to flat color profiles, eliminating all details that would detract from the intensity of the hues. Collage offered him new chromatic possibilities: "Cutting colored papers permits me to draw in the color...Instead of establishing a contour and then filling it with color—the one modifying the other—I draw directly in the color.... This guarantees a precise union of the two processes; they become one."[9] In a number of the last collages, Matisse also began to develop a radically new spatial approach. Instead of situating an image on a background, as is customary in Western art, he so adjusted the color areas that both figure and ground oscillate, perpetually interchanging their positions, and in the process creating an optical flicker. Contemporary artists (Kelly, for example) have extended this radical approach.

In summary, three modernist approaches to color are "plastic", "field", and "optical"—and in each Matisse's contribution is seminal. But, rather than closing off possibilities for other artists, Matisse opened them up, the proof of which is the vital, original, and beautiful painting in this show. I stress the adjective 'beautiful' because the pictures on view are indeed beautiful in the best sense of that old-fashioned word.

Notes

1. Monroe Wheeler, *The Last Works of Henri Matisse: Large Cut Gouaches*, exhibition catalogue (New York: Museum of Modern Art, 1961), p. 10.

2. Clement Greenberg, New York Painting Only Yesterday, *Art News*, Summer 1956, p. 84.

3. Hans Hofmann, Plastic Creation, *The League* (Art Students' League, New York), Winter 1932-33, p. 14.

4. Clement Greenberg, *Hofmann* (Paris: The Pocket Museum, Editions Georges Fall, 1961), pp. 24-25.

5. See Barnett Newman, The Sublime Is Now, *The Tiger's Eye*, No. 6 (December 1948), p. 51, and Mark Rothko, *The Romantics Were Prompted, Possibilities 1*, Winter 1947-48, p. 84.

6. Greenberg, Hofmann, p. 32.

7. Clement Greenberg, *'American-Type' Painting, Partisan Review*, Spring 1955, p. 194.

8. Henry Geldzahler, *Interview with Ellsworth Kelly*, Art International, 15 February 1964, p. 48.

9. Monroe Wheeler, *The Last Works of Henri Matisse: Large Cut Gouaches*, p. 1.

My essay on expression through color set the stage, as it were, for my piece on Mark Rothko. I also addressed Rothko's intentions—his aspiration to create a tragic art—and how they could be related to his abstract painting. I also presented the interpretations of art critics and historians who wrote extensively on Rothko's works and evaluated them in a kind of criticism on criticism. In the essay, I deal with the difficulties in interpreting enigmatic but intensely moving abstractions.

Mark Rothko

In Memory of Robert Goldwater

R obert Goldwater once cautioned against reading cosmic allegories and other literary fancies, into Mark Rothko's nonobjective paintings. Such "program notes...relax the visual hold of these canvases, filter their immediacy, and push away their enigmatic, gripping presence:[1] It is noteworthy that even in this warning against the excessive interpretation of their content, an art historian as tough minded as Goldwater should have found it necessary to characterize Rothko's abstractions as "enigmatic" and also as "apparitional" He obviously could not avoid reporting on his subjective response, a response shared by other viewers, myself included, in sufficient numbers to indicate that inscrutable and preternatural qualities do inhere in Rothko's paintings. Indeed, these ineffable qualities are the source of their distinction, their greatness. But what can be said about them with credibility?

Because Rothko's paintings are enigmatic they have frequently summoned forth the kind of excessive commentary that Goldwater warned against, particularly in the fifties when such art criticism was common. Not surprisingly, the language of Rothko appreciation has been immoderately poetic. Or as Robert Hughes has written, "out come the violins, the woodwinds, the ket-

tledrums, everything."[2] Art critics have churned out inflated rhetoric about Rothko's content, commonly ornamented with quotes from the Kabbalah and the like, although a few have written with insight, relying on their own experience. However, the quality of the prose, even at its best, has not approached the quality of the painting. Rothko has yet to find his Baudelaire or Apollinaire. Maybe he won't or can't, as John Ashbery, perhaps our greatest living poet, suggested. Ashbery remarked that he "had produced a text [on Rothko] containing the words 'shades snapped down against the day,' 'Rembrandt,' 'Dominican,' 'poverty,' 'Spinoza' and 'the all-importance of fine distinctions.' After having put this paper aside for a few days and come back to it I was infuriated by the inadequacy and silliness of what I had written. Rothko seems to eliminate criticism."[3]

In reaction against the glut of turgid subjective and poetic analysis of content, critics, for example Clement Greenberg, whose formalist approach dominated art criticism during the sixties, dismissed all such analysis as irrelevant. In the name of objectivity, they insisted on dealing exclusively with the formal components of art. Inquiry into issues "external" to art was condemned as disreputable.[4] During the last decade, the formalist approach lost its sway over art discourse. It succumbed to a surfeit of wordy interpretations of formal minutiae. Critics in increasing numbers and with growing confidence have been investigating extra-aesthetic feelings and thoughts that inhere in the physical properties of works of art, taking care to check their personal responses against the formal evidence, verifying them, as it were, or at least making them understandable.

Critics have also been looking to the artists' own statements of intentions for suggestions as to how their works might be perceived and for information as to how they came into being. Everyone is aware of the intentional fallacy, that an artist's intention is not necessarily conveyed by his or her works. But it can be tested against pictorial or sculptural "facts". Actually, there is no way to avoid considering an artist's aims if we know them; we cannot make believe that we do not. Even our awareness of a work's date conditions our experience of it, as Thomas McEvilley wrote. "Imagine yourself looking at a painting in a gallery, by an artist whose name is unknown to you, and reading its date, from the wall label, as 1860; suddenly a gallery attendant

approaches and corrects the label to read 1960. One's critical awareness shifts immediately in response to one's new sense of what the artist knew, what paintings the artist had seen, and what the artist's implicit intentions, given his or her historical context, must have been."[5]

In the case of Rothko, the correlation between the statements he published in the forties and the pictures he painted is a close one, making the analysis of his intention valuable. Indeed, his remarks not only elucidate but at times appear to anticipate developments in his work. Rothko wrote that changes in his style or its "progression" were motivated by a growing clarification of his content[6]—and content was primary. He and Adolph Gottlieb emphasized this as early as 1943, in a now-famous letter to *The New York Times*. They declared: "It is a widely accepted notion among painters that it does not matter what one paints as long as it is well painted. This is the essence of academicism. There is no such thing as good painting about nothing. We assert that the subject [or content, as we would say today] is crucial"[7] The "subjects" that engaged Rothko and Gottlieb at the time (as well as Jackson Pollock, Clyfford Still, William Baziotes, and other painters who would soon be labeled the Abstract Expressionists) were, as they said, concerned with primitive myths and symbols that continue to have meaning today.[8] Beginning around 1942, Rothko employed the Surrealist technique of "a free, almost automatic calligraphy"[9] to invent fantastic hybrids composed of human, animal, bird, fish, insect, and plant parts, protozoa and other primitive, often aquatic, organisms that seem to be engaged in cryptic mythic or ritual activities.[10]

Rothko conceived of these "pictures as dramas: the shapes...are the performers. They have been created from the need for a group of actors who are able to move dramatically without embarrassment and execute gestures without shame."[11] His mythic or Surrealist pictures, as they are now called, were inspired by Greco-Roman legends and tragic plays which Rothko believed expressed Man's fears and destructive passions.[12] His purpose was not to illustrate specific anecdotes but to suggest the "tragic and timeless"[13] "Spirit of Myth, which is generic to all myths of all time," as he wrote of a canvas titled *The Omen of the Eagle*, 1942, whose subject was derived from the Agamemnon Trilogy of Aeschylus.[14]

In 1946, Rothko began to think that specific references to nature and to existing art conflicted with the idea of the "Spirit of Myth" or what he began to call "transcendental experience"[15] The two terms are related but not the same in meaning. The one seems to issue from some deep, barely accessible stratum of being—one thinks of Jung's collective unconscious; the other is more readily available and directly apprehended. Rothko did not specify what transcendental experience was, but his writing on the whole suggests that it involves the release from banal, everyday existence, the rising above the self's habitual experience into a state of self-transcendence. That, as I see it, is what he meant by his "idea".

As Rothko wrote: "The familiar identity of things has to be pulverized in order to destroy...finite associations."[16] He soon stopped titling his pictures and expunged from them any semblances of nature, symbols or signs. These had become "obstacles" in the way of a clear presentation of his "idea".[17] Instead of depicting "fragments of myth" calligraphically,[18] Rothko began to paint irregular washes of color, but he found them too diffuse and drifting. Toward the end of 1949, he reduced these amorphous areas into a few soft- ly painted and edged rectangles of atmospheric color, placed, or, rather, float- ed symmetrically one above the other on somewhat more opaque vertical fields. He also greatly enlarged the size of his canvases. These "classic" abstractions, as they have come to be known, were at once unprecedented and the culmination of a long development, anticipated not only by the abstractions that immediately preceded them but by the banded back- grounds of the Surrealist pictures and even by the insistent rectangularity of his subway scenes of the thirties.

Rothko's radical simplification of format calls to mind his intention, and that of Gottlieb, which they stated in their letter to the *Times*. "We favor the simple expression of the complex thought. We are for the large shape because it has the impact of the unequivocal. We wish to reassert the picture plane. We are for flat forms because they destroy illusion and reveal truth"[19] Although Rothko thought of the biomorphic shapes in his Surrealist paint- ings of 1943 as simple, large and flat, these adjectives apply with far greater pertinence to the rectangles he began to paint six years later. To be sure, Rothko was not following a program, but he did seem to extend his ideas

concerning content, until he arrived at unprecedented forms.

Apart from Rothko's published statements, there is another written source that accounts for and in part may have even inspired his "progression" into nonobjectivity. That source was Edmund Burke's philosophic inquiry into the sublime of 1757, which Rothko read, most likely before 1948, that is, before he began his "classic" paintings.[20] The word "sublime", which bears a close resemblance to "transcendental experience", has been applied to the abstractions of Rothko, and also of Still and Newman, so often as to become a cliche. Hughes spoofed its repeated use in an article on Rothko's retrospective in 1978, the "sublime, sublime, sublime, sublime: the reflexes go clickety-clack, all the way down the Guggenheim [Museum] ramp."[21] However, the sublime need not be thought of in inflated, hackneyed terms. It has been experienced by most if not all of us before certain natural phenomena and works of art. And it is to be expected that artists, such as Rothko, should have aspired to reveal their experiences of the sublime in their painting and sculpture, and that a few should have succeeded.

In his treatise, Burke listed the qualities which evoke the sublime, among them vastness, oneness, infinity, vacuity, and darkness. As if heeding Burke's warning that the imagination should not be checked "at every change...[making it] impossible to continue that uninterrupted progression which alone can stamp on bounded objects the character of infinity,"[22] Rothko eliminated line from his paintings. The blurring of demarcations dislodges the rectangles, causing them to hover in and out, but it also turns the surface of each of his pictures into an allover field, creating an effect of oneness. Enhancing this effect is the spread of the rectangles across the canvas, terminating near the framing edges, declaring the wholeness of the work. At the same time, the field is continuous and open, suggesting an extension into infinity.

Having eliminated line, all that remained to convey content was color. (Rothko was disposed toward expression through color early in his career; during the thirties, he looked for inspiration to Matisse and Milton Avery when most other American vanguard artists venerated Picasso and Mondrian for whom drawing was primary.) Rothko built up his rectangular containers

of color from lightly brushed, stained and blotted touches which culminate in a chromatic crescendo. These resonant nuances also function as subtle lights and darks which create atmosphere, a tinted aura that emanates from within the painting and suffuses the entire surface. This aura is at once glowing and shadowy; Lawrence Alloway remarked on "Rothko's characteristic effect of light combined with obscurity" and added that it is "anticipated by Burke when he observes that 'extreme light...obliterates all objects, so as in its effects exactly to resemble darkness.'"[23] Burke also remarked that dark colors evoke the sublime;[24] Rothko favored a somber palette, particularly after 1957. Moreover, because his vaporous colors are used in large expanses, they seem void, even suggestive of The Void. And because they do not call to mind anything of this world, they seem otherworldly. The colors, even the brightest reds and yellows in most cases, are sufficiently "off," dissonant, disquieting. They are not decorative, seductive and sensuous; thus they do not fulfill the familiar expectations of color. Instead, they evoke other-than-sensuous qualities.

Burke observed that the sublime is caused by "greatness of dimension" and when "the mind is so entirely filled with its object, that it cannot entertain any other."[25] Bigness can overpower, reduce the observer. It can also produce an effect of intimacy; the latter is what Rothko desired. "To paint a small picture is to place yourself [and the observer] outside your [and his or her] experience, to look upon an experience as a stereoptican view or with a reducing glass. However you paint the larger picture, you are in it"[26] Rothko scaled his pictures to human size. He also wished for them to be exhibited in small rooms, drawing observers close up to the surface, enveloping them in luminous atmosphere while compelling them to contemplate the nuances of the painting. It is as if Rothko wanted to detach the observers from their prosaic environment and attachments which prevent self-transcendence and at the same time, to convey this experience dramatically, with color.

In this sense, Rothko's pictures can be viewed as backdrops in front of which observers are transformed into live actors, the range of whose response but not the particulars is controlled by Rothko's "idea." The evolution of Rothko's painting can be interpreted in dramaturgical terms as the assimilation of myth inspired action-the shapes as performers against banded back-

grounds-into scene- the horizontal rectangles as a kind of stage set.[27] (And yet, the hovering rectangles also function as performers of a sort; their colors and sizes and the intervals between them are varied, directing attention to their interactions.) That Rothko had in mind an immediate and intimate communion between the painting and the viewer is suggested by the last statement he wrote for publication in 1949. It reads in part: "The progression of a painter's work, as it travels in time from point to point, will be toward clarity: toward the elimination of all obstacles between the painter and the idea, and between the idea and the observer."[28]

Rothko was preoccupied, at times obsessed, or so it seemed, with the observers' responses to his work.[29] The intensity of his concern is disclosed in a comment he wrote in 1947 that a picture "lives by companionship, expanding and quickening in the eyes of the sensitive observer. It dies by the same token. It is therefore a risky and unfeeling act to send it out into the world."[30] In 1952, he refused to submit two of his works to the purchasing committee of the Whitney Museum because of "a deep sense of responsibility for the life my pictures will lead out in the world."[31]

The problem of communication had troubled Rothko as early as 1943. He and Gottlieb had written to Edward Alden Jewell, the senior art critic of *The New York Times*, that it was their "function as artists to make the spectator see the world our way-not his way."[32] But in the case of Jewell, they had not succeeded. He remarked that Rothko's *The Syrian Bull* and Gottlieb's *The Rape of Persephone* had left him in a "dense mood of befuddlement"[33] And these were two myth inspired paintings-with recognizable imagery and explanatory titles. The "classic" abstractions, because they were nonobjective, turned out to be considerably more befuddling, at least to most art critics. Those who commanded the greatest attention because their writing was stimulating and/or because of the prestige of the publications in which it appeared, did not see Rothko's pictures his way-or each other's way. It was very dispiriting for him, the gloom not lessened much by the fact that these critics with a few exceptions were very laudatory.

There were several critics whose writing addressed issues with which Rothko himself was concerned. For example, in 1954, Hubert Crehan wrote that in

our culture light is a metaphor for spiritual essence. "Rothko's work is charged with what we mean by matters of the spirit." Crehan likened it to "the Biblical image of the heavens opening up and revealing a celestial light, a light sometimes so blinding, its brilliance so intense that the light itself became the content of the vision, within which were delivered annunciations of things closest to the human spirit." Crehan concluded: "Rothko's vision is a focus on the modern sensibility's need for its own authentic spiritual experience. And the image of his work is the symbolic expression of this idea. Now it is virtually impossible to articulate in rational terms what this might be; we can have only intimations of it which come first to us from our artists."[34]

As a critic, Crehan was peripheral, a California disciple of Still displaced in New York City. In contrast, Clement Greenberg was widely recognized as a leading critic. In one of his most important articles, titled "'American-Type' Painting'" 1955, he wrote that Rothko was "a brilliant original colorist. "His "big vertical pictures, with their incandescent color and their bold and simple sensuousness-or rather their firm sensuousness-are among the largest gems of abstract expressionism."[35] Greenberg's high praise probably pleased Rothko, but little else in his essay would have.

In Greenberg's opinion, the purpose of Abstract Expressionism was to break the hold of Cubism, repudiating in particular its contrasts of dark and light. These generate illusionistic space which destroys pictorial flatness, the very basis of painting. Moreover, Cubism was overworked and outworn. Rothko, Newman and Still had progressed further than their colleagues, because they had achieved "a more consistent and radical suppression of value contrasts than seen so far in abstract art." This had liberated their color, which "breathes from the canvas with an enveloping effect, which is intensified by the largeness itself of the picture."[36] Their vision was "keyed to the primacy of color."[37] Rothko accepted Greenberg's description of his formal innovations. But he objected to the implication that he was primarily a picture-maker whose intention it was to avoid any allusion to Cubism in order to paint flat color-fields. If it had been, he certainly would have suppressed light and dark contrasts more than he had-as much as Newman perhaps.[38]

Rothko also disapproved of Greenberg's purist point of view. Greenberg maintained that "visual art should confine itself exclusively to what is given in visual experience, and make no reference to anything given in any other order of experience."[39] This notion that painting ought to refer to nothing beyond itself, to be self contained like an object, was alien to Rothko. He once remarked that he would "sooner confer anthropomorphic attributes upon a stone than dehumanize the slightest possibility of consciousness."[40]

Greenberg's formal analysis was also foreign to a group of Abstract Expressionists generally labeled the painterly or gestural or "action" painters which included Willem de Kooning, Franz Kline and Philip Guston. But they, like Greenberg, admired Rothko's painting, even though its intention was opposed to theirs. Elaine de Kooning, a respected painter and critic at the epicenter of this group so esteemed Rothko that she tried to turn him into a self-expressive "action" painter, borrowing Harold Rosenberg's notorious label. In an article titled "Two Americans in Action," 1958, she linked Rothko and Kline. As she viewed it, they both used the process of painting to encounter images of "individual identity." It was a sign of the power of Expressionist rhetoric at the time that it should be foisted upon Rothko's painting, even if it did not apply. De Kooning herself acknowledged that Rothko's pictures were devoid of idiosyncratic signs of "action" namely visible brushwork and drawing; his "image seems to settle on the canvas indirectly, leaving no trace of the means that brought it there." The upshot was "tinted hallucinated cloth,"[41] a characterization that would have pleased Rothko were he not upset by the Rosenbergian rhetoric. De Kooning meant well in situating Rothko among the "action" painters. She was a champion of that style, and Kline was one of her favorite painters. She wanted to embrace Rothko in what she loved, but he did not want to be included.[42]

Unlike de Kooning, Rosenberg considered Rothko's works as the "antithesis to action painting." They were "based on the idea of one idea. This was an aspiration toward an aesthetic essence, which...[Rothko] sought to attain...by rationally calculating what was irreducible in painting." He was engaged in a "marathon of deletions," "acts of subtraction," "reductionist aesthetics," "the act of purging," and the like.[43] Rosenberg turned Rothko into a purist, as if he were an unfinished Ad Reinhardt. Had Rothko lived to

read this review, he would have found it baffling. But even in his lifetime, the more art criticism about his work he read, the more convinced he must have been that "the workings of the critical mind is one of life's mysteries," as he and Gottlieb wrote to the *Times* in 1943.[44]

In 1949, Rothko stopped publishing statements, except for a letter to *Art News* in 1957.[45] He had come to believe that they instruct the viewer as to what to look for and thus stunt his or her mind and imagination.[46] However, in 1958, he felt the need to refute his critics and chose to do so by giving a talk at Pratt Institute.[47] He strongly denied any concern with self-expression, with Expressionism. He insisted that his aim was to formulate a message which transcended self and was about the human condition generally or, as he put it, the human drama. Rothko also denied that his purpose was to make formal innovations, although he allowed that he had "used colors and shapes in a way that painters before have not."

In rebuttal to the notion that he was an unpremeditated "action" painter, Rothko stressed (not without irony) the deliberateness of his process. He enumerated seven ingredients that constituted his painting and claimed to "measure [them] very carefully." Above all, his work had to possess "intimations of mortality." Next in order (of quantity) was "sensuality .. a lustful relation to things that exist." "Three: tension. Four: irony, "a modem ingredient-the self-effacement necessary for an instant to go on to something else." And to make the awareness of death endurable, five, wit and play; six, the ephemeral and chance; and seven, hope, 10 % worth. Rothko then said that he mixed his ingredients with craft—he dwelt on this—and with craftiness or, to use his own word, "shrewdness." His listing was also an ironic gloss on formalist analysis. He enumerated elements of human content as if they were measurable quantities, just as formal components were supposed to be.

Rothko not only refuted the ideas of de Kooning and Greenberg in his talk at Pratt, but he confirmed the direction his work had begun to take the year before-toward "a clear preoccupation with death," the sign of which was his growing use of tenebrous browns, deep maroons and plums, grays and black. Rothko had long thought of his painting as essentially tragic. In fact, in the

letter to the Times of 1943, the only words he himself had written were: "only that subject matter is valid which is tragic and timeless."[48]

But Rothko's conception of tragedy was not always bleak, not in the late forties and early and middle fifties. In 1947, he remarked: "For me the great achievements of the centuries in which the artist accepted the probable and familiar as his subjects were the pictures of the single human figure-alone in a moment of utter immobility. But the solitary figure could not raise its limbs in a single gesture that might indicate its concern with the fact of mortality and an insatiable appetite for ubiquitous experience in face of this fact."[49] This figure is Renaissance Man, and Rothko's comment signals his liberation from the restrictive vision of the Renaissance.[50] He also implied that Modern Man's tragic awareness of death freed him to live. This is an existentialist conception; as William Barrett, a philosopher friendly with the Abstract Expressionists, wrote: "In the face of death, life has an absolute value. The meaning of death is precisely the revelation of this value."[51] (The writing of Sartre and Camus was introduced into America only after the European phase of World War II ended in 1945. Rothko's statement was made in the following year, indicating the speed with which be embraced existentialist thinking.)

In reaction against the immobility of Renaissance Man, Rothko concluded: "It is really a matter...of breathing and stretching one's arms again."[52] The earlier "classic" pictures suffused with expansive, translucent atmosphere seem to have provided such occasions for Rothko. But they are also tragic, because they evoke the sensual world and its dissolution into spirit-and/or death. As Robert Rosenblum remarked, they pit "Rothko, the monk" against "Rothko, the voluptuary."[53] The choice is between two goods-the true essence of tragic drama. Rothko's talk at Pratt was far more pessimistic in mood. No longer did the awareness of death give rise to an urge for life; now both were barely endurable. Rothko's growing anguish caused him to darken his palette. The atmosphere in most of his pictures turns oppressive, making it difficult figuratively to breathe and stretch.

In 1958, Dore Ashton accounted for this change in tone. "Rothko struck out with exasperation at the general misinterpretation of his earlier works [as

decorative]—especially the effusive yellow, orange and pinks of three years back." The new pictures speak "in a great tragic voice (although one borders on irritable despair)."[54] Indeed, it appears that the tragic ingredient in Rothko's work as a whole grew in proportion to the others. In many pictures painted in the last two years of his life, particularly in the hopeless "black" ones, there is little but the intimation of mortality.

In his talk at Pratt, Rothko formulated his self-image as an artist. His function was not that of a formal problem-solver or a self-revealing Expressionist but of a contemporary seer who, on the authority of an inner voice, envisions and reveals new truths about the human drama. He said: "I want to mention a marvelous, book, Kierkegaard's *Fear and Trembling/The Sickness Unto Death*, which deals with the sacrifice of Isaac by Abraham. Abraham's act was absolutely unique. There are other examples of sacrifice [that seem related]: Brutus, who as a ruler put to death his two sons [because they had broken the law. Brutus's tragic decision was understandable; the choice was between two known "universals": the State or the Family.] But what Abraham was prepared to do [on God's command audible only to himself] was beyond understanding. There was no universal that condoned such an act. This is like the role of the artist."

God did not require Abraham to sacrifice Isaac. Abraham's problem then became, as Rothko saw it: what to tell about his vision-even to his own wife. What would she believe? What would the neighbors believe? What is believeable today, in an age of modernist skepticism? Not monsters, demi-gods, gods, God. Their images, symbols and signs have lost their power to grip the modern imagination. A contemporary artist could only be reticent. It was a matter of shrewdness, as Rothko said in his talk at Pratt. Besides, "there is more power in telling little than in telling all."

What was to replace conventional subjects? The answer to this question, as Rothko viewed it, was his own self-transcendent experience as revealed through art, through painting and, above all, color, the inherent expressiveness of color. Such experience, personal though it is, possesses intimations of The Transcendental, "of the presence of God, the all-holy."[55] In this sense, it is religious or, because it is not based on any established dogma, quasi-reli-

gious. To put it another way, transcendental experience generated through the creation and apprehension of art is analogous to that generated through religion. Because such experience is "real and existing in ourselves,"[56] it is human. Because it is intense, it is dramatic. Because it calls to mind death, it is unbearably tragic. And when it promises nothing beyond, it can be tragic. Rothko's talk at Pratt was studded with the words "human," "drama" and "tragic."

Who would believe a private vision revealed through nonobjective art? Rothko was skeptical whether his abstractions, because they were unprecedented, were comprehensible to anyone else. This caused him great anxiety, exacerbated by the hostility they elicited. But he also spoke of being surprised not only that there was an audience for his work, but that this audience seemed to be waiting for "a voice to speak to them" and responded totally to it. "There was a revolution in viewing, a 'well at last, that's exactly what should have been done' This was a reaction based on life not on art. This is the thing to be explained."[57]

A nagging question remains. Were Rothko's paintings of transcendental experience too private, too humanly vulnerable, too reduced, even impoverished in their pictorial means to be major? Hughes thought so. He granted their mythic and quasi-religious resonance but added: "In an age of iconography, he might have been a major religious artist...He did not live in such an age." Certainly, Rothko could not partake of the fusion of "myth, dogma, symbol, and personal inspiration that gave religious artists from Cimabue to Blake their essential subjects."[58] Yet, even in a time of modernist doubt, when leading philosophers such as Sartre and Camus have asserted that our universe is lacking in ultimate meaning, that it is absurd, even in such an age there remains the yearning, the need, for self-transcendence. It has become difficult to specify but the urge for it not only has not lessened but can stir passions as intense as those in any past age. The same impulse that prompted earlier artists to invent their monsters and gods motivated Rothko to seek self-transcendence through nonobjective painting. For him- and for many of us-his pictures are a convincing "revelation, an unexpected and unprecedented resolution of an eternally familiar need,"[59] as much as that can be resolved in our age.

Rothko stopped publishing statements in 1949 because of his "abhorrence of...explanatory data."[60] Let the viewer be! But art criticism would not cease. If anything, the explanatory data seemed to grow excessive, one indication of which was Peter Selz' catalogue of the Rothko retrospective at The Museum of Modern Art in 1961 where Selz wrote of Rothko's paintings as "open sarcophagi. . . which] moodily dare, and thus invite the spectator to enter their orifices."[61] But there was rigorous writing, above all Goldwater's review of the retrospective, which stretched formal analysis to the point where it evoked poetic interpretation without overdoing it. Rothko greatly admired Goldwater's essay, in part for its reticence.

Confronting the central issue in Rothko's work, Goldwater wrote: "Rothko claims that he is 'no colorist' and that if we regard him as such we miss the point in his art. Yet it is hardly a secret that color is his sole medium. In painting after painting .. there are handsome, surprising and disquieting harmonies, and supposedly difficult colors are made to work together with apparent ease...There is a sense in which one is inclined to agree with him, or rather to say that Rothko has been determined to become something other than a colorist...[What] Rothko means is that the enjoyment of color for its own sake, the heightened realization of its purely sensuous dimension, is not the purpose of his painting. If Matisse was one point of departure...Rothko has since moved far in an opposite direction. Yet over the years he has handled his color so that one must pay ever closer attention to it, examine the unexpectedly joined hues, the slight, and continually slighter, modulations within the large area of any single surface, and the softness and the sequence of the colored shapes. Thus these pictures compel careful scrutiny of their physical existence...all the while suggesting that these details are means, not ends."[62]

Notes

1. Robert Goldwater, "Reflections on the Rothko Exhibition," *Arts* (March 1961): 44.

2. Robert Hughes, "Blue Chip Sublime," *The New York Review* (21 December 1978): 16.

3. John Ashbery, "Paris Notes," *Art International* (25 February 1963): 73.

4. See Clement Greenberg, "Art: How Art Writing Earns Its Bad Name," *Encounter* (19 December 1962).

5. Thomas McEvilley, "Heads It's Form, Tails It's Content," *Artforum* (November 1982): 57.

6. Mark Rothko, "Statement on His Attitude in Painting," *The Tiger's Eye* (October 1949): 114.

7. Adolph Gottlieb and Mark Rothko (in collaboration with Barnett Newman) "Letter to the Editor," *The New York Times*, 13 June 1943, sec. 2, 9.

8. See ibid and Adolph Gottlieb and Mark Rothko, "The Portrait and the Modern Artist," broadcast on "Art in New York:' Radio WNYC (13 October 1943). Unlike Gottlieb and Newman, Rothko was not interested in primitive art.

9. Mark Rothko, Statement [exh.cat., Art of This Century Gallery] (New York, 1945).

10. Rothko and his friends such as Gottlieb, Newman and John Graham were interested in myths in the thirties. See John D. Graham, System and Dialectics of Art (New York,: Delphic Studios, 1937). In 1969, Rothko inscribed the date 1938 on the back of Antigone, a Surrealist picture. However, if Rothko did paint pictures in this style so early, he did not show them, even privately, to his close friends Gottlieb and Newman, who would certainly have remarked on them. The earliest published date of a Surrealist painting by Rothko is 1942, ascribed to The Omen of the Eagle, reproduced in Sidney Janis, Abstract and Surrealist Art in America (New York: Reynal & Hitchcock, 1944), 118. This fact was confirmed by Bonnie Clearwater, curator of The Mark Rothko Foundation.

11. Mark Rothko, "The Romantics Were Prompted," *Possibilities* I (Winter 1947-48): 84.

12. Gottlieb and Rothko, "The Portrait and the Modem Aritst." Rothko's reading of Friedrich Nietzche's The Birth of Tragedy stimulated his interest in Greco-Roman mythology.

13. Gottlieb and Rothko, "Letter to the Editor."

14. Mark Rothko, Statement of 1943, in Janis, Abstract and Surrealist Art, 118.

15. Rothko, "The Romantics Were Prompted."

16. Ibid.

17. Mark Rothko, "Statement on his Attitude in Painting."

18. Rothko, Statement, 1945.

19. Gottlieb and Rothko, "Letter to the Editor."

20. Edmund Burke, *A Philosophical Enquiry into the Origin of Our Ideas of the Sublime and the Beautiful* (1757; New York, Columbia University Press, 1958).

Rothko, Newman and Still were close friends in the late forties. It is likely that if one considered a book important, the others read it or, at least, heard it discussed at length. Newman was sufficiently impressed with Burke's treatise to remark on it in "The Sublime Is Now," *The Tiger's Eye* (December 1948): 51. In a New York interview (3 November 1964), Rothko spoke favorably of Robert Rosenblum, "The Abstract Sublime," *Art News* (February 1961), and Lawrence Alloway, "The American Sublime," *Living Arts* (June 1963), partly because of their reliance on Burke.

21. Hughes, "Blue Chip Sublime," 16.

22. Burke, quoted in Alloway, "The American Sublime," 15.

23. Ibid., 18,

24. Ibid., 12.

25. Burke, A Philosophical Enquiry into .. the Sublime, 72, 57.

26. Mark Rothko, statement delivered from the floor at a symposium on "How to Combine Architecture, Painting and Sculpture:" The Museum of Modern Art, 1951, published in *Interiors* (May 1951): 104.

27. See Irving Sandler, "New York Letter: Rothko," Art International (I March 1961): 40.

28. Rothko, "Statement on his Attitude in Painting."

29. Rothko spent a good deal of time at his retrospective exhibition at The Museum of Modern Art in 1961 eavesdropping on viewers, such was his curiosity about their responses. I accompanied him on several occasions.

30. Mark Rothko, Statement in "Ideas of Art," *The Tiger's Eye* (December 1947): 44.

31. Mark Rothko, Letter to Lloyd Goodrich, Whitney Museum of American Art (20 December 1952).

32. Gottlieb and Rothko, "Letter to the Editor."

33. Edward Alden Jewell, "End-of-the-Season Melange," *The New York Times*, 6 June 1943, sec. 2, 9.

34. Hubert Crehan, "Rothko's Wall of Light: A Show of his New Work at Chicago," Arts Digest (I November 1954): 19.

Rothko was bolstered by a few artist friends, such as Gottlieb, Newman, Still, and Tony Smith. For example, Smith, not yet known as an artist, was a trusted colleague of Rothko, Still, Newman, and Pollock. What struck him about their painting was its alloverness. "There was no distinction between figure and ground Moreover, their pictures seemed untouched by human hand-no autograph, no handwork. Pollock got away from the mantipulation of paint with the drip; Rothko with washes; and Still, with the palette knife. All of this led to a transcendental image. And this image hasn't been fully appreciated yet." Smith was inclined toward a visionary art in the early forties. He met Rothko in 1945; about his Surrealist work, he remarked: "It was in his light. His underwater clay was radioactive" Conversation with Tony Smith, South Orange, New Jersey, (28 December 1966).

The importance of Smith as a significant audience for Rothko, Pollock, Still and Newman has not been properly acknowledged. He played the same role for them that Morton Feldman said Frank O'Hara played for him in "Frank O'Hara: Lost Times and Future Hopes," Art in America (March-April 1972): 55. "What really matters is to have someone like Frank standing behind you. That's what keeps you going. Without that your life in art is not worth a damn."

35. Clement Greenberg, "'American-Type' Painting," Partisan Review (Spring 1955): 193.

36. Ibid., 189, 194.

37. Clement Greenberg, "After Abstract Expressionism," Art International (25 October 1962): 28.

38. Newman objected to Greenberg's formalism as strongly as Rothko did. Greenberg considered Newman's work more radical than Rothko's because it was flatter. For this reason, Greenberg's disciples, more doctrinaire than their mentor, esteemed Newman more than Rothko. Max Kozloff, in "Mark Rothko (1903-1970)," Artforum (April 1970): 88, remarked on the "relative dearth of critical comment on his [Rothko's] art during the sixties [It] is sad [in part because Rothko was hurt] that the importance of his work to such artists as Morris Louis and Jules Olitski was not more emphatically noted."

39. Clement Greenberg, "Modernist Painting," Arts Yearbook 4 (1961): 107.

40. Mark Rothko, "Personal Statement," .A Painting Prophecy-1950 [exh.cat., David Porter Gallery] (Washington, D.C., 1945).

41. Elaine de Kooning, "Kline and Rothko: Two Americans in Action," Art News Annual, no. 27 (1958): 176.

42. Mark Rothko, "Editor's Letters," Art News (December 1957): 6. He strongly rejected Elaine de Kooning's classification of his work as "action" painting. "[it] is antithetical to the very look and spirit of my work."

43. Harold Rosenberg, "The Art World Rothko," *The New Yorker* (28 March 1970): 90-95.

44. Gottlieb and Rothko, "Letter to the Editor."

I could have made a stronger case by including vulgar popular criticism, such as that of Emily Genauer, who in "Exhibit Holds Art Without Subject Line," *The New York Herald Tribune*, 18 January 1961 wrote of Rothko's paintings as "first-class walls against which to hang other pictures," and Frank Getlein, who in "Art:The Ordeal of Mark Rothko" *The New Republic* (6 February 1961) wrote: "The paintings get bigger and bigger, like an inflating balloon. Similarly, in the work the surface gets thinner and thinner, the content gets purer and purer hot air."

45. See 42. A few statements attributed to Rothko were published after 1949. See 26. Seldon Rodman, in Conversations with Artists (New York: Devin Adair, 1957), 93-94, recorded what he remembered of a swift, unfriendly encounter with Rothko. See also Dore Ashton, "Art: Lecture by Rothko," *The New York Times*, 31 October 1958, 26.

46. Katherine Kuh, "Mark Rothko," *The Art Institute of Chicago Quarterly* (15 November 1954): 68.

47. Mark Rothko lectured at Pratt Institute, New York, on 29 October 1958. The talk was not taped. I took detailed notes on the lecture which have not been published. Dore Ashton's notes on the same lecture appear in "Art : Lecture by Rothko." Unless otherwise identified quotes are taken from my notes.

48. Gottleib and Rothko, "Letter to the Editor."

49. Rothko, "The Romantics Were Prompted'

50. See Douglas MacAgy, "Mark Rothko," Magazine of Art (January 1949): 21.

51. William Barrett, quoted in Sandler, "New York Letter."

52. Rothko, "The Romantics Were Prompted ."

53. Robert Rosenblum, "Notes on Rothko's Surrealist Years," Mark Rothko [exh. cat., The Pace Gallery] (New York, 1981), 9.

54. Dore Ashton, "Art," *Arts and Architecture* (April 1958): 8.

55. Thomas F. Mathews, "The Problem of Religious Content in Contemporary Art," a lecture delivered to the International Congress on Religion, Architecture and the Visual Arts, New York (30 August 1967). Mathews' thesis was that the painting of Rothko, Still, and Newman was the valid religious art of our time.

56. Gottleib and Rothko, The Portrait and the Modern Artist.'

57. Conversation with Mark Rothko, New York (22 September 1960).

58. Hughes, "Blue Chip Sublime," 16.

59. Rothko, "The Romantics Were Prompted."

60. Kuh, "Mark Rothko."

61. Peter Selz, Mark Rothko [exh. cat., The Museum of Modern Art] (New York, 1961), 14.

62. Goldwater, "Reflections of the Rothko Exhibition," 43-44.

STILL WAS THE MAJOR INNOVATOR OF THE COLOR-
FIELD TENDENCY IN ABSTRACT EXPRESSIONISM.
HIS INFLUENCE IS FELT IN THE PAINTING OF
MARK ROTHKO, AND BARNET NEWMAN AS WELL AS
YOUNGER PAINTERS, AMONG THEM MORRIS LOUIS
AND JULES OLITSI. STILL WAS ALSO THE MOST
ARROGANT AND CURMUDGEONLY ARTIST OF HIS
GENERATION. I THOUGHT THAT THE FOLLOWING
REVIEW WAS VERY FAVORABLE AND INTERPRETED
THE PAINTINGS CLEARLY AND COGENTLY. STILL
APPARENTLY DID NOT THINK SO AND SAW TO IT
THAT MENTION OF THE REVIEW—AND EVERYTHING
ELSE I LATER WROTE—WAS PURGED FROM HIS BIB-
LIOGRAPHY. AFTER HE DIED, I WAS REHABILI-
TATED IN LATER CATALOGUES AND BOOKS ON HIM.

Clyfford Still

Emerging From Eclipse

Clyfford Still is recognized as a pioneer of Abstract Expressionism; however, during the 1960's, his name has appeared less and less in discussion of post-war American painting, certainly when compared to that of Jackson Pollock, Barnett Newman or Willem de Kooning. There are several reasons for the decline of Still's reputation. From the end of 1952 on, he refused to show in New York, which he considered the Sodom of the art world—too corrupt a place for his art to be properly seen. He did allow occasional retrospectives—in Buffalo (1959) and Philadelphia (1963)— and gave 31 of his paintings to the Albright-Knox Gallery in Buffalo in 1964. But without travelling to these cities, it was impossible for one to assess Still's artistic development and stature at first hand.

This situation changed six months ago; since then a sizeable number of his works have been exhibited In New York: six at the Museum of Modem Art last summer and. currently, five at the Metropolitan Museum and a major retrospective of 45 dating from 1943 to 1966, at the Marlborough-Gerson Gallery.

Still's eclipse had already begun during the 1950's, when Abstract Expressionism was dominated by "action" or gestural painting. "Action"

paintings consisted of overlapping gestures that receded in shallow depth, suggestive of Cubist space. Still's direction was different. References to Cubism were absent in his pictures. Moreover, no matter how violent and raw much of gestural painting looked, it was marked by painterly finesse, marked by a quality that also seemed lacking in Still's work. His ragged drawing and scabrous surfaces were the very antithesis of well-made painting, deliberately so, for he believed that refined and sensuous art was decadent, associated with the World and unworthy of the New.

During the sixties, a new vanguard generation reacted against gestural painting. This was the time when Still should have been rehabilitated, but that was not the case. Responsible perhaps was Still's self-exile from New York. Furthermore, his best-known pictures, with their impenetrable planes, forbidding colors and aggressive impastos, looked too heavily, even excessively, Romantic to be in key with a time when the painting and sculpture that captured the art world's attention were "cool."

Nonetheless, the camparative neglect of Still is surprising, since it was he who first showed the way to the kind of non-Cubist field .painting that has been central in recent abstraction. Indeed, Still's original formal contribution was his rigorous negation of Cubism, of its relational design contained within the picture frame, its implied horizon line and recessive space as well as its small scale.

In his own painting, Still treats the surface as an open field of upward-thrusting jagged areas. The accent is on openness. No horizontals knit the verticals into a relational structure that might break the continuous plane. The torn drawing acts to release the areas, creating an effect of expansiveness. Those on the edges are cut off, appearing to extend beyond the canvas limits. Still's abstractions at their best convey an immediate sensation of awesome boundlessness and upward aspiration. This is his intention, for he desires painting to be a direct incantation of the sublime by making it "both simple and vast and everywhere the same," to quote Longinus, a philosopher he admires.

Still's evolution toward a visionary abstract art can be traced in the MarlboroughGerson show. In the early and middle forties, he went through

a "mythic" phase (as did Pollock. Rothko, Gottlieb and other of his con-temporaries). Exemplifying his work then is an untitled canvas of 1945 com-posed of semi- abstract. demonic phantoms and sun-moon forms, symbolic, as he said, "of the Earth, the Damned and the Recreated." Somewhat later pictures allude to the image of an upright man on a prairie landscape, but by 1947, figurative and symbolic motifs were eliminated. Still seems to have progressed toward abstraction by developing the expressive possibilities of details in his earlier paintings, for example, the frayed or meandering verti-cal line that opened up the surface.

Still's early abstractions are generally dense and somber. The surfaces are heavily incrusted and the color tends to be dark—blacks and earths pre-dominating. In the fifties. he increasingly opened up the picture by lighten-ing the textures and by simplifying the field, leaving bare expanses of canvas. He also keyed up his palette. Such color-field paintings as "1955 D" are more sensuous than before, but they we also, sternly majestic, among the grandest works of the period.

In many of Still's abstractions of the sixties, the paintIng becomes thinner, freer and more atmospheric; the color. brighter and more lyrical. These pic-tures reveal an unabashed hedonism, which is surprising since Still once took an uncompromising position against it. A few are superb, notably a delicate untitled horizontal work of 1964, curiously reminiscent of Monet's late Lily Pads. The way in which two perfectly scaled licks of red and blue-white kick up the large expanses of light blue and unpainted cancanvas is breath-taking. But even this picture does not compare with Still's best works of the late for-ties and fifties.

In the recent "softer", looser pictures. Still seems to have stopped where pre-viously he had just begun. to dig in—to willfully chew and rechew the paint-ing. to find the surface. To be sure, there are beauties of the hand carried off with easy grace but sacrificed is the elating, awesome presence, generated in part by the weighty surface (and I do not mean merely thick paint). In two works a yellow and orange canvas of 1959 and a brown one of 1994, a dis-concerting pictorial idea is introduced. A vertical line is suspended in front of the field, instead of being held within the continuous plane. The line

becomes a dissociating element which pushes the field back, dissipating its forceful projection.

Hanging on opposite walls of the small room at Mariborough-Gerson are an early "hard" picture, "1946 E," and a mellow untitled canvas of 1966. 1 prefer the forties painting. However, anything but a tentative assessment of the recent work is premature on the evidence of the few canvasses now available. Despite my reservations about some of his sixties pictures, Still re-emerges at this time as a giant of contemporary art. This is the overriding impression that remains after having viewed his painting at the Modern and the Metropolitan Museums—seen in relation to his contemporaries—and one corroborated by the current Marlborough-Gerson retrospective.

REINHARDT WAS THE ODD-MAN OUT OF ABSTRACT
EXPRESSIONISM. HE WAS ACCEPTED WITHIN THE
GROUP OF ARTISTS ALTHOUGH HE DETESTED
EVERYTHING HIS COLLEAGUES PAINTED AND STOOD
FOR, AND SAID SO LOUD AND CLEAR. REINHARDT
WAS A PURIST WHO BELIEVED THAT ART SHOULD
BE ART-AS-ART AND AS SUCH SHOULD BE PURGED
OF ALL REFERENCED TO LIFE, OR ART-AS-LIFE.
HIS IDEAS HIT A NERVE IN HIS COLLEAGUES
BECAUSE HE ASKED OF THEM, "YOU MAY NEED ART
TO EXPRESS YOUR FEELINGS, VISION, HANG-UPS,
WHAT HAVE YOU, BUT DOES ART NEED YOU?" HIS
STANCE WAS SO CONTROVERSIAL THAT WHEN MY
FAVORABLE ARTICLE ON HIM APPEARED, BARNETT
NEWMAN, A FRIEND OF MINE, NEVER SPOKE TO ME
AGAIN.

Ad Rienhardt

The Purist Backlash

A d Reinhardt has championed abstract art for the past three decades, and for the last half of that period, he has stood for purism in painting. His uncompromising position negates every other esthetic attitude. Relativism is rejected outright. He allows that he may be wrong but insists that if he is not, then he is absolutely right.

Reinhardt's dicta are always witty and provocative, and more often than not, profound. But it is the brilliance of his painting that has forced his contemporaries to take heed of his writings and, understandably, to rebut.[1] The controversy has been of value, for the vitality of New York art sterns in part from perpetual disputes which sharpen issues. At times, however, Reinhardt's artistic enemies have shifted their assault from his ideas to his work. This is natural, for his "extremist" ideas are embodied in them. But it is also deplorable, because the rancor of polemic has obscured their extraordinary quality.

Reinhardt's painting and esthetics were shaped by geometric abstraction, the dominant vanguard art of the 1930s, and by Abstract Expressionism of the 1940s, much as he later reviled it. In fact, his style since 1950 has derived largely from a synthesis of these antithetical tendencies.

The geometric abstractions that Reinhardt painted from 1937 to 1941 (and later, for he did not limit himself to one style in the forties) were influenced by Miro, Stuart Davis, Carl Holty, Leger, Mondrian and Gris. He exhibited with the American Abstract Artists, and like most of its members, aspired to an art of "essentials", "simplicity" and "purity".

During the early 1940s, Reinhardt reacted against his ascetic inclination. Cubist abstraction had become too mechanical, too confining. He needed to shake it up, and one of the techniques he used was collage. Having previously employed paste-ups as preparatory sketches for his geometric oils (a common practice in the thirties) he now sliced up magazine and newspaper illustrations, each cut so that references to objects were obliterated, leaving only disembodied textures. By juxtaposing these incongruous details, Reinhardt veered toward Surrealism. He also loosened up tightly knit structure by working more directly, painting quickly over hard-edge forms, complicating, shredding and melting them. The free-flowing lines and amorphous patches call to mind oriental calligraphy, Impressionist and Expressionist facture, and particularly, Surrealist automatism. But even the freest of them are too bound to an infra-Cubist structure—too deliberate and orderly—to issue from unconscious impulses. However, the all-over patterns of open and closed shapes of richly varied brushwork frequently evoke mysterious grottos and other phantasmagoria—like the collages of the period. Although Reinhardt's intentions were formal, his organic improvisations are closer in look to those of Tobey, Hofmann or Rothko than to the paintings of the American Abstract Artists.

As Reinhardt turned away from geometry, he became friends with the artists later to be labeled of the Abstract Expressionists. He joined the Betty Parsons Gallery in 1946; among the artists who had shows there up to 1951 were Pollock, Rothko, Hofmann, Still, Newman, Tomlin and Pousette-Dart. In 1949, Reinhardt was a founder of the Club, and in 1950, he was one of the "Irascible18" who protested against the policies of the Metropolitan Museum. In 1951, he and Motherwell edited a widely circulated paperback, *Modern Artists in America*. In sum, he was at the center of Abstract Expressionist activities after World War II.

Of these painters, Reinhardt was closest to Newman, Rothko and Still. Like them, he came to reject gestural intricacy and reduced his pictorial means in the direction of color-field abstraction. Around 1950, he broadened the calligraphic lines of earlier pictures into generally horizontal and vertical swaths. He also simplified his palette, often to a single color on a white ground. Soon after, he transformed the swaths into horizontal bars—a quasi-geometric, magnified pointillism. In many pictures, the hues were high-keyed (a reversion to his Davis-inspired color of the thirties) and dissonant, optical enough to rock the eyes out of your head, as Fairfield Porter observed.

In 1952, Reinhardt hardened the bars into mat rectangles, at first asymmetrical, then arranged into centered cruciform designs. In each of these paintings he used one all-over color—red, blue or black—but the tones of the rectangles were varied slightly. Reinhardt had circled back to geometric abstraction, but with a difference—the affinity to color-field painting.

In some respects Reinhardt's intentions resemble those of Newman, Rothko and Still. Like them, he wants to create an absolute, supra-personal art, and his stance is as heroic and moralistic as theirs. However, unlike them, he renounces extra-esthetic associations in favor of a purist approach. The similarities and differences between Reinhardt's and Newman's points of view are clear in their published statements. In 1947, Newman wrote : "The basis of an esthetic act is the pure idea...that makes contact with mystery— of life, of man, of nature, of the hard, black chaos that is death, or the greyer, softer chaos that is tragedy. For it is only the pure idea that has meaning. Everything else has everything else."[2] In 1962, Reinhardt wrote: "The one thing to say about art is that it is one thing. Art is art-as-art and everything else is everything else."[3]

Reinhardt's remark summarizes an estheticist position he took early in his career.[4] But he diverged from it in 1947 when he exhibited two pictures, titled Dark Symbol and Cosmic Sign in the Ideographic Picture show, organized by Newman at the Betty Parsons Gallery. In the following year, however, he attacked" transcendental nonsense, and the picturing of a 'reality behind reality'." Instead, he professed a desire for "pure painting [which)

is no degree of illustration, distortion, illusion, allusion or delusion."[5]

Like Newman, Reinhardt adopted negation as a means of achieving his absolute. In 1948, Newman wrote: "We are reasserting man's natural desire for the exalted, for a concern with our relationship to the absolute emotions. We do not need the obsolete props of an outmoded and antiquated legend. We are creating images whose reality is self-evident and which are devoid of props and crutches that evoke associations with outmoded images, both sublime and beautiful. We are freeing ourselves of the impediments of memory, association, nostalgia, legend, myth, or what have you, that have been the devices of Western European painting.[6]

No-saying became central to Reinhardt's approach in 1949.[7] In 1962, he summed it up: "The one object of fifty years of abstract art is to present art-as-art and as nothing else, to make it into the one thing it is only, separating and defining it more and more, making it purer and emptier, more absolute and more exclusive—non-objective, non-representational, non-figurative, non-imagist, non-expressionist, non-subjective. The only and one way to say what abstract art or art-as-art is, is to say what it is not."[8]

Reinhardt distills the quintessence of art by purging elements in past art that prevent the rendering of it directly and exclusively. Deriving art from art is a traditional approach, an art historical one, and Reinhardt is an art historian, expert in Far and Near Eastern art. He admires "the completely conventional formalistic, academic tradition wherever it occurs, in China, India or Europe."[9] He also conceives of all art, when it enters the museums, which, for him, are the only places for art, as emptied of every meaning (political, religious, etc.) but one—its value as art. However, Reinhardt has built a vanguard principle into his traditionalism, for he believes that art undergoes a continual revolution, progressing always toward purity.

Such critics as Priscilla Colt have stressed Reinhardt's "ingrained traditionalism." A sign of this, among others, is his preference for grey—the color of modeling, of grisaille. Other writers think that he has gone so far in his criticism of tradition that instead of extending it, he has destroyed it. They consider him a nihilist and brand his avowed love of tradition as fraudulent.

They mistake his irony, often turned against himself, as a lack of seriousness. But how serious is Reinhardt when he asks whether art is too serious to be taken seriously? And can an artist with a pure conception of art (like Kierkegaard's vision of Christianity) dare call himself an artist?

Reinhardt's process is intellectual, and to him, the contrary of art-as-art is life-as-art. Barzun has remarked that art as a mental activity denies art which touches the pulse of life:

> Common language records this opposition in a dozen ways: Life is warm, hot, glowing; intellect is cold and dull. Life is its own mover, impetuous, heedless of reasons and obstacles...intellect is static, calculating, aimed at purposes clear to the few...Intellect observes rules of its own making that no one enforces, and is full of scruples in private, though in public it speaks confidently of itself and callously of life. The classic instance of Intellect's inhumanity is Voltaire's remark after he had asked why someone wrote bad books and was told that "the poor man had to live": "I do not see the necessity." Intellect has apparently nothing to say to the predicaments and tragedies of life... Whereas life is immediate and convinces by throbbing in your veins or panting in your face, Intellect stands on the margin of existence and convinces, if at all, by the roundabout road of argument ...Any pair of common images about the two shows them as antagonists—Intellect, stiff, angular, unchanging; Life, flowing and adaptive. Intellect, the blade that carves and separates forever; life a perpetual mixing and joining, fusion and confusion."[10]

Reinhardt asserts that an artist's concern with purity in art leads to purity in his public role. "Absolute," defined by Webster as "free from imperfection; perfect; free from mixture; pure...determined in itself and not by anything outside itself,- not dependent or relative; ultimate; intrinsic," is close to "absolution"—"an absolving, or setting free from guilt, sin or penalty...are leasing from censures." By this standard, impure art perverts the artist who creates it. Reinhardt has written: "Any combining, mixing, adding, adulterating, diluting, exploiting, vulgarizing or popularizing of abstract art deprives art of its essence and truth, and is a corruption of the artist's artistic conscience."[11] To him, the worst sinners in our time have been the Abstract Expressionists.[12]

By 1952, Reinhardt had rid his art of gesture (the signs of the artist's creative process, active presence and temperament); organic shapes (which evoke life more than do geometric ones); and varied, high-keyed. colors, but not tonal variations. After 1954, he simplified his format and attempted to subtract all color and line. He limited the canvas shape and composition, eventually to the trisected square. He also greyed his colors, gradually making them indistinguishable—colorless. As the tones grew closer in value, the lines that separated them dissolved. Drawing, like color, became almost invisible. The viewer had to strain to make either out. What remained perceptible oil first viewing was a homogenous, dark surface. As Sidney Tillim observed: "This field is the real structure...rather than the...grid."[13]

Reinhardt achieved the consummate picture in 1960—a five foot square canvas, composed of nine identical grey squares. He has been repeating it since then. About this series, he wrote: "The one work and the one direction of the fine artist or abstract painter today is to paint and repaint the same, one thing over and over again, to repeat and refine the one uniform form again and again. Intensity, consciousness, perfection in art come only after long routine, preparation and attention."[14]

Such programmatic thinking (a reversion to the thirties love of ideology) which results in preconceived and finished pictures, has been anathema to the Action Painters, whose attitude has been summed up by Franz Kline: "To be right is the most terrific personal state that nobody is interested in."[15]

As a classicizing artist, Reinhardt aims at clarity, but he also accomplishes its opposite, for the black paintings deny visual logic, as if illustrating de Kooning's remark that nothing is less clear than geometry. Much as Reinhardt's abstractions make explicit his intention of removing color from color, the ghosts of colors remain and function as colors. And the harder one peers, the sharper the colors one coaxes from the monochrome become. Reinhardt is revealed as a masterful colorist who cultivates a low register palette and the most nuanced of color interactions. The minute shifts in tone generate vibrations which prevent the pictures from becoming static, inert and monotonous (qualities he desires), for they keep the eye active and alert—nervous. Furthermore, although the black paintings look anonymous

and self-effacing, they are original and immediately recognizable as Reinhardt's invention, as personal as his signature.

Reinhardt also intends the late pictures to be aloof and inaccessible, and to communicate nothing but themselves. But in this too, the reverse holds. The image of the cross is, of course, loaded with associations. To be sure, he generalizes the form so that symbolic references are minimized. Still, thoughts of iconography and icons—or empty iconography and empty icons—come to mind. More important, in order to purge color and line, Reinhardt shrouds them in a dim atmosphere. But the atmosphere induces contemplation, for the activity of peering, which requires time, effects a trance-like state in the viewer. And the ambiguous and haunting aura of darkness invites associations and suggests mysteries.

Priscilla Colt has written that Reinhardt's pushing of the visible toward the brink of the invisible, of logic toward the brink of illogic, of the material to the verge of immateriality, inevitably suggests a link with a transcendent level of existence. It is as if he intended the act of straining to see to become symbolic of a straining for an elusive or unattainable objective. But ultimately the eye discovers the futility of straining: ultrapassivity, neutral receptivity are necessary to the process. Identity with Reinhardt's unnameable absolute will be attained only through a suspension of goal-seeking and egocentric activism. So nothing may become everything. It is in this sense that the black square may be regarded as a "ritual aid in a quasi-religious search."[16] Reinhardt has disparaged mystical interpretations of his work, but he does at times seem to elevate art-as-art into an object of worship, and religious terms do appear in his writing ("the museum ought to be a shrine").

The roles that Reinhardt has played in the art world are as paradoxical as the black paintings. Lucy Lippard once wondered what the relationships were between the "expressionist and the purist, the editor and the theorist, the scholar and orientalist, and the cartoonist and social satirist, the idealist and the 'conscience of the art world', or, as he has called himself, 'the Great Demurrer in a time of Great Enthusiasms.'"[17] Contradictory though these roles may seem, they can be viewed as aspects of a unified stance.

Reinhardt would like his purism to be universally accepted, but it is not. Therefore, he relies on history and esthetics for justification, discovering a universal principle whereby art rids itself of excess baggage in an inexorable urge toward its own essence. "The one way for the fine artist, the one thing in art left to do, is to repeat the one-size-canvas—the single-scheme, one-color monochrome, one linear-division in each direction, one symmetry, one texture, one formal device, one freehand brush-working, one rhythm—into one dissolution and invisibility, into one overall uniformity and regularity."[18] Hence, the ultimate stage of art's evolution is Reinhardt's black painting. But it may only be his private vision of an absolute art. Reinhardt turns, against his wishes, into an Expressionist.

However, he continues to yearn for a purist academy and assumes the role of polemicist to achieve it, using his satire as his main weapon. His ridicule is aimed at other artists. "The one fight in art is not so much between art and nonart as between true and false art, between pure art and action-assemblage-art, between abstract art and surrealist-expressionist-anti-art...The one struggle in art is the struggle of artists against artists, of artist against artist, of the artist-as artist within and against the artist-as-man, -animal or -vegetable."[19]

Accordingly, Reinhardt has written, lectured and exhibited extensively. In order to advance his esthetic point of view, he enters the arena of his "enemies". Removed from what ought to be his natural habitat—the ivory tower—he descends to their level. Given his hatred of art world commercialism and promotion, he should not exhibit at all, but he has, and at times with the Abstract Expressionists. An effective way to fight is to join—bore from within, sharpen contrasts by proximity—but by his standards, it is also an evil, if a lesser one.

Reinhardt's argumentativeness is a denial of the primary values in his painting: aloofness, muteness and harmony. But cantankerousness has generally been an attribute of the life style of classicists. It is best characterized by a story of Reinhardt's about "a teacher who asked her class one day who wanted to go to heaven. When Johnny was the only student who didn't raise his hand, the teacher asked, 'What's the matter, Johnny, don't you want to go to

heaven?' 'Sure,' he answered, 'but not with them guys'."[20]

Reinhardt's place in contemporary art is ambiguous. During the fifties, his geometric abstractions were widely put down as a throwback to the thirties. Reflecting this attitude, the Museum of Modern Art omitted him from its important New American Painting show of 1958. His position among Abstract Expressionists has recently been rehabilitated in important group shows at the Guggenheim Museum (Abstract Expressionists and Imagists, 1961) and at the Los Angeles County Museum (New York School, 1965). The Museum of Modern Art gave him his due recognition by including him in its Americans, 1963 exhibition, which excluded Abstract Expressionists, however.

This situation has prompted an ironic comment from Reinhardt. In a self-interview, he asked: "You're the only painter who's been a member of every avant-garde movement in art of the last thirty years, aren't you?" He answered, "Yes." "You were a vanguard pre-Abstract Expressionist in the late thirties, a vanguard Abstract Impressionist in the middle forties and a vanguard post-Abstract Expressionist in the early fifties, weren't you?' I asked. 'Yes,' he said. 'You were the first painter to get rid of vanguardism, weren't you?' I asked. 'Yes!' he said."[21]

Although Reinhardt should be numbered among the Abstract Expressionists, of them (with the exception of Newman), he has had the greatest influence on minimal" artists who have emerged in the 1960s, notably such central figures as Frank Stella and Robert Morris. They have found in his works precedents for their own anti-romantic, anti-angst attitudes, for their inclination to a hermetic, impersonal and impassive, classicizing art whose forms are predetermined and schematic, geometric, monochromatic and repetitive.

Thus the present Reinhardt retrospective at the Jewish Museum, arranged by Sam Hunter and Lucy Lippard, is timely, but of greater consequence, the paintings are the issue of a masterful eye and touch, and they possess a vitality of surface, rightness of scale and resonant glow. In the end, only such qualities count; everything else is everything else.

Notes

1. See "The Philadelphia Panel," *It Is* #5, Spring, 1960. The participants were Guston, Motherwell, Reinhardt, Rosenberg and Tworkov. Also Elaine de Kooning, "Pure Paints a Picture," *Art News*, Summer 1956, and Harold Rosenberg, *The Anxious Object*, 1964, Chapter 4.

2. Barnett Newman, Introduction to *The Ideographic Picture*, an exhibition at the Betty Parsons Gallery, Jan. 20-Feb. 8, 1947.

3. Ad Reinhardt, "Art-as-Art," *Art International*, Dec. 20, 1962.

4. As the art critic of PM, Reinhardt parodied extra-esthetic references. His butt was Surrealism and the interest of artists oriented to it in primitive art, particularly Northwest Indian. In a cartoon in PM, March 24, 1946, entitled *How to Look at Low (Surrealist) Art*, he wrote: "If you still think that 'paintings' should be 'pictures' then you weren't around a few years ago when Surrealism turned the 'picture-art' tradition inside out and ran it into the ground. Digging deep into your mind's recesses, Surrealist art hit below the belt and the things you see become lots of other things."

5. Reinhardt, Statement, in the catalog of his exhibition at the Betty Parsons Gallery, Oct. 18-Nov. 6, 1948.

6. Newman, "The Sublime is Now," *Tiger's Eye* 6, Dec,, 1948.

7. In an Incidental Note in the catalog of his show at the Betty Parsons Gallery, Oct. 31-Nov. 9, 1949,7 Reinhardt wrote: "Most of these paintings were made in the American Virgin Isands, on a small -island off St. John. They contain no sea shells or undersea caves, no blinding sand of wild winds or superstitions, no terror of the deep, no west-indian magic, no zombies, no sea-urchins. There is in them no trace or taste of lobster or turtle, mangoe or mongoose, no rum or coca-cola, no bamboo or barracuda or outboard motor. No tropical fish or fowl, no human caricaturing, no native land or sea or skyscape, no abstracting from nature, high or low or still-life, no camouflaged Carribbean stories, no regional, religious strains, no local racial or political myths."

8. Reinhardt, "Art-as-Art," *Art International*, Dec. 20. 1962. Reinhardt goes on to say: "No lines or representations, no shapes or composing or imaginings, no visions or perceptions or sensations, no decoratings or colorings or picturings, no symbols or signs or impulses, no expressions, no objects or subjects, no things, no ideas, no relations, no attributes, no qualities...nothing that is not of the essence."

9. Reinhardt, a statement in "Is today's artist with or against the past?", *Art News*, Summer, 1958.

10. Jacques Barzun, *The House of Intellect*, 1959, p. 162-63.

11. Reinhardt, interviewed by Irving Sandler, "In the Art Galleries" *New York Post*, August 12, 1962.

12. Reinhardt has often condemned "the cafe-and-club-primitive and neo-Zen-bohemian, the Vogue-Magazine-cold-water-flat-fauve and Harpers-Bazaar-bum, the Eighth-street-existentialist and Easthampton-aesthete, the Modern-Museum-pauper and international-set-sufferer, the abstract-'Hesspressionist' and Kootzeniammer-Kid-Jungian, the Romantic-ham-'action'-actor," in Reinhardt," The Artist in Search of An Academy Part 2: Who Are the Artists," *College Art Journal*, Summer, 1954.

13. Sidney Tillim, "Month in Review," *Arts*, Dec. 1960.

14. Reinhardt, "Art-as-Art," *Environment*, Autumn, 1962.

15. Frank O'Hara, "Franz Kline Talking," *Evergreen Review*, Autumn, 1958.

16. Priscilla Colt, "Notes on Ad Reinhardt," *Art International*, Oct., 1964.

17. Lucy Lippard, "New York Letter," *Art International*, May, 1965.

18. Reinhardt, "Art-as-Art," *Environment*, Autumn, 1962.

19. Reinhardt, "Art-as-Art," *Art International*, Dec. 20, 1962.

20. Reinhardt, "The Artist in Search of an Academy," *College Art Journal*, Summer, 1954.

21. Reinhardt, "Reinhardt Paints a Picture," *Art News*, March, 1965.

Chapter Two

The New York School

A SECOND GENERATION OF ABSTRACT
EXPRESSIONISTS EMERGED IN THE WAKE OF
THE FIRST. THE WORK OF THESE ARTISTS WAS
RELATED TO THAT OF THE OLDER ARTISTS BUT
WAS SUFFICIENTLY DIFFERENT TO WARRANT
THE INVENTION OF A NEW TITLE, NAMELY THE
NEW YORK SCHOOL.

JOAN MITCHELL WAS A YOUNGER NEW YORK
SCHOOL ARTIST. HER GESTURE PAINTING IS
DIFFERENT FROM THAT OF HER ELDERS IN THAT
IT REFERRED MORE DIRECTLY TO LANDSCAPE
AND WAS MORE LYRICAL. MITCHELL WAS ALSO
AMONG THE FIRST WOMEN TO ACHIEVE WIDE-
SPREAD RECOGNITION AS A MAJOR YOUNGER
ABSTRACT EXPRESSIONIST; THE OTHERS WERE
HELEN FRANKENTHALER AND GRACE HARTIGAN.

Joan Mitchell Paints a Picture

Joan Mitchell is a painter who hates esthetic labels. She agrees with Harry Holtzman that "the hardening of the categories causes art disease." She finds particularly distasteful moral insinuations concerning "good" versus "bad" criteria, and insists that "there is no one way to paint; there is no single answer." Miss Mitchell is reticent to talk about painting, so in order to approach the underlying processes in her work, the Socratic method was needed, rejecting some classifications, modifying or keeping others. The catchphrase to which she objected least was "New York School," and she readily admitted membership in that non-academy. Unlike some of the younger artists who have reacted away from the elders of Abstract-Expressionism, she sees herself as a "conservative," although her pictures can hardly be described as hidebound. She not only appreciates the early struggles of the older painters, whose efforts expedited acceptance for those following them, but finds a number of qualities in their work that have a profound meaning for her.

Those elements in New York painting to which she responds are difficult to isolate. They have little to do with technique, for although Miss Mitchell has assimilated some of the methods of Gorky, de Kooning, Kline, et al., she

couldn't pretend to know how they make their pictures. More, significant is a feeling of familiarity she experiences when she looks at their work, specifically, a kindred involvement with space.

Her concern with space is rooted in the impact of the city. "I am up against a wall looking for a view. If I looked out of my window, what would I paint?" She lives on the fourth floor of a lower East Side walk-up. Miss Mitchell has to remember her landscapes: "I carry my landscapes around with me." They become the windows in her house; as Baudelaire wrote: "A man who looks out of an open window never sees as much as a man who looks out of a closed one."

The painting which Miss Mitchell started for this article was called Bridge. She titles pictures only at the request of galleries, reviewers and friends. This work was discarded, and another was begun and completed. She jokingly named this painting *George Swimming at Barnes Hole, but it Got too Cold.* In both works, a recollected landscape provided the initial impulse, but the representational image was transformed in the artist's imagination by feelings inspired by bridge and beach; in the one, sensations of girders and height and the varied meanings implicit in "spanning a void," and in the other, thoughts of George, a dog she once owned, and a memorable summer day spent swimming in East Hampton, Long Island.

Those feelings which she strives to express she defines as "the qualities which differentiate a line of poetry from a line of prose." However, emotion must have an outside reference and nature furnishes the external substance in her work. When asked what she felt about the word "nature," she replied: "I hate it. It reminds me of some Nature-Lover Going Out Bird Watching." She dislikes compulsive attitudes toward nature, which for her has a simple meaning and beauty. "I feel like a little child coming up out of the basement and saying: who put the sidewalk there, who put the tree there?" Nature—country and city—is that which is outside of her; it is the theater in which she lives, her decor. In this sense Miss Mitchell does not like Non-Objective art: "what is so interesting about a square, circle and triangle?"

But if nature supplies the raw material, the artist then sifts it through memory

to convert it into the essential matter of her art. But not all remembered scenes are equally significant. There are those fleeting moments, those "almost supernatural states of soul," as Baudelaire called them, during which "the profundity of life is entirely revealed in any scene, however ordinary, that presents itself before one. The scene becomes its symbol." Miss Mitchell attempts to paint this sign, to re-create both the recalled landscape and the frame of mind she was in originally. Memory, as a storehouse of indelible images, becomes her creative domain.

However, a "state of soul" is indefinite, and cognition of the total "profundity of life," unattainable. Still, if sparks of these are experienced, a yearning so poignant arises, so superior to what is accessible, that it can only be called "joy," in C. S. Lewis' sense of the word. The most complete satisfaction is achieved, not in the realization of the possible, but in the most intense desire for the illimitable. The lack of yearning for any length of time causes an inquietude and despondency, a sedulous longing for the yearning. Miss Mitchell paints to reawaken this desire. Her bridge, lake or beach must transcend the finite (what can be seen) and partake in same of the Infinite, expressing its paradoxes and ambiguity. This is the "something more" that she means when she says: "The painting has to work, but it has to say something more than that the painting works." In such transformations, the bridge leads to the Gates of Paradise, and the beach rims a lake in the Garden of Eden, the instant before the Fall.

The expression of remembered joy has priority over the painting process. The artist tries to forget herself while working. "I want to make myself available to myself. The moment that I am self-conscious, I cease painting. When I think of how I am doing it, I've been bored for some time, and I stop. I hate just to fill in spots to cover a painting, and if I do so, it's only because Lewitin once told me that the canvas would rot if it were not covered." Yet spontaneity does not mean absence of craft. She would like to have her technique sufficiently at her finger tips, so that "the commands of the mind may never be distorted by the hesitations of the hand" (Baudelaire).

The artist chose to paint *Bridge*, because the image was a favorite. In a sense it is a synthetic symbol; she was born in Chicago near Lake Michigan, and

the impress of city, bridges and water are central in her work. Moreover, she wanted to explore further a technical problem which developed in a recently completed, diptych and in *Harbor, December*. In the latter picture, she experimented with color areas, but as yet, these "painty" sections were not as accurate as her whiplash lines.

Bridge was begun directly on an unstretched linen canvas 90 inches high by 80 inches wide, and stapled to her studio wall. She sketched in charcoal a central horizontal stroke about which she composed an over-all linear structure. Turning almost immediately to tube paints, she attacked the chalked areas with housepainters' and artists' brushes, her fingers and, occasionally, rags. Although the original composition is important to her, she worked rapidly. A full range of color was used, dull oranges and dark blue-blacks predominating.

The picture was allowed to sit for a day. The artist resumed painting the next evening and worked through the night. "I prefer daylight, but I also like to work at night." She painted slowly, studying the canvas from the furthest point in the studio (23 feet away), simulating in a way the panoramic view of memory. She spends a great deal of time looking at her work. "I paint from a distance. I decide what I am going to do from a distance. The freedom in my work is quite controlled. I don't close my eyes and hope for the best. If I can get into the act of painting, and be free in the act, then I want to, know what my brush is doing."

Miss Mitchell painted intermittently for several days, and then determined to abandon the picture. Unlike many New York artists, who scrape and change, she normally adds paint and rarely makes basic alterations, preferring, rather, to destroy the whole work. However in the case of *Bridge*, she hesitated and decided to save this canvas for future study. The picture was rejected because the feeling was not specific enough, and because the painting was not "accurate." To her, accuracy involves a clear image produced in the translation of the substance of nature into the nature of memory. It also involves the mechanics of abstract painting, the creation of a positive-negative ambiguity necessary to achieve such clarity. "Lines," for instance, "can't just float in representational space." When asked about color, she shrugged

and said, "I guess I would wish it not to be what Hofman calls 'monoto-nous,' that is tonal and boring"; on light, "I hate it when it looks muddy [earthbound]." "Motion is important, but not in the Futurist sense. A move-ment should also sit still [the peregrination of memory]." The artist's arm-long sweeps are always caught back in horizontal and vertical lines, giving her paintings their structure. Above all, she must like her pictures. She stressed, "I am not a member of the make-it-ugly school." Her works are, what Baudelaire called, "the mnemotechny of the beautiful."

After putting aside the first canvas, she became somewhat depressed and found it difficult to work. Yet she felt that she had to, so she forced herself to paint, but what? Miss Mitchell needs a subject she likes in order to feel positively enough to work. A friend jokingly suggested that she paint a poo-dle she once had swimming. The dog, George, became the mnemonic cata-lyst which provided the remembered attitude, and the beach in East Hampton furnished the remembered landscape image, although once the painting was started, it took over.

George Swimming at Barnes Hole began as a lambent yellow painting but dur-ing the second all-night session, the work changed. The lustrous yellows turned to opaque whites, and the feeling became bleak; therefore, "*but It Got Too Cold.*" The artist did not carry her buoyancy any further; the beach was transposed from summer to fall. It seemed as if the hurricane that struck East Hampton in the autumn of 1954 invaded the picture. Since her early child-hood, lake storms have been a frightening symbol both of devastation and attraction, and the sense of tempestuous waters appears frequently in her work. Miss Mitchell painted four hurricane canvases based on this experi-ence in 1954. *George* is a return to this series, the realization of what was attempted then. This picture is less linear than her work in the intervening years. The contrast of the happy heat of the multicolored central image, the shimmering water and the sun streaked atmosphere with the fearful sugges-tion of the impending hurricane creates a remarkably subtle tension.

The artist stretched the finished canvas, which measured 86 by 78 inches, without trimming any away, and decided to include it in her show at the Stable gallery that spring [A.N., Mar. '57]. She liked *George*, but felt that it

still lacked a certain structure and an "accuracy in intensity." When asked about her personal meanings in this work and their communication, she answered: "If a painting comes from them, then they don't matter. Other people don't have to see what I do in my work." As time goes on, past pictures became increasingly remote, and Joan Mitchell tends to see them as others do, as paintings. The vital matter is transferred to works in progress.

In the 1950s, a number of younger artists of the New York School began to incorporate found materials into their paintings and sculptures. The junk materials of which these works were composed called attention so assertively to their origins that initially they were labeled Neo-Dada, the new anti-art. In time their aesthetic qualities came to the fore, and Neo-Dada was renamed Assemblage, the title of a major survey at the Museum of Modern Art in 1961. "Ash Can Revisited," published in 1960, was the first attempt to survey the new tendency and establish it as a major new direction.

Ash Can Revisited

a New York Letter

The popularity of an art label in New York depends in large measure on the vociferous and generally justifiable denials by the artists concerned that the term applies to their work. "Neo-Dada" is no exception. Not only does it fail to account for all the essentials, but it forces attention to the anti-art elements in the works of artists grouped under the heading. The patronymic pleases the "enemies" of the movement who mean to damn it in just this way; one painter has even coined the title, Neo-Mau-Mau. At the same time, the name delights Neo-Dada's fashionable "friends" who have made it the catchword of an avant-garde fad. But "Neo-Dada" has stuck, and until a better label takes hold, it will have to do.

The New Media-New Art Forms exhibition at the Martha Jackson Gallery in June (a new version will be presented in October) brought together seventy-two works by more than sixty artists who have experimented with unconventional materials. There was a historical section with examples by Schwitters, Arp, Cornell, Dubuffet; in the main, the show consisted of works by Neo-Dadas, among them Robert Rauschenberg, Richard Stankiewicz, Louise Nevelson, Jasper Johns, Allan Kaprow, John Chamberlain, Jean Follett. Other galleries, notably the Leo Castelli Gallery and the downtown

Reuben Gallery, have championed the Neo-Dada tendency in New York art –and have featured similar groups in the past. What makes, this particular show noteworthy is its size, prompting a fresh appraisal of Neo-Dada, and its timing, coming as it does so soon after the Museum of Modern Art's "official" Installation of six Neo-Dadas in the SIXTEEN AMERICANS show and the Tinguely performance with self-destroying machine, also at the Modern.

Any attempt to define Neo-Dada as a style must fall short in describing the uniqueness of its most interesting artists. Yet they share in varying combinations a number of elements. Unlike other artists who have been working with novel substances since the early years of this century, the Neo-Dadas prefer to use found materials of city origin, this contributing a particular urban character to their imagery. Second, these artists piece together chunks of environment; the line between painting and sculpture becomes so blurred, that Neo-Dada construction-collages are most fittingly called "objects". And finally, the Neo-Dadas have to some degree been influenced by Abstract Expressionism as well as by Dada and Surrealism, but their deviations from these styles are equally significant.

The Neo-Dadas look upon the city as their landscape-dump would be more accurate. The junk material that they use suggests urban forms and images, metaphors for both the poverty and the richness of city life, its terror and anxiety as well as its particular spectacle and rhythm. There is poignancy in this rejected matter the expendable detritus of a concrete, steel and glass leviathan that evokes the tragic vulnerability of the city dweller, his progressive insignificance. Henry Miller once wrote: "Only the object haunted me, the separate, detached, insignificant thing. It might be a part of the human body or a staircase in a vaudeville house; it might be a smokestack or a button I had found in the gutter. Whatever it was enabled me to open up, to surrender, to attach my signature...I was filled with a perverse love of the thing in itself-not a philosophic attachment, but a passionate, desperately passionate hunger, as if in the discarded, worthless thing which everyone ignored, there was contained the secret of my own regeneration."

The crumpled metal sheet and the worn sock in a "Combine" by

Rauschenberg, may be ugly, but they give off human warmth and are therefore precious. The cut-out letters spelling "Orpheum", "Empire", "Tarzan" attached to the charred burlap and corrugated cardboard personages by Claes Oldenburg seem to stand for the American dream of glory never to be fulfilled in the anonymity of modern life. Stankiewicz ironic robots teeter between the mechanical and the living; these boilers transmuted into torsos are simultaneously funny and grim. The smashed automobile fenders in a construction by Chamberlain might be savage symbols of man's inability to cope with the machine. His abstract figures whose winding metal entrails are exposed in pain, and yet they strut with their own kind of indomitable elegance. Robert Mullary's recent reliefs chart the landscape of ruined tenement walls and Follett's black tables are poetic wastelands populated with despairing, rubble. In painted collages, Johns reclaims the commonplace symbol— the American flag, targets, numbers, letters—forcing the spectator to see that which has become invisible through overuse.

A distinction can be made between artists who base their imagery on the city and those who use found and industrial materials without such associations. Kemeny's bas reliefs, Scarpitta's canvas constructions and Berke's compositions of tacks and nails, for example, are fundamentally formal in conception and are not Neo-Dada. Neither are Zogbaum's metal sculptures inset with stones, Kriesberg's paintings composed of reversible parts or Ortman's symbolic "boxes." In general, the line can be drawn between American and European artists. The impact of the city, especially New York; on the Neo-Dadas appears to be so predominant that these artists have evolved a variant of American- scene art without having been influenced in any specific-way by past realist styles. The resemblance of certain Neo-Dada attitudes to those of the Ash Can School (even the name is appropriate) around the turn of the century must be more than accidental. "The Ash Can school stood for 'truth' as against 'beauty', for 'life' as against 'art', for the 'real' as against the 'artificial'. They accepted Henri's advice: 'Be willing to paint a picture that does not look like a picture. The realists defended crudity and ugliness because such things were true...They refused to dodge the philistinism, the gaucheness of American life; on the contrary, they sought to live and picture that life in its common aspects." (Milton Brown.)

In embracing a viable constructionist-collage esthetic, the Neo-Dadas have placed themselves in the mainstream of twentieth-century sculpture. The fracturing of the monolith has fostered interest in drawing in space; colour has been increasingly introduced; surfaces are handled in a more painterly fashion-particularly in welded sculpture; the torch is often used as a brush. Similarly, a great deal of painting has become, sculptural. An increasing number of painters have become involved with the tactility of their medium, building pigment out from the surface and embedding objects in it. The metal constructions of David Smith* have been especially influential an the work of the Neo-Dadas, notably Stankiewicz and Chamberlain. Smith's mechano-mythological creatures fuse Surrealist fancy and machine power. He has been experimenting with the sculptural silhouette since the 1930's, and has frequently incorporated industrial parts and colour into his work. Frederick Kiesler's giant "galaxies," mixtures of sculpture, collage and painting, which are meant to be walked into ("architecture for sky gazers") and Joseph Cornell's fetishistic glass fronted wooden boxes, in which found materials are incongruously juxtaposed, are also progenitors.

Neo-Dada appropriated from Dada some of its iconoclastic spirit—its rejection of all preconceptions about what art was supposed to be. However, unlike the Dadas who carried on an organized insuiting of modern civilization and who used art as part of their "shock treatment", the Neo-Dadas are accepting of their condItion and are primarily interested in expressing a heightened sensitivity to it. Their work, in a word, is art, and they mean it as such regardless of how it may appear to others. The extent of Neo-Dada's subversion has been an occasional spoofing of other current styles and the rejection of painting in itself, prompting Thomas B. Hess to call it the "soft revolution". If any one artist can be considered the father of Neo-Dada, it is Kurt Schwitters (Neo-Merz might be a more accurate name). It is significant, but not surprising, that he was disowned by the other German Dadas. In 1920, Schwitters wrote: "In the history of Dadaism, Huelsenbeck writes: All in all art should get a sound thrashing. In his introduction to the recent Dada Almanach, Huelsenbeck writes: 'Dada is carrying on a kind of propaganda against culture.' This Huelsendadaism is oriented towards politics and against art and against culture ... As a matter of principle, Merz aims only at art, because no man can serve two masters." The kind of Dada that

Schwitters wanted, what he called "Kernel Dadaism", "holds to the good old traditions of abstract art," meaning Cubism, much as Neo-Dada is the off-spring of Abstract Expressionism.

Accordingly, Neo-Dada is not concerned with what Robert Motherwell described as "an essential dada dilemma, how to express oneself without art when all means of expression are potentially artistic". Duchamp, for one, cleverly solved this problem by placing commercial objects on a pedestal, creating an anti-art art. The Neo-Dadas are fascinated, not shocked, by Duchamp's "readymades" and make of them a material legitimate to art. This does not mean that Neo-Dada objects are "esthetic"; they are seamy, crude and unnerving, but they draw their vigor from the streets, not from the barricades.

.Several Neo-Dadas, have been attracted by Surrealism, its predilection for "concrete irratlonality", the unexpected, the absurd and the automatic, but not its Freudian orientation and its old masterlsh clichés. Particularly is this true of Stankiewicz and Nevelson. Nevelson's wooden boxes, assembled from discarded mill-ends and painted a uniform black, white or gold, evoke shad-owy, fantasy worlds. She magnifies the effect by attaching the cubicles to one another, creating room-size enclosures that physically box in the viewer.

Neo-Dada can be considered one extension of Abstract Expressionism or Action Painting. The younger Neo-Dadas inherited a concern with discov-ering the image in the act of working; immediacy (the "reality" of debris); improvisation (the ease with which objects can be built up and broken down) and even, at times, the "look." The Neo-Dada, however, is more explicitly concerned with expressing his environment than is the Action Painter, for whom the impact of the city, what de Kooning calls a "no-envi-ronment", is a function of the search for identity. Artists such as Chamberlain, Rauschenberg and Mallary have made good use of de Kooning's powerful abstractions and his monumental women-tabloid furies-and of Kline's rude black and white structures.

The size of Abstract Expressionist paintings, particularly those of Pollock, their "assault" upon the viewer—the picture as environment—has stimulat-

ed Kaprow, Grooms, Oldenburg, Whitman, Dine and others to create actual environments. Kaprow, a leader in this development, wrote: "Not satisfied with the suggestion through paint of our senses, we shall utilize the specific substances of sight, sound, movement, people, odors, touch." These artists have transformed the entire gallery space into a stage set, a kind of collage-theatre In which are superimposed simultaneously improvisational drama and dance, electronic music, noise and silence (related to Dada "bruitism" and the compositions of John Cage) and audience participation. The "happenings", as these events are called, are reminiscent of Dada and Surrealist performances; they also call to mind a similar project that Schwitters wrote about before 1920 but couldn't produce: "My aim is the Merz composite art work that embraces all branches of art in an artistic unit...the composite Merz work of art, par excellence, however, is the Metz stage...people can even appear actively, even in their everyday position, they can speak on two legs, even in sensible sentences... A man in the wings says: 'Bah.' Another suddenly enters and says: 'I am stupid.' (All rights reserved.)"

"Freedom is not lack of restraint, but the product of a strict artistic discipline." A concern with "the adjustment...of the elements in painting", for Schwitters, "the aim of art", has become a preoccupation for Stankiewicz, Rauschenberg, Mallary, Nevelson and other Neo-Dadas. In this attitude they have been sustained by the example of the Abstract Expressionists who have used the painting medium in revolutionary ways without sacrificing the ideal of quality in painting. Design is of primary significance in the constructions of Chamberlain. Not only does he cut scrap metal to desired forms, but he carefully balances their battered colours. At times, the adjustment of colours and invented forms seems to predominate over the images of wreckage that his works evoke. Similarly, Stankiewicz has been attempting to make machine parts entirely his own. He has recently turned to abstraction in order to counter the tendency of found objects to assert their original state and to overwhelm the imagery. Nevelson continues to be involved with Cubist structure, and Mallary, with the formal evaluation of every segment of his medleys of waste. In his latest pictures, Johns has superimposed the names of colours onto colours—a blue RED is stenciled onto an orange area. In his desire to test the visibility of colours, he explores an essential of painting. Oldenburg may try to capture the immediacy of chil-

dren's scribbles on tenement walls; his draftsmanship is far from childlike. Rauschenberg's recent "combines" are rawer than before; they partake more of the street. Big, fragmented letters that seem to have been cut from peeling billboards replace the newspaper illustrations and clippings in earlier works. The way in which these large areas interact becomes increasingly important. The viewer tends to stand away and to take in the picture as a whole instead of moving close to "read" it.

Given the artistic possibilities inherent in Neo-Dada, it is no wonder that many young artists have been attracted to it. What is disturbing, however, is the number, and the speed with which an avant-garde tendency has become a mass-manner. Artists still under forty such as Rauschenberg, Johns, Stankiewicz and Kaprow find themselves in the ironic position of old masters, their ideas incorporated into the work of imitators before they themselves are able to develop them. Newcomers have already jumped to extremes. Dine, a naturalistic Neo-Dada, uses at random whatever comes to hand. Conner's conglomerations of silk stockings, photographs of naked girls, etc., are decadent; he becomes a kind of Neo-Dada Gustav Klimt. In Bontecou's fabric reliefs, Cubist planes are landscaped into terraced volcano vaginas with an awesome dexterity down to the last deft turn of a wire.

There are talented other artists who stand out among the scores who have climbed aboard the Neo-Dada bandwagon. But, a new folk art, as Philip Guston calls it, is in the process of being created. Any one can do it; Neo-Dada becomes a craze like painting-by-the numbers, except the more one doesn't stick to the I lines, the better and one doesn't even need a paint set. Sunday Neo-Dada is not much different from Sunday Painting except that the junkscape replaces the landscape, and making-it-ugly is substituted for making-it-pretty. Art ceases to be therapy, a flinging away of one's neuroses; it becomes fun for the artist and entertainment for the spectator. A honky-tonk atmosphere is generated, desensitized to tragedy or joy, and it becomes difficult to distinguish Neo-Dada productions from the decor of coffee houses. Or Neo-Dada objects begin to resemble bric-a-brac, a new kind of driftwood. The ethic of an avant-garde that appeals so readily to a mass-audience, has with justification been questioned. One can't object to amateur art if it remains amateur, but too many dilettantes are finding ways of showing

their trash. The Neo-Dada idea, that all materials and events are potentially equivalent in value is misconstrued to mean that they are all worth preserving. Unfortunately, it is this bandwagon image that comes across in the first Martha Jackson show, an image reinforced by thousands of dreary objects that clutter floor, wall and ceiling space in dozens of New York galleries. However, the genuine artists refuse to be crushed by the deadweight of derivative art, and any tendency that includes Rauschenberg, Stankiewicz, Mallary, Johns, Nevelson, Follett, Kaprow, Chamberlain, Oldenburg, Grooms-artists who retain the tension of discovery-should remain a lively phenomenon on the New York art scene.

* For some unaccountable reason, Duchamp, Smith, Kiesler and Tinguely are not in the first Martha Jackson show.

Richard Stankiewicz was the innovator of sculptural Assemblage. His works have a source in Cubist paste-ups and in the Kirt Schwiter's Dada collages. Like his predecessors, Stankiewicz was concerned with the formal qualities of his works. Unlike them, though, he stressed the sources of his materials and welded them into bizarre personages, with Surrealism allusions.

These bizarre personages were made from welded found metal objects and these materials were clearly recognizable as the objects they actually were. This was an unprecedented and shocking development at the time, telegraphing the new urge to see things as they are.

THE SCULPTURE OF RICHARD STANKIEWICZ

I n 1953, Richard Stankiewicz exhibited constructions welded from scrap metal that shocked most, intrigued many, and elated a few in the New York School and its audience. The sensation was understandable. No artist before Stankiewicz had exposed junk so nakedly with so little redeeming aesthetic quality—or so it appeared to many at first.

Kurt Schwitters, an original Dadaist, had relied as heavily on found materials more than three decades earlier, but compared to Stankiewicz, he seemed decorous. No wonder that Stankiewicz and other New York artists who soon developed in related directions were commonly labeled (or rather mislabeled) the Neo-Dadaists, the new anti-artists. The misnomer Neo-Dada remained in general use until 1961 when it was replaced by the more descriptive and neutral name, Assemblage, the title of a major show at the Museum of Modern Art. It had taken some eight years for junk sculpture to be widely accepted as serious art—even in the geographic center of the international avant garde.

I still wonder why the use of rusty scrap metal outraged so many in the New York School. True, the material looked rough or "unfinished," but so did

Pollocks's impetuous "drip" and de Kooning's slashed and scraped painterly drawing. Moreover, art was supposed to be modernist precisely because it challenged conventional taste. With Abstract Expressionism in mind, Clement Greenberg has written: "Every fresh and productive impulse in painting since Manet, and perhaps before, has repudiated received notions of finish and unity, and manhandled into art what until then seemed too intractable, too raw and accidental, to be brought within the. scope of esthetic purpose."[1] But many in the avant garde who agreed with Greenberg about the role of modernist painting drew the line at rubbishy pipes, gears, tanks, chains, springs, and bolts, particularly when they seemed "untouched" and "untransformed," as the found objects were often thought to be.

Stankiewicz chose to use metal castoffs because he was inspired by their expressive potential, both figural and formal. He had no intention of being revolutionary, of shocking. Indeed, in the late forties, he studied at Hans Hofmann's school where Art was spelled with a capital A and where students aspired to master aesthetic principles, principles which he continues to value. He believed then (while still a painter) and he believes now that "disciplined construction' is fundamental but that it need not curb free invention and private vision. Making a personal statement has been vital to Stankiewicz. Even as a student, he and his serious colleagues at the Hofmann school ventured to make something of their own, to avoid repetitiousness and established manners.[2]

Given his early disposition for coherent structure and for a personal statement, it is not surprising that Stankiewicz *before* he was attracted to metal detritus should have arrived at ways of conceiving sculpture that would anticipate his later work. As early as 1950, in pieces made of baling wire coated with plaster, he posed formal problems to begin with and discovered his subject matter in the process of solving them. Attempting to incorporate a great deal of space with very little mass, he "found it interesting...to use some reference to nature...to hold it [the composition] together...[in a way] that would be familiar to the eye. And so I began to use insects who have long threadlike legs and small bodies...so I could make my distortions for abstract reasons."

116

Stankiewicz's adoption of junk materials occurred suddenly in 1951 while he was trying to convert his yard into a garden. He had "excavated a great number of rusty metal objects which seemed so beautiful by themselves" that he "set them aside as objects to look at...and of course it was only a short step of the imagination to combine various of these things together to make compositions from them." The next step was to teach himself to weld, and this Stankiewicz quickly did.

Much as Stankiewicz was occupied with abstract design, he could not avoid the figurative associations of his scrap metal. Machine parts suggested human and biomorphic metaphors. Holes called to mind eyes; extending pipes, limbs or grass. As he said, found objects can be "more provocative than invented effects. Also visual puns, mechanical analogies and organic resemblances in machinery provide a large and evocative vocabulary for sculpture."[3] Stankiewicz has conjured up personages and creatures, always imaginative and fanciful, sometimes menacing, more often witty or ironic and funny. Indeed, Stankiewicz's humor compounded his problem of being taken seriously. Despite the precedents of Klee, Miro, and Calder, humor in art was still suspect. In fact, it remains so today.

The role played by Stankiewicz's materials and the process of shaping, relating, and welding them in his invention deserves to be stressed. As he said, "working is a dialogue ... The work conditions my action just as much as my action builds up the work."[4] Stankiewicz has been as resourceful a composer as he has been an image-maker. His form ranges from extreme openness and linearity, as in *The Bride*, 1955, with her bedspring veil, and *Untitled "C"*, 1961, to extreme bulkiness, as in *Soldier*, 1955, and *Cellist*, 1956. In *Chain People*, 1960, hanging chains, rods, and pipes, resembling hair, enmesh a boiler-torso.

Stankiewicz's sculptures have often been viewed as a satire on society, his junk personages the likely inhabitants of mechanical civilization. Largely responsible for this interpretation is his most notorious piece, *Secretary*, 1955 (now in the Tel Aviv Museum), composed of a pale blue boiler whose guts are a mangled typewriter; arms, pipes; legs, sharp angled rods; and hair, a wire fan. Stankiewicz's content strikes me as more psychological than social.

If there is such a being as Technological Man — and I imagine there is something of Him in every one of us—his dreams might be populated by *Male Sitter*, 1955, *Urchin in the Grass*, 1956, *Railroad Urchin*, 1959, and *Playful Bathers*, 1960. These subjects are related to Surrealist grotesques, except that the latter were spawned in the fantasy of Freudian Man.

Such references are understandable to Stankiewicz, but he is rarely intent on making them and is not sympathetic to art criticism which does. In fact, of all that has been written about his junk construction, he likes best the review by Eleanor C. Munro that characterized it as "close to a child's game of monsterbuilding in the vacant-lot."[5] Stankiewicz's boyhood games actually may have been a source of his sculpture. He had grown up in Detroit near a mile-long foundry dump and factory yards where he and his friends played with bits of metal, slag, broken machine parts, and the like.

Stankiewicz himself thinks of his personages as "ghoulish buggy creepers, erect starers, careening exerters, floating fliers, squatting blocky ones."[6] He titled his second show in 1953, "Creatures of Fantasy: Satiric Postures: And Other Things." In 1957-58, he made an aviary, including a hectic *City Bird* and *Speckle Bird Shy*, and in 1960-61, a series of fantastic double-heads.

As I implied, no matter what Stankiewicz's scrap metal components signified, whether as found objects or parts of an image, they had to be integrated into the composition as an entity and were deliberately shaped with this in mind. Each element has to play its structural role. A few perceptive critics remarked on this early in Stankiewicz's career. For example, Sidney Geist, who is also a sculptor, wrote in 1953 that his constructions "prove to be miracles of harmony and architecture."[7] Hilton Kramer remarked in 1956 that Stankiewicz's "sculptural vision...addresses itself to fundamental problems, whatever jokes it may choose to make in the process," and to "the sculptural possibilities still to be uncovered in...direct-metal sculpture whose short history is so disproportionate to its impact on our artistic culture."[8]

Among the formal problems that have engaged Stankiewicz throughout his career has been the interaction of a cylindrical mass with small components juxtaposed *outside* of it, as in *Soldier, Chain People*, and many untitled sculp-

tures of the seventies. He has also been interested in working *inside* cylin-drical voids, as in *Untitled* (1959-66). Each of these constructions consists of a slice of water tank in whose interior space elements are composed in a kind of push and pull that painters learned at Hofmann's school. Stankiewiez's cross-section of a cylinder can emulate painting since the openings at both ends are somewhat like picture planes. The circular elements are even more pictorial in a series of untitled wall reliefs that he has been building since 1975.

During the sixties, Stankiewicz increasingly focused on formal considera-tions, treating structure in its own terms by simplifying or obliterating ref-erences to found materials and recognizable subjects, and verging toward geometry. Although he did not consciously intend it, his work grew more and more abstract. Scrap metal no longer seemed a necessary medium to Stankiewicz. It had become increasingly commonplace in sculpture, and that bothered him. In 1969 when he was given the opportunity to work with newly manufactured steel, he did. During a visit to Australia the facilities of a metal fabrication plant and the I-beams, T-beams, rectangular planes, and cylinders found there were made available to him. Standard industrial forms, which are found objects just as old junk is, prompted a "geometric" imagery very different from his earlier constructions. The change in medium also generated a surge of energy and inspiration in Stankiewicz: he completed fif-teen pieces in his two month stay in Australia. Since then he has continued to work with new steel.

When the geometric works were shown at the Virginia Zabriskie Gallery in in 1972 and 1973, James R. Mellow wrote that they "marked a decisive break with the...sculptures on which his reputation was based in the late fifties sixties. " The leap was "from the comic to the classic."[9] However, there are connections between the junk and new steel pieces. Stankiewicz contin-ued to favor cylindrical volumes which are reminiscent of boilers and pipes. But Mellow's observation was essentially correct. The new steel components do not recall their origins in reality, and thus look more abstract or pure. Formal considerations predominate. Whereas in the scrap metal construc-tions, a water tank might be a pun on a torso, an invention that distracted from the tank's compositional role, in the new steel works, a simple cylinder

calls attention primarily to Stankiewicz's formal invention and the finesse and authority with which he relates, balances, and proportions solids and voids.

Moreover, in most of the "geometric" constructions, the human figure is unrecognizable, and the extravagant allusions it evoked no longer obtain. There are exceptions; eleven pieces exhibited in 1975 are each composed of a cylinder placed at an angle to a cube into which smaller solids are wedged, creating the impression of a devouring open mouth. The humor, though restrained, is unavoidable. Stankiewicz's other pieces generally are not as explicitly figurative, yet the sense of human gesture—squatting, careening, and most of all, floating—remains. Such gestures are essential to Stankiewicz. As he wrote in 1973: "Every sculptural form can be looked at as a personage, at least in its attitude or posture. I think this is the source of what is called presence. I like to try different ways of achieving this."[10] The gestures in Stankiewicz's new steel sculptures give rise to formal problems, such as creating an architecture of gravity-defying volumes that are often off-balance, precariously poised on a small base-like form, or cantilevered out from it. Stankiewicz has long been fascinated by the drama of ordering heavy masses which levitate in space, as in, for example, *Speckle Bird Shy*, 1957-8. However, a turn away from volumetric geometry seems to be occurring in Stankiewicz's latest works on view, each a wall relief composed of a circle in whose interior shallow space irregular planes are arranged. But his development has never been predictable. On the basis of past performance, whatever results will be surprising—to Stankiewicz as well as to us.

Notes

1. Clement Greenberg, in "Is the French Avant-Garde Overrated?" (a symposium), *Art Digest*, September 15, 1953, p. 27.

2. Richard Brown Baker, interview with Richard Stankiewicz for Archives of American Art, New York, August 20, 1963. Unless otherwise noted, Stankiewicz's remarks are taken from this interview.

3. "Stankiewicz, Richard (Peter)," *Current Biography Yearbook* 1967 (New York: The H. W. Wilson Company, 1967), p. 398.

4. Richard Stankiewicz, panel at the Artists Club, New York, "Patriotism and the American Home," March 2, 1958. The other participants were Frederick Kiesler (moderator), Allan Kaprow, George Ortman, and Robert Rauschenberg.

5. Eleanor C. Munro], "Reviews and-Previews: Richard Stankiewicz," *ArtNews*, January 1956, p. 51.

6. Richard Stankiewicz, in Philip Pearlstein, "The Private Myth," *Art News*, September 1961, pp. 44, 61.

7. Sidney Geist, "Miracle in the Scrapheap," *Art Digest*, December 1, 1953, p. 10.

8. Hilton Kramer, "Month in Review," *Arts*, December 1956, p. 47.

9. James R. Mellow, "From the Comic to the Classic," *The New York Times*, Sunday, February 25, 1973.

10. "Richard Stankiewicz, in New York Collection for Stockholm exhibition catalogue (Stockholm, Sweden: Modern Museum, 1973), n.p.

IN THE MIDDLE 1950s, ROBERT
RAUSCHENBERG INCORPORATED MELANGES OF
THE ACTUAL THROW-AWAY OBJECTS, CULLED
FROM THE URBAN LANDSCAPE, INTO
ABSTRACT EXPRESSIONISTS PAINTINGS.
IN THE PROCESS, HE TURNED THE INWARD-
LOOKING OF THE OLDER ARTISTS OUT-
WARDS, INTO THE CITY ENVIRONMENT. HIS
COMBINE-PAINTINGS, AS HE TERMED THEM,
INAUGURATED A NEW AMERICAN-SCENE
PAINTING HERALDING POP ART AND OTHER
NEW REALIST TENDENCIES IN THE 1960s.

122

In The Galleries

Robert Rauschenberg

Among other things, Robert Rauschenberg's "Canyon," 1959, contains paint, torn paper, corrugated tin, a baby photograph, a frayed shirt cuff, a stuffed eagle perched on an empty carton and a puffed-out pillow. The line between painting, college and construction-sculpture becomes so obscured that Rauschenberg coined the name "combines" to characterize his works.

These pieces are shocking although less so as time passes. In 1958, "Bed"—which was just that a paint-smeared bed hung on the wall—so scandalized the directors of the Festival of Two Worlds in Spoleto, Italy, where it was sent along with the works of 11 young New York artists, that they refused to display the entire exhibition.

But Rauschenberg is one of the most gifted and original of contemporary artists, and as such is well deserving of a comprehensive survey of his "combines," organized by Dr. Alan Solomon, at the Jewish Museum, Fifth Av. at 92d St. (The opening of its spacious new "Albert A. Kist Building has allowed this museum to expand its activities. It will now feature young artists as well as Jewish ceremonial art.)

Among the first to in orporate urban debris into his works, Rauschenberg was an innovator of "junk sculpture," an important tendency in recent art, as the Museum of Modern Art's "Assemblage" show last year indicated. And in employing commercial illustrations, billboard fragments and newsprint, he also pointed the way to "new realism" or "pop art."

Still Rauschenberg is essentially a second-generation Abstract Expressionist who has developed the ideas of such artists as de Kooning in highly personal ways. His use of discarded matter is an extension of their use of the non-esthetic drips, splashes and free brush work as marks most directly expressive of the personality of the maker, but he is as concerned with transforming non-art substances into art.

In his best pieces, Rauschenberg maintains the tension between a thing as a thing as a design element. For example, he red umbrella in "Allegory," 1959-60, is a red circle, absorbed into the total picture scheme. But, it also retains its identity as a chunk of environment—a metaphor for the city. He also chose this particular object for the private meanings it possessed for him.

More than any of his contemporaries, Rauschenberg has posed questions about the relation of non-art to art. Can a grimy old bucket rapped in a wire mesh box be considered sculpture if it creates a heightened awareness of one's environmental and condition? On the other hand, can a white canvas—a picture with an utter minimum of painting—be considered non-art if it evokes an esthetic response as the epitome of purity or nothingness.

Rauschenberg examines these problems with a good deal of humor, both perverse and high-spirited. Indeed, his diabolic wit is one of his most engaging qualities, particularly when it is aimed at the concepts of other artists. When painters were talking about getting into their pictures, Rauschenberg incorporated a ladder into "Winter Pool"—one way of climbing into a work.

As Dr. Solomon points out in his catalogue, Rauschenberg has opened up "a new world of esthetic experience," which he has explored with unusual versatility. A carnival-like "Charlene," 1954, celebrates the rich color and spectacle of urban life. Conversely, the city in "Rebus," 1955, is a seamy and des-

olate place. In another, more tender yet ironic vein, "Hymnal," 1955, with its faded Victorian fabric, is nostalgic for the past.

In the late Fifties, Rauschenberg began to substitute bulkier, more anonymous objects for the newspaper and magazine clippings in earlier "combines." Instead of moving close to read the details, one tends to stand back and take the picture in as a whole. The emphasis is now on the way the fragments interact formally, and Rauschenberg has a sure sense of scale and balance, feeling for color relationships and for the fluent transitions of one incongruous element to another. But this elegance is countered by the increasing rawness of his materials.

Rauschenberg's sensibility is at its most exquisite in a suite of 34 drawings illustrating Dante's "Inferno." He has extended the ideas in these drawings in his latest black and white paintings, composed of silk screen images printed from photographs the multiple overlapping, blurred and shattered motifs look like all of the TV channels mixed on a single screen. This is a new departure from Rauschenberg and it will be interesting to watch how he develops in this direction.

Like Robert Rauschenberg, Jasper Johns, deflected the "subjective" painting of the older Abstract Expressionists into a new kind of "objective" realism. That is, he rendered in a painterly manner such images as American flags, images that could be taken (or mistaken) for the real things. Johns' paintings of flags would be a major influence in the development of both Pop Art and minimalist abstraction.

In The Galleries

Jasper Johns

When Jasper Johns' paintings of targets, American flags, numbers and letters were first exhibited in 1958, when he was 27 years old, they immediately astounded the N.Y. art world—by no means an easy thing. *Art News* ran a work of his on its cover. The Museum of Modern Art purchased several of his canvases and included him in its important "16 Americans" show in 1959. And now the Jewish Museum, Fifthe Av. at 92d St., is presenting a major retrospective of 174 works, organized by its director, Alan Solomon.

Artists were also stunned by Johns artistry and novel imagery. He has been the most important single influence on Pop Art and other variations of Cool Art—so much so that now, at the age of 33, he finds himself in the ironic position of becoming an "old master."

However, Johns himself is not a Pop Artist. Although he depicts commonplace things, symbols and signs without altering their shapes, his painting does not simulate either the "look" or the techniques of commercial art. Indeed, it possesses an extraordinary patina of high art. Struck by this quality, some critics have claimed that the literalness of Johns' subjects served to

emphasize his masterly paint handling.

This is only partly true, for the role that subject matter plays is of great significance. Johns paints a picture of a flag as if he were fashioning the object itself—much as a skilled worker would and with the same kind of self-detachment. The two kinds of making go hand in hand. The picture does not convey any sentiments about Old Glory, but becomes an exercise in craft. Johns compels us to see ordinary things afresh because he focuses our attention on his way of painting them—and his painting is anything but ordinary.

Johns freely brushed surfaces resemble those of the Abstract Expressionists, but his approach differs sharply from theirs. The most recent Romantics, they used the unpremeditated act of painting to discover new and emotional images of self. Hence, they were willing to sacrifice craft, when necessary, and they rejected the Cubist idea of picture-making as an end in art.

To Johns, he dispassionate process of picture-making is of the first importance. Furthermore, he used pre-existing images (i.e., flags and targets), which was considered by some artists and critics as a retrogression to realism. These images were geometric, akin to 1930s Cubism. And his method—drawing a design of an object or a symbol and filling it in with seemingly spontaneous dabs of pigment—smacked of academism.

But what was shocking in the late Fifties, he succeeded in combining these old-fashioned ideas to create pictures that looked genuinely new and original. Certainly, nothing quite like them had ever been seen before.

Indeed, Johns' knack of combining pictorial ideas that are commonly supposed to be antithetical—static, geometric design (of a flag) with active, Expressionist brushwork—provides much of the fascination. In his paintings, his imagery calls to mind both Harnett's "traditional" trompe l'oeil realism and Duchamp's "modern" Dada ready-mades.

At first glance, Johns' canvases look simple, but the more one studies them, the more complicated they get. The reason for this is that Johns constantly

poses problems of perception. That is, he questions what we see and what is "real." Do his "Flags" come across as flags, pictures or symbols?

In his catalogue, Solomon says of "Three Flags": "It consists of three canvases of different sizes superimposed one on another, each with its own flag... It confuses the images because of the repetition of the stars and striped a different scales; at the same time, it reinforces the flag idea in a strange way."

Johns also uses a screen of pigment to make the image disappear, as in "Large White Flag," or he casts a flag in bronze to make it more substantial than it actually is. He also plays off the atmospheric space created by his free brushwork against the two-dimensionality of his subjects, which, as Leo Steinberg points out, "the eye knows to be flat."

Visual ambiguities are at their most complex in those pictures of 1959 in which Johns integrates the stenciled words "RED," "YELLOW," "BLUE" with painted areas of color. What does the eye register when it sees a blue "RED" on an orange form—blue, red, "RED" or orange? Do the word images in a black and white "Jubilee" evoke the sense of he colors? Theses are not inconsequential games, for they create in the viewer a marvelous heightening of perception. And Johns also makes his subjects magical-like icons. Few pictures in our time are as mysterious as his tomb-like "Tennyson."

Since 1962, Johns has increasingly incorporated forks, spoons, brooms, brushes, rulers and other commonplace household and artists' materials into his works—materials which are more intimate and less public and impersonal than flags and targets. These objects become the poignant mementos of private events which occurred in the dingy light of lonely city apartments and studios. Johns is painting out of his own life more—an exciting turn in his work.

Chapter Three

From the 1950s
into the 1960s

TOWARD THE END OF THE 1950S, ABSTRACT
EXPRESSIONISM BECAME ESTABLISHED, SO MUCH
SO, THAT ARTISTS WITHIN THE NEW YORK
SCHOOL AND A GROUP OF NEWCOMERS BEGAN TO
THINK OF IT AS A NEW ACADEMY.

AT THIS TIME, TOO, NEW TENDENCIES BEGAN
TO EMERGE, NOTABLY POP ART, A NEW
PERCEPTUAL REALISM, STAINED COLOR-FIELD
AND HARD-EDGE ABSTRACTION, AND MINIMAL
ART. IN THIS MEMOIR WHICH INTRODUCED MY
SURVEY OF AMERICAN ART IN THE 1960S, I
TRACE THE STRUGGLE I, AS A CHAMPION OF
ABSTRACT EXPRESSIONISM, HAD IN ACCEPTING
THE NEW "COOL" TENDENCIES THAT EMERGED IN
THE 1960S.

A Personsal Memoir: 1958-1962

Radical changes in Sensibility

I entered the sixties eyes closed to emerging new art. Frank Stella's abstractions composed of symmetrical, concentric configurations of black stripes, when first shown in the Sixteen Americans show at the Museum of Modern Art in 1959, enraged me. I should have been more open to Stella's painting, if only because it looked new, and I was a critic identified with the avant-garde or what was then considered the avant-garde, variously labeled Abstract Expressionism, action painting, the new American painting, and the New York School. I was one of a coterie of some two hundred artists and their friends who lived on or in the vicinity of East Tenth Street in downtown New York City; often visited and partied in one another's studios; frequented the cooperative galleries younger artists organized and managed, the Cedar Street Tavern, and, on Friday nights, a club, simply named the Club, the older artists had founded in 1949; and in general shared a way of life.[1]

We also shared an aesthetic, that of gesture or action or painterly painting, whose creative process is visible in the completed work, as exemplified by the pictures of Willem de Kooning, above all, but also of Franz Kline, Philip Guston, and others. Our involvement with gesture painting was intensified

133

by the downtown art scene. It was stimulating, often inspiring, to be in the company of these artists whom we regarded not only as innovative and great painters but as brilliant and articulate intellectuals as well. We were sympathetic to artists who had developed styles other than gestural, but only if they were of the older generation, like Mark Rothko (who was removed not only stylistically but geographically, living uptown as he did) and Ad Reinhardt (who was always on the scene but was implacably opposed to Abstract Expressionism of any kind). But we would not accept newcomers with ideas different from our own. More accurately, we attacked them angrily. Thus we joined a long line of modernists who, as Francis Haskell has remarked, partook of "two conflicting (and often unconscious) attitudes toward contemporary art...on the one hand, the search...for the new, the vital, the inspired, the unconventional; and, on the other, an almost uncontrollable distaste for just those qualities when...they do in fact appear."[2]

The primary target of our abuse, at least until the emergence of Pop Art in 1962, was Stella. Stephen Greene, his teacher, recalled that when Stella's work was first shown, Greene was unable "to convince a single artist that it was work of any importance or that it was even 'painting'."[3] But there were good reasons for our not taking Stella seriously. His work was so reduced-to absurdity, we believed—as to appear nihilistic; at the very least, it seemed boring, and even to cultivate boredom .[4] Moreover, painting that looked so different from and evidently antithetical to gesture painting, as Stella's did, was something other than expressive, authentic, significant, and contemporary. If gesture painting had value, then Stella's pictures could not. As one eminent art historian summed it up, he was more a juvenile delinquent than an artist.[5]

In retrospect, our response to Stella's work testifies to the importance of its entry into the stream of art. Stella and a few of his contemporaries were the avant-garde and not—as most of us believed—us. Those of us who had begun to have doubts still claimed that gesture painting was the vanguard or, at least, the last worthy one, but we claimed it with lessening confidence. By 1959, gesture painting was avant-garde only in the sense that it was in advance of the taste of the general public: in fact, it had not been extended in any radical manner for some half-dozen years. Moreover, its premises had

become so familiar that it had attracted followers in numbers that seemed more like a main army than a vanguard.[6]

Because of this, a growing number of artists and art professionals who had earlier supported gesture painting—among them Alfred H. Barr, Jr., Clement Greenberg, Dorothy Miller, William Seitz, and Leo Castelli— began to think that it was in crisis. By that they meant that the tendency had become too established to yield significant and fresh stylistic developments. They also began to be on the lookout for styles that were in their opinion more viable. Barr believed that he had found an alternative to gesture paint- ing in the flags and targets of Jasper Johns; and Greenberg, in the stained color-field abstractions of Morris Louis and Kenneth Noland.

Members of the coterie to which I belonged were bothered, too, by the mediocrity of most of the recently arrived gesture painters, but their num- ber struck us as a validation of the tendency. I assumed that they (as I) had embraced the art of de Kooning, Kline, and Guston not merely because it was new in style but because it was true to their (and my) experience. Our search was for what we felt was genuine and real in ourselves, each for his or her own individual identity, as Harold Rosenberg wrote in his article on action painting (an article that strongly affected me.)[7] And we believed that the struggle for authentic being was occurring at a time when the efficacy of man's individual actions appeared to count for less and less; when man and his future were increasingly problematic; when man himself was in crisis. The crisis, as we saw it, was existential, social, and political, and not the cri- sis in style envisaged by Greenberg.[8]

But we could not disregard the glut of gesture painting for long. By 1958, it had become obvious that most gesture painters were making pictures in a known and accepted style. They were the "school" artists—unambitious, derivative, and professional—who fabricated pictures in someone else's man- ner, with minor deviations to be sure, or who mixed the styles of others, con- triving a measure of "originality."[9] Some of us recognized the problem and claimed that its resolution was to be found in distinguishing the genuine and deeply felt from the mannerist and contrived—that is, the good from the bad. After all, inferior art, no matter in what quantities, could not invalidate

135

superior art. But in fact, it did affect what artists created and how viewers attended to art. A glut of banal art in any style rendered that style stale and discouraged lively artists from working in it and viewers—from looking at even the best of it.[10] The falling attendance at the artist-run galleries on Tenth Street in the late fifties and their subsequent collapse was proof of that. Gesture painting that was expressive and of quality remained expressive and of quality, certainly, but the style was no longer difficult enough to be challenging; it had become an overworked and thus outmoded manner.

By 1959, the question of whether gesture painting was in crisis or decline as frequently debated by downtown artists. In response to the growing controversy, I organized at the Club a series of panel discussions entitled "What Is the New Academy?"[11] asking—"What Is?" rather than "Is There?" to imply that in fact there was one." I then compiled a series of seventeen statements by the artist-panelists and several others and published them in Art News under the heading "Is There a New Academy?"—the title softened by the editor, Thomas Hess.[12] Opinions differed as to whether gesture painting had become academic. But what disturbed me most was Helen Frankenthaler's blunt comment: "It is no longer a question if the question must be raised."[13]

Almost as troublesome, several of the contributors detailed what a "new academic" picture looked like, as though gesture painting had become predictable. It was, in John Ferren's words, "rough, 'real gutsy' and American...a certain speed limit—325 miles per hour. Black and white, of course, with possibly one other color, providing that it is dirty." Ferren went on to say that painterly finesse was taboo since it was European. The picture had to possess a "floundering" look and be "very big."[14] Frankenthaler had a similar image in mind, but she deprecated more than Ferren did, and with less irony, "the slickness of the unslick" and painting that was slightly ugly "in order *not* to look obviously like academy pictures."[15] Friedel Dzubas also denigrated "all the tricks of the current trade, the dragging of the brush, the minor accidents (within reason), the seeming carelessness and violence ever so cautiously worked up to."[16]

Gesture painters rebutted the attacks on the viability of their style, of course, but with a new defensiveness. For example, Nicholas Marsicano even grant-

ed that there was a new academy but quickly added that it was "an informal one," because

> it has no rules or definitions, fixed leaders or followers, but is in the process of constantly being defined. There are a number of elements that we possess in common...that we search for and need...

> We are in a state of exposing and what we do is made available to everyone. There are no secrets...Anyone has a right to take ideas [if one also replaces the inspiration].

> If a picture painted today possesses one truth, it remains the absolute truth until you possess one better...The force of certain truths in painting today makes it impossible to paint outside of them.[17]

But Marsicano's "truths" were not those of young artists who were formulating styles different from gesture painting. And the question for the New York art world became: Were they the new avant-garde? During the late fifties, claims were made for Robert Rauschenberg and Jasper Johns, on the one hand, and Morris Louis and Kenneth Noland, on the other. If the measure of their avant-garde status was the negative response to their works by the gesture painters, then the claims were justified—but only somewhat, since their work had its admirers within my coterie, myself included. Still, Rauschenberg's Assemblages, composed of junk materials, and related works by younger sculptors, and Johns's pictures of American flags, targets, etc., were thought by most of us to be Neo-Dada, the new anti-art—in Johns's case, neo-Duchampian—and Louis's and Noland's stained color-field abstractions were regarded as little more than glorified decorations.

But such opinions were beginning to seem vulgar as some of us recognized the quality of the work and understood its rationales. We also made the connections between the recent work and accepted styles. Using Pollock's and Frankenthaler's technique of pouring paint, Louis and Noland had extended Frankenthaler's flooded areas of interacting colors to a purer chromatic abstraction, a field abstraction, reminiscent of that of Barnett Newman and his model, Matisse. And we could no longer consider decorative art neces-

sarily trivial, as we had, even though we were always confronted by the example of Matisse. Rauschenberg and Johns had extended gesture painting by introducing commonplace objects and images, suggestive of Dada Readymades, but their intention was not at all anti-art. Neither was that of young sculptors who made even junkier-looking constructions than Rauschenberg did. Besides, so-called Neo-Dada had begun to achieve art-world recognition, the culmination of which was the *Art of Assemblage* at the Museum of Modern Art in 1961. Rauschenberg would soon be acclaimed internationally as the most important artist of his generation. For a while, it seemed that a development from Assemblage into a form of theater called Happenings was the new avant-garde, but Happenings went into a rapid decline when most of their originators—for example, Red Grooms, Claes Oldenburg, and Jim Dine—reduced or ceased their performance activities and turned to object making. By 1961, neither Assemblage nor color-field abstraction struck us as difficult.

Stella's black-stripe abstractions were something else. In retrospect, it is difficult to understand why they should have looked as unprecedented as they did. We were aware that in their preconceptual approach and their preoccupation with picture-making, they were derived from Johns's flags (which were in the line of Duchamp's Readymades) and related to Reinhardt's monochromatic, symmetrical, geometric abstractions (which had their source in Malevich's white-on-white painting.) But Johns and Reinhardt were generally denigrated by my circle (although not by me). Geometric abstraction, such as Reinhardt's, and realism, such as Johns's, were considered throwbacks to the thirties, and dead ends. Besides, it seemed to us at the time that Stella had carried the ideas proposed by Reinhardt and Johns to a nihilist extreme. Stella purged whatever human content Johns allowed in his work—the imagery and virtuoso signs of the hand, at least and although he seemed to share Reinhardt's art-for-art's-sake aesthetic, he made a mockery of it, in our opinion. We had not accepted Reinhardt's purism, and we were not about to accept Stella's seemingly corrupt version—or what we knew of it. Paradoxically, we believed that Stella was mocking Reinhardt in his black-stripe abstractions because they were brushed and their edges were "soft," rendering them impure—like Johns's work. Stella could be viewed as playing off Reinhardt against Johns; purist nonobjectivity against

impurist painterly realism. He could also be seen as synthesizing the two, although this was only sensed at the time. Later, when both tendencies were understood to be the major ones in sixties art, Stella's prophetic and ambitious enterprise became clearer.

Yet the "painterliness" of Stella's painting, its directness as well as its large scale and immediacy, could be seen as deriving from gesture painting. But it rarely was, it was simply too systematically reduced, too mechanistic, too indifferently painted. The black-stripe abstractions seemed not only unrelated to gesture painting but to depart radically from it. Stella seemed to refer to gesture painting only to reject it: this apparently was his intention, and that is how it was perceived. Lucy Lippard wrote of Stella that his

> unequivocal rejections of illogic, illusion, and allusion, his advocacy of symmetry, impersonalism and repetition, was unique in its impact on younger artists, most of whom were older than Stella himself. He did not write, but his ideas spread through conversations and through criticism.... It seemed as though he had looked at painting as it was in 1959, brilliantly diagnosed its symptoms and prescribed the "right" cure.[18]

Certainly Stella's "rational," preconceptual geometry was totally at odds with the "intuitive" improvisation and cultivation of accidental effects found not only in gesture painting but in the pictures of Rauschenberg, Johns, Louis, and Noland as well. In the fifties, chance was taken to be avant-garde, and shocking; in the sixties, preconception was. And yet Stella's pictures did not appear related to such older conceptual styles as geometric abstraction; his were far too direct and immediate. In retrospect, it seems that Stella had found a position between gestural and geometric abstraction that distanced his work from each and thus looked unprecedented and new. But he seems to have had in mind the merging of the two modes of painting, as is suggested by the title of one of his pictures: *The Marriage of Reason* and *Squalor*, shown in *Sixteen Americans*.

Just as Stella's work shocked the New York School, so did the Pop Art of Andy Warhol, Roy Lichtenstein, James Rosenquist, and Tom Wesselmann when it emerged about two years later. The fact that Pop Art was anticipat-

ed by the work of Rauschenberg and, particularly, Johns did not lessen the shock. And the waves it generated reverberated beyond the confines of the art world, because it partook not only of the formal changes that Stella had introduced but of mass culture —and this disturbed American intellectuals as a whole. To most of us, mass culture, or kitsch, as we called it, was the enemy of both authentic expression and high art. Now we asked: What motive could artists have in introducing kitsch into art? Obviously to debase high art. Pop Art became notorious, the center of controversy from 1962 to 1964, when as a topic of contention it was superseded briefly by Op Art and then by Minimal construction, spawned by Stella's abstraction.

It was not only Stella's abstraction and Pop Art that infuriated us but the art writing on their behalf. What angered us most were the repeated claims that Abstract Expressionism was dead. "Who killed it?" we asked. Frank Stella? Andy Warhol? The thought was preposterous. Moreover, it was inconceivable to us that Pop artists might in good faith desire to view American urban life and its proliferating communications media anew. And we found perverse, if not absurd, assertions that Stella's painting was painting for its own sake only. And yet Carl Andre, later an innovator of Minimal sculpture, made just that claim in the first statement about Stella's abstraction, published in the catalogue of Sixteen Americans. He wrote:

> Art excludes the unnecessary. Frank Stella has found it necessary to paint stripes. There is nothing else in his painting. Frank Stella is not interested in expression or sensitivity. He is interested in the necessities of painting...

> Frank Stella's painting is not symbolic. His stripes are the paths of brush on canvas. These paths lead only into painting."[19]

Andre was obviously serious, but that was not clear to us. His remarks seemed to parody a claim often made for gesture painting, that it was painting about painting. But we thought this claim was vulgar unless it meant that the painting itself embodied the artist's experience, which was its content, and that was not what Andre (or Stella) had in mind.

Most incongruous of all pronouncements were Stella's own. In 1960, while

participating on a panel at New York University, he remarked that he could find few creative ideas in current art; there were not even any good gimmicks. What interested him most was a good idea and not the process of painting it; he could not understand why it was bad for an artist who had a good idea just to execute it, to be an executive artist, as it were. Indeed, Stella claimed to be so indifferent to process that he would welcome mechanical means to paint his ideas. He also said that his conception of a picture was one in which only paint was used and nothing of himself. Stella implied that his major idea was to make a picture that referred only to itself. He seemed to be saying that his idea was both the pretext for making art and its content. Nothing else counted. Stella concluded that he did not know whether he was an artist.[20] He was, of course; what he obviously meant was that he did not want his art to look like what art had looked like or was supposed to look like. But we claimed to take him at his word.

Yet we could not dismiss Stella that easily. We were aware that his ideas were being taken seriously by artists outside our coterie, particularly emerging ones—and that dismayed us. Even had we accepted Andre's assertion that Stella's preoccupation with painting only as painting was valuable or Michael Fried's claim (which he was to make in 1963) that Stella had posed and solved the central formal problem in modern art since Impressionism—to emphasize the thing-nature of painting because that was what painting honestly was—and was therefore the most relevant and ambitious painter of his time, even then we would have considered his enterprise trivial.[21] As we saw it, the idea of posing and solving problems, merely rendering solutions, and the art it gave rise to were impoverished. A view of art as a campaign to advance art toward objecthood and the artist as a brilliant strategist could not compare to the justification for Abstract Expressionism as heroic and sublime, or at least as "serious," the test of which, as Rosenberg asserted, "is the degree to which the act on the canvas is an extension of the artist's total effort to make over his experience."[22] To be valid, such confrontation required that the painter be honest, not to the picture as a thing but to his or her experience of the act of painting.

Claims made for Pop Art struck us as even more trivial than those made for Stella's abstractions, because of its connection to kitsch. The most outrageous

141

statements were Warhol's—for instance, the one echoing Stella: "I think somebody should be able to do all my paintings for me...The reason I'm painting this way [with silk screens] is that I want to be a machine, and I feel that whatever I'd do and do machine-like is what I want to do." When Warhol was asked whether the commercial art he had once done as more machine-like than his fine art, he replied:

> No, it wasn't. I was getting paid for it, and did anything they told me to do.
> If they told me to draw a shoe, I'd do it, and if they told me to correct it,
> I would...I'd have to invent and now I don't; after all that "correction," those
> commercial drawings would have feelings, they would have a style .[23]

The notion that an artist would want to and evidently did—eliminate creativity from art was appalling. So was its publication by Hess in Art News, which we considered our magazine.

Compared with the comments of Stella, Andre, Fried, or Warhol, those of Rosenberg, Hess, and other art writers and the artists we took our cues from seemed to take up the cause of art and man and generally sounded virtuous. More specifically, Abstract Expressionism was worthy of a strong defense, and we tried. But fewer and fewer young artists seemed to care what we said or even to listen to us, the evidence for which was the decline of the Club after 1960. Worse than that, a number challenged not only our beliefs but their very pertinence to art. What in painting, they demanded to know, represented, symbolized, or signified seriousness or honesty or crisis, existential or any other kind? Point to it, they said. We once could, and could communicate it, or thought we could, but the sensibility, the intellectual climate, had so changed that our kind of art talk was no longer convincing or, at least, intelligible, even to ourselves. I remember thinking around 1958, when the nth artist struck an anguished pose at the Club and announced: "When I paint, I don't know what I am doing," and someone called out: "After twenty years?" and there was laughter, that our rhetoric was no longer believable. But the laughter was edgy, to say the least, because we sensed that values we believed were as necessary in art as they were in life had been lost.

Indeed, our fundamental assumptions concerning Expressionist painting

were questioned. For example, Amy Goldin wrote:

> As far as I'm concerned, Expressionist esthetics—theories about a special relationship between the artist, his materials and his audience—are pure Hollywood, the stuff of which coffee-table art books are made. The painter as yoyo artist, sending SELF out to the end of the line and then retrieving it, miraculously loaded with transcendence, by a tricky flick of the wrist. The audience, sullen, yearning: "Sock it to me." The artist, eyes glazed with looking into the void, leaps, flinging his all—*will he make it?* If he makes it, *we've* made it. Orgasms all around. Happy, happy.
>
> Almost everything that has been written about any Expressionist art uncritically accepts it as an illustration of Expressionist esthetics. It is the unchallenged consensus of opinion that these paintings express the personal feelings of the artist and that they reflect his emotional relationship to the world. As the story goes, Expressionist painting is pure content-for-mal devices as well as subject matter are read as the "natural" results of direct emotional impulse. The question of individual quality is seldom raised.... Expressionist techniques . . . are not treated as components of a style, but as the quasi-involuntary traces of emotion.
>
> As pure argument, this formulation is silly.[24]

What Stella—at age twenty-two—and Pop artists and their friends said was appalling enough, but it was exacerbated by the attention it received and, even more, by the self-possessed, brash manner in which it was said. This made them seem utterly lacking in respect for their Abstract Expressionist elders, not only of the second generation but also of the first. (We did not know it at the time, but this was not so; their contempt was only for the second generation, with the exception of Frankenthaler, Johns, Rauschenberg, Mark di Suvero, John Chamberlain, and a few more.) Their anti-establishment stance was seen by us to be not in the great tradition of modernist iconoclasm but as part of the youth cultism that gripped the sixties, which we found distasteful. One of the popular slogans of the decade was: "Don't trust anyone over thirty." We did know that serious young artists trusted Newman, Reinhardt, and Greenberg, who, however, were not among the painters or critics esteemed by my coterie. Like other young people, for

143

example, students who demanded participation in revising curriculums, in formulating their own rules of discipline, and in protesting restrictions on their private lives, young artists refused more readily than those who preceded them to accept received aesthetic ideas or even to give them lip service. They dared to be openly critical of what did not feel true to their experience. Moreover, there was a change in dress, music, sexual mores—indeed, a pervasive change in life-style—that made communication between them and us awkward at best. What had occurred was a profound and complex social and cultural upheaval, and that was unnerving.

We were also taken aback by another side of the youth culture and the youth cult, namely: the success of its idols in conventional social terms. We considered ourselves alienated from society and disparaged success, which, at any rate, was rarely forthcoming. Young artists seemed to want to become famous and make money, lots of it. They considered themselves professionals, and most had Master of Fine Arts diplomas to show for it. And a number quickly achieved recognition. For example, by 1961, Stella had been included in *Sixteen Americans*, had received one-person shows at the Castelli Gallery and the Galerie Laurence in Paris, had had a picture reproduced as the cover of *Art International*, and had had his works purchased by the Museum of Modern Art, Nelson Rockefeller, Philip Johnson, and the Burton Tremaines, among others. Unlicensed freedom and licensed professionalism and careerism struck us as irreconcilable, but young artists, raised on youth and college cultures, embraced both without compunction. And they, proved to our disbelief that to achieve worldly success they would have to be avant-garde. And to be written into art history, they would have to seem to break with it. The aesthetic icons they created would have to be iconoclastic.

These young artists and their curator and critic friends and other art-conscious people of their generation, together with a few older and respected figures in the art world, notably Barr, Castelli, Greenberg, Miller, and Seitz, despite differences of taste and opinion, literally constituted a new art world. They created a new climate of opinion in which the new art could be seen sympathetically-indeed, be perceived as art. The philosopher Arthur Danto remarked: "To see something as art requires something the eye cannot

decry—an atmosphere of artistic theory, a knowledge of the history of art: an artworld."[25]

As for myself, much as I resisted, there was no escaping the power of Stella's abstraction. I was forced to reconsider my definition of "valid" art, to realize that new art demanded an approach different from that of Abstract Expressionist painting, that it could not be judged with criteria that no longer applied. I did not change my mind about the best of gesture painting-and its values—but I stopped treating it as a cause and began to entertain other artistic options and strategies. This enabled me to recognize the chief nongestural developments of the sixties, including formalist investigations of the objecthood of art (Minimal Art) and representations of objects in the world (Pop Art)—both of which drew from sources external to the artist. And I also accepted the impassive, distanced, or cool, seemingly objective, and obviously nonexpressionistic attitude with which the new art enterprises were carried out. However, my resistance to sixties abstraction and Pop Art crumbled slowly; it was not easy to give up old convictions, even if they had ceased to inspire the best new artists.

My change of mind about the new art was influenced by Reinhardt, who was my friend. He professed to hate it all, but I knew that he disliked nongestural styles less than he did gestural ones. I had always admired Reinhardt's self-effacing, polished work, although to his chagrin that did not stop me from loving the Abstract Expressionist painting he hated. I also took Reinhardt's art-for-art's-sake polemic very seriously, considering it the dialectical antithesis of Abstract Expressionist thinking and an antidote to its frequent self-indulgence. It troubled me when Reinhardt asked whether true art was too elevated, too pure to need anyone's ego-tripping self-expression or fantasizing. At the time, I did not connect his purist ideology with Stella's work, which hardly seemed to ennoble art. But I knew that Reinhardt was interested in the younger artist's work. He objected when I savaged it in a review of 1961 by comparing it to his own black paintings.[26] Had Stella's work been Surrealist or Expressionist, Reinhardt would not have protested. Stella in turn was largely responsible for the rehabilitation of Reinhardt's work—and to a degree, of Newman's. Newman had been patronized at the Club as the little guy with the monocle in the corner until his show at the

French and Company Gallery in 1959. But it was only in 1961, when a large picture of his was exhibited at the Guggenheim Museum in the company of major works by his colleagues in the New York School and overshadowed them, that his work was sharply upgraded, even by my coterie.

My change of mind was facilitated by changes in style and attitude by three artists of my generation whom I knew on Tenth Street and whose work I had long admired. These artists—Al Held, Alex Katz, and Philip Pearlstein—unlike most of their contemporaries who matured within the New York School during the fifties, had made successful—indeed, masterly—transitions into nongestural styles. I witnessed all the steps in their developments and was strongly influenced by our conversations at the time.

Katz and Pearlstein suppressed heavy, gestural painting because it had become mannered, or academic, as Katz said as early as 1957. Equally important, rough, overlapping, and scumbled brushwork conflicted with sharp-focus realism, a goal toward which they had begun to aspire, a figurative art more literal, more directly perceptual—that is, based on observed reality—than it had been. The desire for specific representation was announced by Katz in the many portraits of his wife, Ada, that he began to paint in 1957. It would become the essential component of the New Perceptual Realism that would emerge in the early sixties. Moreover, he enlarged his pictures in size and scale so that they would compete in visual impact, muscle, and grandeur with the "big" abstract canvases of the period, looking "major,", as it were. At the same time, inspired by Matisse, as were the stained color-field and hard-edge abstract painters, such as Louis, Ellsworth Kelly, and Held, Katz began to make his color more vivid and unexpected, and this expression through color, too, required the suppression of painterly facture. And so did Pearlstein's detailed rendering of his models' mass, which became his primary concern. He formulated a rationale for a new realism in two major articles published in 1962 and 1964. Titled "Figure Paintings Today Are Not Made in Heaven" and "Whose Painting Is It Anyway?" they greatly influenced my thinking.[27]

Pearlstein spoke often of the changes occurring in American art. As he later summed it up, "the sixties were characterized by Pop art, constructions of all

kinds, hard-edge abstraction and my own kind of hard realism-it's all 'hard'-sharp, clear, unambiguous. In the fifties everything was ambiguous."[28]

In 1959, Held was confronted with the crisis in gesture painting, which exacerbated his growing dissatisfaction with his own work. This led him to review with, a critical eye the abstractions he had painted in the previous four or five years all-over fields of pigment-laden gestures. He became aware that his artistic bent was toward clarity—a kind of classicizing urge. The design in his pictures increasingly engrossed him, and it was buried beneath the thick textures. Held's primary need was to bring his infrastructures up to the surface and articulate them. The ambiguous and unfinished-looking troweled and smeared slabs of paint would have to be cut through and cleaned up.

This Held proceeded to do in the following year, when he brushed freehand quasigeometric and curvilinear configurations in flat, vivid colors, reminiscent of Matisse. In Held's early quasi-geometric abstractions, the direct process of painting is clearly evident; that is, the forms are composed of visible brushstrokes. But the painterly gestures were soon suppressed, absorbed into the concrete forms of unmodulated colors that they shape. The color-forms and not the gestures came to bear the burden of content. That content remained Expressionist in spirit, since Held aspired to invest each of his color-forms with an individual character and presence, as if each were a real being. But because Held's paintings no longer looked gestural, they were derogated by the leading tastemakers in my coterie. This shocked me into a recognition of how rigid Abstract Expressionist orthodoxy had become. And, as Held said, "there was another way of making art."[29]

NOTES

1. For a discussion of the New York art world in the fifties, see Irving Sandler, *The New York School: The Painters and Sculptors of the Fifties* (New York: Harper & Row, 1978), chap. 2

2. Francis Haskell, "Enemies of Modern Art," *New York Review of Books*, 30 June 1983, p. 19.

3. Barbara Rose and Irving Sandler, eds., "The Sensibility of the Sixties," *Art in America*, January-February 1967, p. 46.

4. 1 should like to stress how boring Stella's work looked to us and how absurd that seemed. I wrote in "New York Letter," *Art International*, December 1960, p. 25: "Stella seems interested in monotony in terms of itself, as an attitude to life and art. His pictures are illustrations of boredom." Defenders of Stella's abstractions claimed that they were not boring but seemed to be to viewers who brought to them expectations generated by Cubist and Abstract Expressionist art.

5. The art historian was Robert Goldwater. He made this remark after a panel titled "Art 60," at New York University, New York, 21 April 1960, which he moderated. The other participants were jasper Johns, Alfred Leslie, Robert Mallary, Louise Nevelson, Richard Stankiewicz, and Frank Stella.

6. See Sandler, *The New York School*, chap. 13, for a detailed analysis of this development.

7. Harold Rosenberg, "The American Action Painters," *Art News*, December 1952.

8. Clement Greenberg, in *Post-Painterly Abstraction*, exhibition catalogue (Los Angeles: Los Angeles County Museum of Art, 1964), n.p., characterized the crisis as follows:

> Abstract Expressionism was, and is, a certain style of art, and like other styles of art, having had its ups, it had its downs. Having produced art of major importance, it turned into a school, then a manner, and finally into a set of mannerisms. Its leaders attracted imitators, many of them, and then some of these leaders took to imitating themselves.

9. See Sandler, *The New York School*, p. 281.

10. A member of my coterie, Alex Katz, in Irving Sandler, ed., "Is There a New Academy?" part 2, *Art News*, September 1959, p. 39, spoke for artists and other art professionals who had turned against gesture painting or, as he put it, "the more traditional of advanced New York paintings," when he remarked that so many painters were working in this vein that "a reaction against their ideas in general" had set in. "This paradoxical compliment of flattering imitation forces style to change. The general look shifts."

11. From 1956 to 1962, I was responsible for organizing panels at the Club.

12. Irving Sandler, ed., "Is There a New Academy?" *Art News*, part 1, Summer 1959, and part 2, September 1959.

13. Ibid., part 1, p. 34.

14. Ibid., part 2, pp. 39, 58-59.

15. Ibid., part 1, p. 34.

16. Ibid-, part 2, pp. 37, 59.

17. Ibid., part 1, p. 36.

18. Lucy R. Lippard, "Constellation in Harsh Daylight: The Whitney Annual," *Hudson Review 21* (Spring 1968): 177-78. Among the artists influenced by Stella that Lippard had in mind were Carl Andre, Donald Judd, Dan Flavin, Robert Morris, Sol LeWitt, Robert Smithson, Mel Bochner, Eva Hesse, Robert Mangold, and Robert Ryman.

19. Carl Andre, Introduction, *Sixteen Americans*, exhibition catalogue (New York: Museum of Modern Art, 1959), p. 76.

20. Frank Stella, "Art 1960," New York University, 21 April 1960.

21. Michael Fried, "Frank Stella," Toward a New Abstraction, exhibition catalogue (New York: Jewish Museum, 1963), p. 28, and Michael Fried, "New York Letter," *Art International*, 25 April 1964, p. 59.

22. Harold Rosenberg, "The American Action Painters," p. 48.

23. G. R. Swenson, interviewer, "What Is Pop Art? Answers from 8 Painters," part 1, *Art News*, November 1963, p. 26.

24. Amy Goldin, "One Cheer for Expressionism," *Art News*, November 1968, pp. 49, 66-67.

25. Arthur Danto, "The Art World," *Journal of Philosophy*, 29 October 1964, p. 571.

26. See Sandler, "New York Letter." When I learned that Stella had not seen Reinhardt's famous slides of art monuments throughout the world and mentioned it to Reinhardt, he offered to give Stella a private viewing, indicating his interest in the younger painter. The slide showing took place in my apartment around 1961. Stella brought Henry Geldzahler. Architectural historian Richard Pommer was also there.

27. Philip Pearlstein, "Figure Paintings Today Are Not Made in Heaven," *Art News*, Summer 1962, and "Whose Painting Is It Anyway?" *Arts Yearbook 7, New York The Art World* (1964).

28. Rose and Sandler, eds., "Sensibility of the Sixties," p. 53.

29. Maurice Poirier and Jane Necol, eds., "The 60's in Abstract: 13 Statements and an Essay," *Art in America*, October 1983, p. 125.

I WAS REARED IN AN ART WORLD IN WHICH
KITSCH WAS UNIVERSALLY BELIEVED TO BE THE
ENEMY OF HIGH ART, BENEATH ANY CONSIDER-
ATION, SINCE EVEN NEGATIVE COMMENTS WOULD
ENDOW IT WITH MORE SERIOUSNESS THAN IT
DESERVED. ART WAS "HIGH" AND POPULAR CUL-
TURE WAS "LOW" AND NEVER THE TWAIN SHALL
MEET. CONSEQUENTLY, IT TOOK ME TIME TO
COME TO TERMS WITH ART WHICH TOOK AS ITS
SUBJECT SO-CALLED "KITSCH" AND TO UNDER-
STAND ITS SIGNIFICANCE. POP ART WAS THE
CONSUMMATE ART OF OUR POST-WORLD WAR II
CONSUMER SOCIETY, WHICH, LIKE IT OR NOT,
IS OUR SOCIETY.

The Deluge of Popular Culture

P op Art exploded with a WHAM! on the New York art scene in 1962 and was quickly featured in both art and mass media. The new movement appalled the Abstract Expressionists, the reigning avant-garde whose leading painters had achieved international recognition for the first time in the history of American art. For them, art existed to reveal the artist's inmost feelings and private visions; consequently, their generally abstract works could be difficult to understand. But, as Andy Warhol said, "the Pop artists did images that anybody walking down Broadway could recognize in a split second—comics, picnic tables, men's trousers, celebrities, shower curtains, refrigerators, Coke bottles—all the great modern things that the Abstract Expressionists tried so hard not to notice at all."[1]

In the opinion of the Abstract Expressionists, the only art more despicable than that which blatantly appropriated its subject matter from popular art or kitsch[2] was that which also borrowed its techniques from commercial art: Roy Lichtenstein's stenciled benday dots, James Rosenquist's billboardlike rendering, and Warhol's photomechanical silkscreening. Pop artists were branded the new vulgarians, while they, in turn, ridiculed the romantic rhetoric of the Abstract Expressionists. Lichtenstein, for example, poked fun at

151

their need for the anxious, improvisational "action" of painting by repre-
senting a brush stroke in his meticulous, machine like Pop style.

Although the fact was not acknowledged at the time, by 1962, Abstract
Expressionism had become outworn and was in decline. Lively young artists,
both abstract and figurative, were turning to different subjects and different
pictorial means. Pop Art was one manifestation of a "new" art that also
encompassed the hard-edge abstraction of Ellsworth Kelly and Al Held; the
stained color-field abstraction of Morris Louis, Kenneth Noland, and Jules
Olitski; the Minimalism of Frank Stella, Carl Andre, Donald Judd, Robert
Morris, Dan Flavin, and Sol LeWitt; the New Realism of Philip Pearlstein
and Alex Katz; and the Photo-Realism of Malcolm Morley, Richard Estes,
and Chuck Close. All of these artists rejected the heated subjectivity implied
by ambiguous painterly brushwork and opted for a cool literalism manifest
in clearly defined forms. Because of Pop Art's affinities to the new abstrac-
tion of painters such as Stella, Held, Kelly, and Noland, claims were made
that it was as much "elitist" as it was "populist," and that dualism was the
basis of much of Pop Art's appeal in the art world.

The suddenness with which Pop Art emerged was deceptive; there had been
a buildup of some dozen years. Pop elements had already begun to appear
within Abstract Expressionism itself, starting with Willem de Kooning's
Woman 1 (1950-52), whose smile was based on a cigarette advertisement.
Second-generation Abstract Expressionists, notably Larry, Rivers and Grace
Hartigan, also had introduced popular imagery into their "action" paintings.
Other precursors were the collagists and assemblagists who had incorporat-
ed urban detritus and ordinary objects into their work: Richard Stankiewicz
in fantastic figures made from junk metal;[3] Allan Kaprow in garish collages;
Claes Oldenburg in corrugated cardboard reliefs; Jim Dine in collage-paint-
ings and reliefs incorporating tools and pieces of clothing; John Chamberlain
in crumpled automobile assemblies: Mark di Suvero in abstract construc-
tions of weathered timbers, heavy chains, rope, and the like; and H. C.
Westermann in bizarre dwellings. There were also the huge, simplified por-
traits by Alex Katz that called billboards to mind, Robert Rauschenberg with
his combine paintings, mélanges of throwaway materials and images from
the city, and Jasper Johns, whose American flags and targets served as

instantly recognizable signs.

Assemblage of this kind led to Environments, in which entire rooms were filled with urban detritus and everyday artifacts, and to Happenings, a sort of collage theater, that introduced live improvisational drama, music, and dance into Environments. As one of the innovators of Happenings commented: "Not satisfied with the suggestion through paint of our other senses, we shall utilize the specific substances of sight, sound, movements, people, odors, touch."[4] The content of these assemblages, Environments, and Happenings was generally city life in all its poverty, terror, and anxiety, as well as its spectacle.

Assemblages, Environments, and Happenings were the latest manifestation of a time-honored avant-garde practice of muscling nonart, or "low" imagery, into "high" art. They were also the continuation of a long-lived urban Realist tradition in American art, exemplified by the Ashcan School. Indeed, Assemblages, Environments, and Happenings could be thought of as Neo- Regionalist.

The avant-garde composer John Cage provided a persuasive rationale for the works of Rauschenberg, Johns, and related artists. Influenced by Marcel Duchamp and Zen Buddhism, Cage was indifferent to the artist's inner life and emotions. Instead, he looked out at the world and aspired "to open up one's eyes to just seeing what there was to see" and one's ears to what there was to hear.[5] According to Cage, the purpose of art was to make people alive to their surroundings in order to better their lives. Intent on breaking down every barrier between life and art, Cage announced that any material or sound by itself or in any combination, whether intended or not, is art.

Indicative of the change in the sixties from inward looking to outward looking is this comment by Oldenburg: "I am for an art that takes its form from the lines of life itself, that twists and extends and accumulates and spits and drips, and is heavy and coarse and blunt and sweet and stupid as life itself."[6] By introducing real materials and real images and objects into their art, the creators of Assemblages, Environments, and Happenings showed the way to Pop Art. Indeed, Rauschenberg and Johns were often counted among its ranks.

Although the Abstract Expressionists and their supporters saw Pop Art only in negative terms, as nihilistic and unworthy, there were positive reasons for its emergence. American society had changed radically during the dozen years after World War II. Two revolutions had occurred: one in newly computerized and automated production; the second, in mass communications. The upshot was a postindustrial, or consumer, economy, an affluent society defined by an abundance of commodities produced by computer technology and fueled by the newly prevalent mass media.

The revolution in communications was exemplified by a jump in the number of television sets in American households, from ten thousand in 1947 to forty million a decade later. At the touch of a button, viewers were witness to wars, assassinations, and other political happenings; to natural catastrophes; and to the intimate details of life...in an underprivileged ghetto or at a go-go party-as they happened, with remarkable vividness and immediacy. This was in addition to soap operas, sitcoms, crime series, game shows, movies, etc. Even if one wanted to, it became difficult to avoid popular culture and the ceaseless flow of commercials—all in one media package. Mass culture filtered through television, exerted novel pressures on the American consciousness.

Furthermore, because of the new affluence, unprecedented numbers of young people attended college, where they were required by many schools to take at least one course in art history, art appreciation, or a studio discipline. As a consequence, art departments flourished. So did art museums and community art centers, and in the late, 1950s, a boom market for contemporary art developed. This growing art consciousness of the American public was reflected in the demand for up-to-date and knowledgeable art reporting in the mass media. Gone were the days when *Time* would label Jackson Pollock "Jack the Dripper," as it did in 1956.[7]

In short, the time was ripe in the early sixties for the introduction of "low" commercial art into "high" culture. It is noteworthy that all the original Pop artists developed their styles independently—each responding to something in the air, as it were, Indeed, only in the sixties was it possible for artists to even imagine borrowing subjects from popular culture with the intention of

creating high art. This would have been literally unthinkable during the Depression thirties or wartime forties, when consumer goods were not affordable for, or available to, the great mass of Americans. But with the emergence of a consumer society in the fifties, artists came to believe that the evolution in mass media had so drastically and irrevocably changed ways of seeing the world, it had to be dealt with seriously in art.

It was not only Pop artists who sensed that the world had changed and that their art exemplified this change. Responding to the same social stimuli, a new generation of art professionals promoted Pop Art in reviews and articles and in major museum exhibitions at home and abroad. All of this attention led the judges at the 1964 Venice Biennale to award the prestigious International Painting Prize to Rauschenberg. Like Abstract Expressionism earlier, American Pop Art had achieved global recognition.

What did Pop Art signify about society? Some saw it as a critique of consumerism and commercialization. And one of the most notorious Pop paintings, *F-111* is a four-panel work by James Rosenquist. Named after a warplane, it comments on the interaction of the military-industrial complex and the consumer society. Still, it was an exception. Rosenquist himself, and Pop artists generally, were accepting of consumer society. As Warhol said, Pop Art was about "liking things."[8] Robert Indiana agreed: "Pop is a reenlistment in the world."[9] What was significant was how these artists appropriated their subjects without interpreting or transforming them—a radical move aesthetically, since artists traditionally had transformed their subjects. To be sure, images gained intensity in Pop Art because they were isolated and enlarged, but the "things" represented were left otherwise unchanged.

Developing independently, the Pop artists created individual styles. Warhol used a photomechanical silkscreening technique to transfer newspaper and magazine illustrations onto canvas. Among his best known images are commodities—Campbell soup cans, Coke bottles—and photos of celebrities who were, in his opinion, "products"[10]: Marilyn Monroe, Jackie Kennedy, and even dancer and choreographer Martha Graham. Warhol's works at once mirrored consumer society and became its consummate icons.

155

Roy Lichtenstein tackled big themes—love and war—but for fear of senti-mentality, he counteracted their human drama by appropriating images from comic strips. He also culled images from the history of art, particular-ly those that had been widely circulated as postcards or posters. In the *Bull Profile Series* (1973), he represented with tongue in cheek the famous picture by the Dutch de Stijl artist Theo van Doesburg that transformed the recog-nizable image of a bull into a geometric abstraction. At the same time, Lichtenstein was occupied with formal issues. For instance, his treatment of traditional subject matter such as a window view or still life in *Still Life with Book, Grapes and Apple* (1972), proves that despite the resemblance of his pictures to cartoons, the arrangement of every pictorial element was recom-posed to create a visually cogent structure—which, in the end, was his pri-mary purpose.

Rosenquist used a billboard painting technique to paint fragments of images drawn from the urban environment. Because the constituent images were often unrelated, as in *F-111*, or shattered like panes of glass, as in *Telephone Explosion* (1983), they evoked a mood of strangeness associated with Surrealism. Talking about his work as a whole, Rosenquist said: "I still think about a space that's put on me by radio commercials, television commercials, because I'm a child of that age. Things, billboard signs, everything thrust at me. [In] the numbness that occurred, I thought that something could be done."[11]

Lichtenstein, Rosenquist, and Warhol have been called "hard-core" Pop artists because they all appropriated mass-media images and rendered them in the depersonalized techniques of commercial art. However, much of Pop Art is not "cool," certainly' not that of Oldenburg and Jim Dine. Drawing on their background in Assemblage, Environments, and Happenings, they created works that depicted or incorporated common objects, but instead of representing them in a deadpan, manner, they transformed them imagina-tively. In a sense, Oldenburg and Dine are "Pop Expressionists."

Oldenburg was an innovator of "soft" sculpture composed of canvas or vinyl, stuffed with kapok and foam rubber. In these works, he introduced a novel range of sensual experiences associated with the human body and its func-

tions, a range that traditional "hard" sculpture did not express. He also enlarged his objects—a hamburger or an ice-cream cone—to gargantuan sizes, often realizing his works in public places. One can imagine *Baked Potato with Butter* as a giant outdoor monument. Oldenburg's works in all mediums are extravagant and fantastic. Oldenburg considered his work autobiographical."[12] Dine's art is more explicitly so. The common images and objects that he painted or incorporated into his artworks had personal associations. Dine imagined a bathrobe—which he said "seemed to be my body inside"—to be his self-portrait[13] Indeed, the bathrobe is his consummate self-image.

Many artists who were identified with Pop—among them Johns, Dine, Indiana; and Edward Ruscha—took their cues from advertising and introduced text into their pictures. juxtaposing words and images, they created visual and verbal poetry. Ruscha's 1982 lithograph *Cities* is a depiction of the word city repeated three times, punctuating a barren landscape like skyscrapers.

What was the legacy of Pop Art? It had no immediate second generation but went underground, emerging again only in the late 1970s. By then, as Kirk Varnedoe and Adam Gopnik wrote, popular culture had become so pervasive and powerful as to "become in every sense, the 'second nature' of modern life."[14] Many artists believed that the mass media had corrupted American society and culture and that it had to be confronted critically and, to use the fashionable word, *deconstructed*, as in the case of Barbara Kruger's photomontages). For a greater number, however, among them Richard Prince, David Salle, and Julian Schnabel, vernacular imagery became a compelling realm of fresh experience that stimulated artistic acts of discovery.

NOTES

1. Andy Warhol and Pat Hackett, *POPism*, 3.

2. *Kitsch* is from the German verb, *verkitschen*, which means "to make cheap." The current use of the word is largely derived from an essay by Clement Greenberg entitled "Avant-Garde and Kitsch" (*Partisan Review*, Fall 1939).

3. Richard Stankiewicz, quoted in Philip Pearlstein, "The Private Myth," *Art News* (September 1961): 44,61.

4. Allan Kaprow,"The Legacy of Jackson Pollock," *Art News* (October 1958): 56-57.

5. John Cage, interview with the author, New York, May 6,1966.

6. Claes Oldenburg, *Store Days*, Documents from "The Store" (1961) and "Ray Gun Theater" (1962). Selected by Claes Oldenburg and Emmett Williams (New York: Something Else Press, 1967), 39.

7. "The Wild Ones," *Time* (February 20,1956), 129.

8. Andy Warhol, quoted by G. R. Swenson,What Is Pop Art?" part 1, *Art News* (November 1963), 27.

9. Robert Indiana, quoted by G. R. Swenson, op. Cit.

10. "Products," *Newsweek* (November 12, 1962), 94.

11. Jeanne Siegel,"An Interview with James Rosenquist," *Artforum* (June 1972), 32.

12. Claes Oldenburg, quoted in "New Talent USA: Sculpture (Chosen by Robert Scull)," *Art in America* 1 (1962), 33.

13. Jim Dine, quoted in *Art in Process* (New York: Finch College Museum of Art/Contemporary Study Wing, 1965), n.p.

14. Kirk Varnedoe and Adam Gopnik, *High and Low*, 402, 40 7.

159

GRAPPLING WITH THE CHANGES IN AMERICAN ART
FROM 1958 TO 1962, THAT IS, THE TURN FROM
ABSTRACT EXPRESSIONISM TO POP ART AND
MINIMALISM, IT OCCURRED TO ME THAT THE NEW
STYLES WERE ALL RELATED, IN THAT, THEY SHARED
AN URGE FOR LITERALISM OR SPECIFICITY. IT WAS
THLS FACTUAL QUALITY THAT CHARACTERIZED THE
ART AND MADE IT PECULIARLY OF THE 1960s. IN
1964, IN A SERIES OF ARTICLES IN THE NEW YORK
POST I PROPOSED TO SUBSUME POP ART AND
MINIMALISM UNDER THE LABEL COOL-ART, THE FIRST
ATTEMPT TO CHARACTERIZE THE NEW SENSIBILITY.
IN THE FOLLOWING YEAR, I EXPANDED THESE IDEAS
IN AN ARTICLE IN ART IN AMERICA. HOWEVER, MUCH
AS I HAD BEGUN TO RECOGNIZE THE SIGNIFICANCE
OF COOL-ART, I STILL CONTINUED TO PREFER
ABSTRACT EXPRESSIONISM. BUT I HAD MADE A START
AND WOULD SOON FULLY APPRECIATE WARHOL,
LICHTENSTEIN, STELLA, JUDD, AND OTHER POP AND
MINIMAL ARTISTS.

The New Cool-Art

During the last five or six years, a growing number of young artists have rejected the premises of abstract expressionism. The most extreme are Frank Stella, Andy Warhol, Roy Lichtenstein, Larry Poons and Don Judd, became the group they are a part of is the most vociferous and perhaps the most populous in the. New York art world today, I have tome to believe that its point of view may turn but to mark the 1960s as abstract expressionism did the 1940s and 1950s.

The basic outlook of these artists is best summed up in statements by Stella and Warhol. In 1960, Stella remarked that it was enough for him to have a good idea he would be just as happy if someone else or a machine made his pictures according to his specifications. His idea was to paint stripes of pigment arranged in all-over, square-within-square designs, which allude to nothing outside of themselves. Three years later, Warhol, who copies mass-produced commodities said: "I think somebody should be able to do all my paintings for me. The reason I'm painting this way is that I want to be a machine, and I feel that whatever I do and do machine-like is what I want to do." The upshot of this approach has been an art so dead-pan, so devoid of signs of emotion, that I have called it cool-art.

The belief that art ought to be mechanistic is poles apart from the ardent romanticism of Rothko, Newman and Still who searched for pictorial equivalents of their visions of the sublime, and such action painters as Pollock, de Kooning and Guston who tried to discover color forms which might stand for intense feelings.

To grasp the felt intricacy of their experience, the action painters remain open to every possibility in art. Conversely the cool-artists limit themselves to single, pre-determined ideas, which are repeated with little variation. In so doing, they have changed the anxious "I don't know" of the action painters to a calculated "I know." (The cool-artists' reduction of artistic means is unrelated to that of Rothko and Newman who do not restrict their palettes but simplify composition to maximize the impact of color.)

To the action painters, the spontaneous act of painting is crucial, for only through it can they arrive at their subjective ages. To the coot-artists, process is unimportant, for they think up ideas which require either little or no creative transformation.

The difference is obvious when one compares de Kooning's fervid, energy-packed gestures, as personal as handwriting, with Stella's static, enervated stripes which are wholly lacking in tension variety and climax. And Warhol, who uses a mechanical silk-screen technique to print his images, has also reduced the passionate action in action painting to an anonymous and apathetic activity. The best of the action painters have tried to avoid painting which is, on the one hand, "cookery"—the facile manipulation of materials for decorative purposes—and on the other hand, "recipe"—the rote execution of an idea. The cool-artists cannot be accused of "cookery", but they are certainly "recipe" artists.

The Forerunners of The New Cool Art

The painters most influential in the development of the cool point of view have been Ad Reinhardt and Jasper Johns. Johns' choice of pre-existing subjects—American flags, targets, letters, numbers—anticipated those of

Warhol and Lichtenstein, but of greater consequence, was his gloss of action painting. That is, he filled in his designs of commonplace images with free painting which, resembles de Kooning's and Guston's. However, in their urgency to give form to their deepest passion and thoughts, these artists discarded the cubist ideal of picture-making. In contrast, Johns has elevated the dispassionate exercise of picture-making to a major end in art. His brushwork is not as impulsive as it seems; rather, he "crafts" the took of action painting while denying its romantic content.

Johns' attitude toward subject-matter serves to underline his concern with the well-painted picture. He makes a picture of a flag as if he were making the object itself—much as a skilled worker would and with the same kind of self-detachment. (His painting conveys no sentiments about Old Glory.) The two kinds of making go hand in hand and reinforce each other.

Although he is often linked with the abstract expressionists, Reinhardt has been their long-standing enemy. Reinhardt is a purist who believes that art ought to be isolated from life—de-personalized. He also thinks that art which represents anything but itself is immoral; no extra esthetic meanings are permissible. In his *Black Paintings*, he has systematically eliminated everything but what he feels to be the art-ness of art.

Stella, who of the cool-artists is closest to Reinhardt, shares his distaste for abstract expressionism. This aversion may have motivated both to base their canvases on elementary preconceived ideas, as if thinking along the lines of Jacques Barzun's remark: A romanticist position is breached at once by anyone who wants to tidy up the world by enforcing a few simple rules."

However, while adopting Reinhardt's negative approach, Stella has reacted against his purism. Where Reinhardt uses negation to create a positive, ideal art, Stella seems to value it as an end in itself. To make his color colorless, Reinhardt keys down the blues, yellows, browns and purples that he begins with until they become almost indistinguishable. Still, as one peers, subtle tonal variations emerge. To make his lines, divisions, he dissolves them in a grey atmosphere. But this dark luminous aura is hypnotic and invites contemplation. In contrast, Stella's color, until recently, was uniform; his painting

and drawing are blunt and ordinary, and his light is an impassive surface shine.

In renouncing abstract expressionism, Reinhardt embraced a classicist position (even though his extremeness can be considered romantic), if by classicism we mean an art whose "values are rooted in the universe, rather than dependent upon (man's) fallible and changing judgment, to quote Barzun. Stella cannot be so categorized. Where Reinhardt has simplified his painting to express a vision of an absolute, perfect art, Stella has reduced his, because he has reduced his aspiration—almost to zero.

An art as negative as Stella's cannot but convey utter futility and boredom. Abstract expressionistic painting also possesses a sense of existential absurdity, but at the same time—and it is here that Stella diverges—it affirms that meaningful action, self-realization and transcendence are possible.

In its boredom, Stella's painting has affinities to Reinhardt's but where the latter cultivates monotony to underscore the connection between art and real life, Stella appears to have made it the content of his art—a content so novel and perverse as to be interesting. He emphasized this content in the pictures in his show last year by painting all the stripes the same metallic purple. It is true that his color—nasty, close-up, but oddly bland at a distance—is unusual, as are the octagon, diamond and parallelogram pictures, each of which has a hole the same shape as the canvas cut in the middle. Artists traditionally have located the main events of their paintings in the centers; in these pivotal spots, Stella places holes—nothingness. Furthermore, artists have generally wanted their works to transcend the materiality of their mediums. Stella's holes accent the object quality of his canvases; they become dumb things. And there is anything but purple passion in his purple; it is bleak when compared to the royal purple it ironically calls to mind.

The Emergence of Optical-Art

Stella's latest canvases, composed of stripes of dissonant colors that oscillate in swift, perpetual motion, approach optical-art, a variant of cool-art. The most provocative of the painters working in this manner is Larry Poons (who

was presented in Art in America's New Talent issue last year.) Poons paints small circles of one or two colors, set off against a ground stained with a contrasting hue, that bombard the retina until it hurts. Although it is difficult to stop blinking when looking at hese pictures, one soon becomes aware that the discs are arranged in patterns that seem haphazard but are preconceived and schematic—like John Cage's musical compositions.

Many of the cool-artists as well as Johns and Rauschenberg are indebted to the ideas of Cage, who more than any other composer has treated music as a visual experience and has even exhibited his scores in art galleries. Among other things Cage has experimented with mechanical music and the relation of music to noise and silence (non-music). He has also lectured and written extensively about emptiness and monotony as values in art, even though, unlike the cool-artists, his orientation is to Zen. He once wrote: "In Zen, they say: "If something is boring after two minutes, try it for four. If still boring, try it for eight, sixteen, thirty-two and so on. Eventually one discovers that it's not boring at all but very interesting."

Larry Poons essays in optics were anticipated by Vasarely, who initiated this trend in Europe during the early '50's, but they are based on color rather than design. Therefore, they owe more to the Newman and Rothko color fields than they do to the pre-World War II geometric abstraction whose tradition Vasarely continues. In this, they are also linked to Albers' experiments with the interaction of colors and optical illusion; Morris Louis' visually aggressive last works and of Ellsworth Kelly's adjustment of simple color shapes so that all are equally positive, an idea taken from Matisse's late collages.

Akin to the optical-artists are a growing number of kinetic artists who either assault the eye with movements of such velocity as to prevent thinking or feeling, or who are intrigued with motion in art as a meaningless activity. (These artists differ from George Rickey, Len Lye and others who charge their mobile sculptures with emotion.) Several kinetic-artists, among them Walcer de Maria, invite spectator participation. On one of his wood contraptions, de Maria printed: "If you come upon the box and the block is in, pull it out. If you come upon the box and the block is out, push it in."

The push and pull manipulation here is senseless; the hand moves but not the heart.

Pop-Art; Cool and Hot

The most notorious of the cool-artists are the pop-artists, notably Andy Warhol and Roy Lichtenstein who are the most way-out. Both reproduce commercial illustrations, employing such mechanical devices as stencils and silk screens. Warhol depicts food packages and Lichtenstein, comic-strips,, as they are—dead-pan, without much change except in scale and medium. In their literalness, these artists are unlike Claes Oldenberg, who infuses ordinary objects with new meanings, and such "esthetic" pop-artists as James Rosenquist and Tom Wesselmann who, taking their cues from Robert Rauschenberg, use advertising motifs as design elements in quasi-cubist compositions.

Warhol and Lichtenstein also differ sharply from Rauschenberg, Larry Rivers and other "new realist" abstract expressionists, who, nevertheless, have influenced them. Rauschenberg's introduction of newsprint and billboard fragments in his "combines" is a highly individual extension of de Kooning's painting method. His nostalgia for found objects of urban origins and their "painterly" juxtaposition is unrelated to the impersonality of pop-art themes and execution.

Another forerunner of pop-art is Alex Katz whose flat statues and pictures of artist friends take off from display cut-outs and billboards. However, Katz does not simply duplicate road-signs, but uses their vulgarity and impassiveness as foils for his sophisticated artistry and for the feeling of intimacy imparted by his portraits.

Pop-art has been treated by some critics as an up-to-date version of American scene-painting—an innocent naturalism that twangs America' heartstrings. It is also implied that it has fused high art and the mass media into an integrated American culture—a kind of cross media into an integrated American culture—a kind of cross between Matisse and Milt Caniff. Other critics

166

consider it a social protest or dada-minded satire on the shodiness of popular culture, and still others, a glorification of our affluent society in which supermarket goodies become icons, worshipped, I suppose, by a breed of consumer whose culture hero is the junior executive.

However, these explanations miss the deeper content of Warhol's and Lichtenstein's work; the sense of absolute frustration and despair that it conveys. More than any earlier artists, they focus on subject-matter, not on execution, which is mechanistic, or on the artist's interpretation, which is minimal. But the subjects to which they force attention so intensely are totally banal and interchangeable. Furhermore, as copyists, they signify that they cannot realize any but the most elementary, initiative ends in art—that it is impossible for them to communicate anything of import. And in the tedious repetition of their images they intensify the feeling of boredom and indifference. In this, they contrast with the abstract expressionists who, when they repeated motifs, did so in order to zero in on a zone of compulsion.

The pessimistic outlook of both of these artists resembles that of such French "objectivist" writers as Robbe-Grillet, although the one art form was probably not directly influenced by the other. Convinced that all emotional and intellectual comments that novelists might make about human experience have been exhaused, Robbe-Grillet described only the surface of the world around him, impervious to any system of meaning. He once wrote: "Around us, defying the mob of our animistic or protective adjectives, things are there. Their surfaces are clear and smooth, intact, neither dubiously glitering nor transparent. All our literature has not yet succeeded in penetrating their smallest corner, in sofening their slightest curve." There is no room for the spirit of man or for the exercise of his imagination in this world of resistant things. And when the image of man does appear, it is as an impersonal thing—the offspring of ads and comic-strips.

Price of Subtlety

Warhol's and Lichtenstein's reproductions of commercial art are so close to

the originals that they have been accused of plagiarism, of not transforming their subjects in any appreciable way. In every act of duplication, there are, of course, changes—clearer in Lichenstein's case than in Warhol's—but they are not pronounced enough to open up fresh ways of experiencing the imagery or formal relations. But non-transformation, it seems to me is precisely the point. It enables Warhol, for the first time in the history of art, to produce an utterly impassive representational art.

If seen in a supermarket display window, Warhol's sculptures of Brillo boxes would be unnoticeable. But exhibited as art in a gallery, they shock, for by presenting objects that resemble non-art as art, Warhol calls into question traditional definitions of art. In this, he takes after Duchamp and Johns.

A half-century ago, Duchamp placed a urinal on a pedestal and proclaimed it a sculpture. In so doing, he posed the problem, still to be resolved, of whether it was art. A few years ago, Johns cast two beer cans into bronze (the material of art) and painted labels on the metal (the technique of art) so adeptly that the painted sculptures looked like the real things. By lavishing craft in the re-creation of mass-produced products, he complicated the issues raised a generation ago by Duchamp.

Warhol's Brillo boxes, which are silk-screened wood constructions, could also pass for the real cartons. But their effect is different from that of his two predecessors. Duchamp's dada gestures aimed to subvert every conventional esthetic and social value; his "ready-mades" were anti-art. Conversely, Johns' work possess the patina of high art; his masterly hand is felt in all of them. However, Warhol's fabrications do not in the 1960's act to decry the absurdity of established institutions. Instead, they express an existential point of view; a sense of the utter futility of being creative at all. Therefore, unlike Johns' objects, artistry is unimportant; the distinction between art and non-art is of no account.

Warhol made his indifference clear in an interview with G. R. Swenson. Asked whether his commercial art was more machine-line (and so, more to his liking) than his "fine" art, he replied: "No, it wasn't. I was getting paid for it and did anything they told me to do. If they told me to draw a shoe,

I'd do it, and if they told me to correct it, I would . . . I'd have to invent and now I don't; after all that 'correction' those commercial drawings would have feelings, they would have a style."

In adopting non-transformation as an artistic strategy, Warhol and Lichtenstein have come up with a novel solution to a problem which has occupied artists for more than a century; how to stress the reality of subject-matter and of the work of art at the same time, Their answer: make them as indistinguishable as possible. In the case of painting to get around translating three-dimensional figures, into two-dimensional images, choose motifs, e.g., commercial illustrations, which are flat, non-illusionistic, and the same shape as the canvas.

Such solutions do not seem inadvertent. In their deliberate avoidance of extra-esthetic references, many cool-artists have been reduced to making comments about art and nothing more—somewhat like estheticians. They have isolated the formal problems, that, among other matters such as the quality of feeling, have faced modern artists, and have solved them in esthetic terms only. Some are concerned simply with painting a non-abstract expressionist picture or with painting a picture that is purely optical. Others make sculptures that are solely objects--the "logical" culmination of the idea that a work of art is a thing-in-itself as against the representation of a thing. This last seems to be the intent of Don Judd, whose abstract constructions are sculptural counter parts of Stella canvases.

Pop-art and Recent Abstraction

The unconventionality of its subject matter and technique has made pop-art the most talked about phenomenon in current art. But as significant as its novel way of "returning to the figure" has been its relation to the most recent tendency in abstract art—the painting of Al Held, Raymond Parker, Kelly, Louis, Kenneth Noland, Jules Olitski, Paul Brach, Friedl Dzubas and other "abstract imagists," as H.H. Arnason has called them. It is the direction, I feel, which has been most fruitful in the last half dozen years and which has attracted the best painters who have matured during that time.

Like Newman and Rothko who influenced them, the younger abstract imagists have simplified their pictorial means to explore the expressive possibilities of pure color. The pop artists have not been especially interested in this, but they have borrowed from the abstract artists such devices as setting off a large, clearly defined, single image against a field of while canvas. Hence, Lichtenstein's blown-up comic-strips are closer to Noland's or Kelly's abstract images than to any other figure paintings. The reference to abstraction imagism in Warhol's and Lichtenstein's realist illustrations give them a hip look that no other representational art today possesses.

There are other affinities as well, for the cool approach has affected much of the new abstraction, so pervasive has it become. Like the cool-artists, the abstract imagists have reacted against the complex and ambiguous free gestures that characterized action painting. Instead of exposing the ragged marks of their process, they cover their tracks. For example, Kelly and Brach paint their forms mat so that all traces of the hand are obliterated. Louis, Noland and Olitski suppress gestures by scaining pigment into unsized canvas. With the exception of Al Held's works, abstract imagist pictures have a self-possessed, passive quality that differs from the uncertainty, at once anxious and robust, and the raw energy that mark the best of actions painting.

But where the cool-artists are negative, the abstract imagists are positive, in that, like Newman and Rothko, they are preoccupied with the emotional vibrations that color alone can generate. To this end, they have discarded pictorial elements which they consider alien to color—complicated drawing, brushwork, and textures—in order to enjoy it "mysteriously," as Gauguin put it, as "sensations proceeding from its own nature." They agree with Matisse that colors have "the inherent power of affecting the feelings of those who look at them."

However, compared with the visionary paintings of Rothko and Newman, those of Kelly and Brach are willfully deadpan, and those of Louis, Noland and Olitski are suavely hedonistic. Of all the abstract imagists, Kelly and Brach are closest to cool-art. Although he uses Arp-like anatomical images as points of departure, Kelly generalized them until they are impersonal. Furthermore, the black, white and primary colors that he uses repeatedly are

as bland as the hard-edged and uninflected surfaces that he favors. Yet, this blandness is inadvertently enigmatic. Each of Kelly's abstractions engages one like a person who is wholly wrapped up in himself, but who one senses is intriguing. Brach, on the other hand is a symbolist, even through he empties his geometric forms of all meaning. The symmetrical blue-grey circles that he paints are so close in color to their grounds as to appear invisible.

Postscript

The reasons for the emergence of cool-art are, of course, difficult to determine. Some critics have tied it to broader social tendencies. They have claimed that it reflects the spirit of our times. This kind of speculation can be stimulating, but up to now, it has resulted only in empty generalizations, for example, the claim that cool-art is the product of a nihilist generation that cannot feel about The Bomb.

More credible is the idea that abstract expressionism, after more than a decade of hegemony, offers younger artists too few possibilities for development. Therefore, many have embraced a different method--the execution of simple, pre-determined ideas—and other values—calculation impersonality, impassiveness and boredom.

At the beginning of the 1960s, I became interested in a new tendency in a New York art that was being developed by Al Held, Ronald Bladen, and George Sugarman. They seemed to be retaining the attitude of Abstract Expressionism, while "cooling" its heated appearance by employing clearly defined shapes of clear color. In the process they created a new classism. I dubbed these artists the Concrete Abstractionists, awkward though that label was. I also contrasted the attitude of these artists to the Cool Artists, on the one hand, and in the case of Held, to Stained Color-field Abstraction, detailing the similarities and differences.

172

Concrete Expressionism

Lionel Abel once said that the only valid criterion of the vitality of ideas is their power to inspire artists to creation. By this standard, Abstract Expressionism in all of its variety remains the most alive force in art today, for many of the artists who initiated it in the 1940s and who developed it in the following decade are painting their strongest pictures. And its content has been embodied in a new form by a number of vigorous artists who emerged in the last half-dozen years. Five of them—painters, Al Held and Knox Martin, and sculptors, Ronald Bladen, George Sugarman and David Weinrib—are presented at the Loeb Student Center of New York University. Although their abstractions have been individually acclaimed, the qualities they share have been ignored.

The five artists have been grouped together for the first time because they are closer in attitude to each other than to any other tendency. For example, Held and, to a lesser degree, Martin have often been linked to Kelly, Louis, Noland, Olitski and others variously named the Abstract Imagist, Hard-Edge or Color-Field painters. These artists paint simple, more or less clearly articulated areas of high-keyed color. But this comparison is superficial, for the impacted, incrusted images of Held and Martin possess an assertive

physicality and a sense of energy, lacking in the others, but akin to the Action Paintings of Pollock, de Kooning and Kline.

Like the Action Painters in whose ambience they matured, Held and Martin have adopted a direct unpremeditated approach. The improvisational act of painting is crucial, for it enables them to remain open to new and unforeseen possibilities. But more important, it is suited to their temperaments, for they are the kind of artists who are suspicious of things that come easy-- in one-shot. They have to grope for a form, to worry and sweat it through, in order to be sure that it evolved from what Kandinsky called "inner necessity." And an agonized form tends to be cumbersome and "unfinished," lacking in gracefulness and elegance. Like Action Painting, Held's and Martin's abstraction "judges itself morally in declaring that picture to be wrothless which is not the incorporation of a genuine struggle, one which could at any point have been lost." to quote Harold Rosenberg. And the anxiety generated--the energy expended--in this struggle inheres in their images.

But Held and Martin have also reacted against Action Painting, against the restless ambiguity, intricacy and the look of spontaneity conveyed by its open, gestural forms. Rather, they seem motivated by a classicizing inclination—a will to clarity—which predisposes them to quasi-geometric structures, composed of exact planes of unmodulated color. Yet much as each covers the tracks of his emotive process, the heavily pigmented surfaces are laden with the traces of a torturous error and trial method. Of course, structural lucidity was not lacking in the best Action Paintings, but it tended to be implicit. By making it explicit, the two artists, as if illustrating the "grandfather principle" in art history, appear to look back to Léger, Davis and the Cubist oriented, geometric abstraction of the 1930s—that which Van Doesburg labeled art concrete. Therefore, I have called them and the three sculptors with whom they are associated, the Concrete Expressionists.

It may seem incongruous to couple the terms "concrete" and "expressionist," for historically, they are antagonistic. The one is commonly connected to Non-Objective styles whose end was calculated "pure" relationships; the other is descriptive of an impulsive, romantic art, whose content was the

artist's own creative experience. (In this context, "concrete" is a key word in the vocabulary of the romantic realists who were occupied with particulars, i.e., concrete events.) But the most significant moves in art generally involve new and ambitious syntheses of older, contradictory traditions.

The works of the Concrete Expressionists differ from past geometric abstraction in that they are not relational, not unified by the rhythmic repetition of pictorial or sculptural elements. That is, the forms are *disassociated*; each is shaped to exist in its own isolated, self-contained space. The unmodulated hues also serve to accent the separateness of the forms. In a sense, this idea was anticipated by the Surrealists who juxtaposed disparate images and materials to create psychic shock. But the Concrete Expressionists are not interested in Surrealist psychologizing; instead, they use disassociation as a formal principle. Therefore, they are adventuring in an unknown space, experimenting with a new way of seeing, which because it is unfamiliar, does shock. And because they are engaged in a radical expansion of perception and of the language of art, they can be considered avant-garde in the best sense of that old-fashioned word.

Painted images that are disjoined take on the aspect of objects. Held and Martin emphasize this thing-like property by packing their forms so that all of them appear to thrust out at the viewer hence, their aggressiveness and immediacy. To intensify the visual impact of their canvases, both artists generally work on a large scale. The implied motion forward of bulky planes—it might be called "inverse illusionism"—resists the tendency of a picture to become a static, two dimensional design, and so, decorative. It calls to mind Hans Hofmann's dialectic: "The highest three-dimensionality is two-dimensionality." But where that master insists on the suggestion of depth, Held and Martin require the sensation of projection. In part, the thing-like quality of their forms relates the two painters to the three sculptors. In the case of Bladen who began as a painter, his desire to protrude his surfaces into the room led him from painting slabs of pigment to assembling wood reliefs to constructing sculpture in the round.

Held's elemental forms are sparser, more muscular and disjunctive than Martin's. No painter of his generation has executed pictures that are starker,

175

more forceful and epic. He shapes generalized images—squares, circles, tri-angles, fragments of letters in common colors—and makes them distinctive, uniquely his own. These mural-sized, frontal configurations are laborious monuments to their maker—like the pyramids, but instead of using plans, Held relies on his nerve ends. Therefore, the paintings impart a disturbing feeling of uneasiness, despite their seeming confidence and unequivocality.

Although Martin has squeezed out the enigmatic atmosphere that permeat-ed his earlier Expressionist works,his recent canvases retain a sense of poetic fantasy, despite their clear form, clear color. His painting is more sensuous than Held's; his palette, more lyrical—pinks, yellows and reds predomi-nate—and his tilting shapes, which sweep in off the canvas edges like de Kooning's and Kline's, are less weighty and more motile. The forms suggest recognizable images; a circle might be an eye, a flower, a breast or foliage. In the latest works, pop-eyed birds—the issue of some strange obsession—stare out at the viewer. Martin's use of disassociation is enhanced by the juxtapo-sition of figurative and abstract motifs. Indeed, much of the drama of his painting arises from the attempt to express a private fantasy in a mode of art closely identified with classicism.

Bladen, Sugarman and Weinrib are akin to Held and Martin in that they use an improvisational approach to disjoin precise shapes and to charge them with energy. Each form is colored a different, vivid hue to help individuate it and to add to its emotional impact. Several of their ideas were anticipated by Calder's stabiles and Smith's metal pieces. However, unlike most con-struction sculptors today who "draw in space" with linear and planar ele-ments, organizing them around a central core, the Concrete Expressionists build solid volumes and unfold them in sequence. Sugarman considers this "extended space" "non-Cubist," for it is more open-ended than that of Gonzales and his followers. But the open-ended structure contrasts with the massiveness of its components. The three sculptors rarely use found objects, because these materials call attention to their original state; this detracts from their function as unique forms shaped by the artist.

Sugarman is more audacious than Bladen and Weinrib in the way he disas-sociates forms. The segments of his wood constructions, disparate in shape

and Liquitex color, engage in a visual dialogue, and in this sense are connected, but they do not cohere in any conventional manner. This sculptural idea demands a multiplicity of forms, and Sugarman possesses the fertile imagination to create them. He laminates pieces of wood, a technique that enables him to build weighty volumes and to cantilever them boldly into space. His work is not as tormented as Held's, but is marked by exuberance and gusto.

Weinrib suspends curved shapes, none of which is repeated, from a rectangular plane, bolted to the wall or ceiling—somewhat like a relief. The anchor plane becomes the side of a cube of air, an imaginary enclosure—energized by the gravity-defying, wrenched elements. They tend to be more linear and active than Sugarman's—more airy and lighthearted. In the past, Weinrib used a greater variety of materials than the other two sculptors, but lately, he has tended to limit himself to plastic. He turned to this medium to avoid the "crumpled" look of his earlier metal pieces which evoked an indefiniteness he no longer wants. Plastic is Weinrib's ideal material for another reason: it best suits his playful temperament. It is tractible, allowing him to invent freely extravagant, sinuous volumes—the progeny of Arp and Miro. It is also brightly colored and semi-transparent; the play of dissimilar colors and bouncing lights adds to the ebullient imagery.

Bladen is occupied with the idea of sculpture as a kind of abstract architecture. He works on a large scale and prefers geometric to organic shapes. In this, he is closer to Held than to Sugarman, Weinrib or Martin. To emphasize his constructionist esthetic, Bladen has reduced his formal vocabulary to simple block-like masses-put together from sheets of plywood joined by steel rods. Although the monumental forms that Bladen projects into space are separate entities, one is always aware that they support each other. In fact, he begins a piece with an idea, e.g., how to suspend an off-balanced element, and he improvises to achieve it. The structural function yields the unifying principle. Bladen sprays each form a different enamel or lacquer hue to define it in space, but the shiny surfaces—they are mirror-like—also work against the mass. The polished skin conceals the wood grain and becomes a paint-job finish. The mechanistic quality is accented by the hot-rod cast of Bladen's colors, which at the same time, are fantastic.

Despite the affinities the Concrete Expressionists feel for each other's work, they have issued no manifesto nor organized a movement. Indeed, as has been mentioned, they have never been exhibited before as a group. Each is intent only on developing his own artistic personality; therefore, they tend to minimize what they hold in common. (In this, they resemble the older Abstract Expressionists.) Such independence is laudable, but it has had one unfortunate, though minor, consequence. It has caused their shared ideas to be eclipsed by those of more organized and vociferous groups of artists, critics and curators, notably such color field painters as Louis, Noland and Olitski, championed by Clement Greenberg.

FIGURATIVE GESTURE PAINTING OF THE FIFTIES HAD FLUCTU-
ATED BETWEEN IMAGE AND PROCESS, THAT IS, BETWEEN REP-
RESENTING A SUBJECT, AS IN LARRY RIVER'S PORTRAITS, OR
EMPHASIZING THE EXPRESSIVENESS OF BRUSHWORK FOR ITS OWN
SAKE, AS IT DAVID PARK'S PAINTINGS. ALEX KATZ, PHILIP
PEARLSTEIN, AND OTHER PAINTERS WHO WOULD BE LABELED THE
NEW PERCEPTUAL REALISTS, CARRIED REPRESENTATION TO AN
EXTREME BY DEPICTING HUMAN SUBJECTS AS THEY APPEAR,
THAT IS, BY RENDERING THEM MORE LITERAL OR FACTUAL THAN
EVER BEFORE IN PAINTING. THE NEW PERCEPTUAL REALISTS
SPURNED PHOTO-BASED REPRESENTATION BECAUSE IT VIEWED
REALITY THROUGH THE LENS OF A CAMERA INSTEAD OF THE
EYE. AS THEY SAW IT, THE CAMERA WAS A CRUDE AND IMPER-
FECT MACHINE THAT DISTORTED VISUAL REALITY, WHEREAS THE
EYE WAS AN ORGAN OF SUCH EXTRAORDINARY COMPLEXITY AND
SOPHISTICATION AS TO MAKE IT INFINITELY SUPERIOR TO THE
CAMERA AS A TOOL OF PERCEPTION. BECAUSE THE EYE IS A
SCANNING ORGANISM, PERPETUALLY ADDING INFORMATION, THE
FIGURES OF THE NEW PERCEPTUAL REALISTS LOOK ANIMATE,
UNLIKE THE FROZEN IMAGES RECORDED BY A CAMERA. THIS
ESSAY SURVEYS THE COURSE OF AMERICAN FIGURATIVE ART
FROM THE 1930S THROUGH THE 1980S.

The Decline and Rise of American Realism

Alex Katz, A Retrospective

H istorians and critics have few (if any) convincing answers to the
question of what constitutes aesthetic quality. A related problem,
and one almost as difficult to treat is why and how works. of art
command recognition. We do know that it has been usual for a successful
modern artist to be recognized initially by a peer group (generally very small)
that shares his or her sensibility by growing segments of the art world, then
and later by a larger public. Perhaps most important in this process is a suc-
cession of loose consensuses by certain key artists and art professionals—art
editors, critics and historians, museum directors, curators and trustees, and
dealers and collectors.

Katz first earned the esteem of artists and art professionals with his show at
the Tanager Gallery in 1959, and he achieved a widening reputation with
each subsequent show. His success depended on the growing originality and
quality of his work, but it was also influenced, by the fortunes of figurative
art in America from the 1930s on—and this historic context will be consid-
ered first. In the Great Depression, the prevailing painting styles were figu-
rative, either left-leaning Social Protest or right-leaning Regionalism. It was
natural in a time of economic crisis for artists motivated by social ideologies

to take and hold the center of interest. Their dogmatic attitudes, moreover, led them to attack, often viciously, all modernist tendencies as either bourgeois decadence and ivory-tower escapism or as un-American. Social Protest and Regionalist styles, however, were progressively challenged in the 1930s by a small avant-garde composed mainly of Cubist-inspired geometric artists and were deposed in the 1940s by the Abstract Expressionist vanguard that followed next. Art in the service of proletarian or nationalistic causes was discredited for lacking formal values and for being academic and banal. No matter how noble its aims, none of it stood up against the best—or even second best modernist art. Most damning of all, propagandistic illustration did not look or feel true either to life or to art.

Unfortunately, with the downfall of politically conscious styles, all realist art went into an eclipse, at least in the eyes of the audience that favored advanced art. More than that, it was widely assumed, that the creation of major new figurative styles, neither retrogressive nor provincial, was highly unlikely, if not impossible, This belief was more implicit than explicit, since the Abstract Expressionists whose art and/or ideas commanded most attention in the 1950s—Pollock, de Kooning, Kline, and Hofmann—were painting pictures with recognizable imagery as well as abstractions. In fact, they themselves strongly denied. that one was superior to the other. But the reputations of even these masters were based primarily on their abstract work.

In truth, abstract artists of the forties and fifties, unless they were obviously retardataire, derivative, or decorative, never had to worry about being minor, but purely figurative artists did. This certainly was the case as late as the 1961-62 season in New York. In that year, Sidney Tillim, in "The Present Outlook on Figurative Art," hailed a new realism; the Museum of Modem Art mounted a major survey, *Recent Painting USA: The Figure*, meant to convey the range and quality of realism in the best light, with a catalogue introduction by Alfred H. Barr, Jr.; and, almost as consequential, the Kornblee Gallery organized a show, *Figures*, with a catalogue introduction by Jack Kroll.

All three writers implied that figuration was inferior to abstraction. Even Tillim remarked that it "has far too many flaws to be considered a serious

contender for the throne it is far from certain abstract art has surrendered."[1] Barr remarked that the figurative pictures selected by him "were painted in a period (a glorious period in American art) when the painted surface often functioned in virtual and even dogmatic independence of any representational image."[2] And Kroll, much as he predicted that "the best and most interesting of them [figurative artists] are moving toward the next a authentic and historically secure image of man, [abstraction] is still the seminal and resolving image of contemporary art.[3]

Certainly, the figurative artists in the New York School who received the most attention in the fifties worked in an essentially abstract, gestural vein. The more representational or perceptual a picture, the more clearly delineated and rendered, the less chance it had for serious consideration. And yet, in the early sixties, young painters and sympathetic critics became uneasy about the role of recognizable subject matter in an art whose manner of painting was essentially abstract. They questioned whether the human figure ought to be used merely as a spatial counter. Did not responsibility have to be taken for the human subject—by dealing with it in its own terms? They concluded that if figurative art was to be renewed and to yield major new styles, it would have to become more literal and less getural.

At the time, Gesture Painting, both abstract and figurative, was in crisis, and it offered decreasing resistance to the new realism. But challenges came from other emerging tendencies: Pop Art and Hard-edge, Stained Color-field, and Minimal Abstraction. Pop Art achieved instant notoriety as the avant-garde realism because, shockingly, it took its subjects from beyond the boundaries of what was commonly thought to be high art, namely commercial art, advertising, and comic strips. At its most extreme, Pop Art copied, or appeared to copy, preexisting images using mechanical means. The New Perceptual Realists met the challenge of Pop Art by appealing to the historic tradition of realist painting, a tradition that they revealed was open to fresh developments.

The New Perceptual Realists also had to meet the challenge of new abstract styles, notably Stained Color-field painting. Stained Color-field painting had been justified by formalist theories of Clement Greenberg. He insisted

that modernist painting had to purge itself of all that was not inherent in the medium. As a two-dimensional surface, a picture had no room for figurative subjects and illusionistic space, which were inherently three-dimensional, and hence bored into the surface and/or appealed to the sense of touch, that is, the tactile as opposed to the purely optical. As early as 1954, moreover, Greenberg had declared that figuration could yield only minor art.[4] The future of painting was with Post-painterly Abstraction, as he labeled it. Greenberg's opinions grew in influence with the publication in 1961 of his book of essays, *Art and Culture*, and dominated art discourse throughout the decade. The formalist rhetoric of the new painting was reinforced by that of Minimal sculpture, which was heavily influenced by Greenberg. The new move in art, it seemed, would be in sculpture, not painting. Such was the aesthetic temper of the times that Donald Judd, a leading Minimal sculptor (and critic), not only refused to accept any figuration in art, but even condemned the usage of two lines as looking too much like anatomy, too "anthropomorphic", as he put it.

The New Perceptual Realists countered the assaults of formalists and Minimalists by formulating a contemporary and rigorous conceptual framework for literal representation, a rationale that in time helped establish realism as a serious alternative to abstract art. The realists confronted head-on the whole line of thinking that had begun with Maurice Denis, who said in 1890 that before a painting is viewed as a battle horse or nude woman or some anecdote, it is essentially a flat surface covered with colors in a certain order, Denis's approach was carried to a reductionist extreme by. formalist and Minimalist aestheticians. Indeed, the New Perceptual Realists reversed this position by insisting on the primacy of the observed subject.

The urge for specificity led realists to suppress pictorial elements that obscured details, such as brushy handling. It soon became clear that subtle differences existed between the facture of such realists as Katz and Fairfield Porter, the two having previously been linked by critics on the outer edge of Gesture Painting. In 1961, Tillim drew a line between the old and the now, that is, between a Porter who favored loose brushwork, and a Katz, who was attempting a more imaginative revisionism based, as I have noted, on accurate rendering and "the big picture," the last enabling representation to stand up against abstraction.[5]

184

The success of the claims that Pop Art and its successor Photorealism were the *new* realist styles somewhat delayed the recognition of perceptual representation, but there did emerge a growing audience responsive to it. Critics and art historians began to take notice and to organize shows and publish articles that helped change art-world opinion. In 1968, for example, Linda Nochlin and some of her students mounted a large exhibition at the Vassar College Art Gallery The question posed by the show was whether it was "possible for a realist to be new at all in the second half of the twentieth century." The answer was "an unqualified yes."[6] In the following year, the Milwaukee Art Center organized *Aspects of a New Realism*. Tillim wrote in the catalogue that the new realism was not "'minor' art. It is an independent entity with its own 'minor' figures and not a lesser version of some presumably 'major' current statement."[7] In an article in *Artforum*, he reiterated that contemporary representation was authentically new and not "a rehash of some older style like Dadaism, Surrealism or Expressionism or...simply another variant of Pop art."[8]

But at the time, painting, both figurative and abstract, was under attack from two new quarters, on the one hand, from Postminimal sculptors who declared (once again) that painting was dead, and from Conceptual artists who proclaimed that all art objects, sculpture as well as painting, had ceased to be viable. Nonetheless, abstract painters, such as Robert Ryman, Brice Marden, and Robert Mangold., began to achieve recognition, as did representational painters such as Katz and Philip Pearlstein. By the end of the sixties, the New Perceptual Realism had attracted growing numbers of young artists, among them Robert Berlind, Rackstraw Downes, Janet Fish, Yvonne Jacquette, and Harriet Shorr.

In 1976, a group of artists organized an exhibition in five SoHo galleries, including works by 140 painters and sculptors, to indicate the scope of current American realism (with the exception of Pop Art and Photorealism). This show proved that much of the best and worst of recent art was based on recognizable subject matter. But it also raised issues about the condition of the new realism at the time. Was it still embattled? No New York museum would accept the show or organize a similar one. But how consequential was that? Certainly, representational art had come a long way in the decade and was receiving growing acclaim in the art world and among a wider public.

Contributing to its new status was a change in art-world attitudes. During the 1960s, one style after another—Pop, Op, Minimal, Conceptual —commanded art-world attention, because each seemed "mainstream" and avant-garde. Katz's painting did not fit easily into any "ism" and was, thus, at a disadvantage. Toward the end of the decade claims made for art as avant-garde became increasingly unbelievable particularly after the official acceptance of Conceptual Art by the Museum of Modem Art in its *Information* show of 1970. Artistic tendencies hitherto, neglected now commanded growing art-world attention. In *Time* magazine, Robert Hughes remarked with special reference to representational art, "The American mainstream has fanned out into a delta, in which the traditional idea of an avant-garde has drowned, Thus, in defiance of the dogma that realist painting, was killed by abstract art and photography, realism has come back in as many forms as there are painters."[9]

But the Postminimalist and Conceptualist polemical war against painting continued into the 1970s. In 1975 the editors of *Artforum*, in a special issue devoted to the current state of painting, claimed that a large segment of the art world had come to believe "that painting has ceased to be the dominant artistic medium at the moment. [Artists] understood to be making 'the inevitable next step' now work with any material but paint."[10] "Brushwielders, were [accused of being) afflicted by a creative halitosis."[11]

Despite the attacks on painting, the 1970s saw the emergence of Pattern and Decoration painting and New Image painting. These tendencies developed in part in reaction against the realistic tendencies that had emerged in the 1960s—Pop Art, New Perceptual Realism, and Photorealism—by cultivating a provocative "bad" look. But the Pattern arid Decoration painters and New Image painters were *painting*, and most of them painting figurative pictures at that. They and their advocates asserted that painting was a proven medium of sensuous expression, and there seemed to be a need for such expression. The need would seem to grow as the seventies progressed.

Indeed, there appeared to be a virtual Renaissance in painting around 1980, not only in the United States but in Europe—and in the face of a new assault on painting, this one by art theoreticians, most of them associated with the

journal *October*, who championed conceptually based, socially oriented art, produced by mechanical means, notably photography. The contributors to the magazine claimed that painting had nothing new or relevant to say and was, therefore, hopelessly retrogressive and, in a word, dead.

Nonetheless, painters such as Julian Schnabel, David Salle, and Eric Fischl in the United States, Francesco Clemente and Enzo Cuccbi it Italy, and Sigmar Polke, Gerhard Richter, and Anselm Kiefer in Germany, suddenly became the center of art-world attention. Rebutting the polemics of the October group, the champions of painting maintained that because of the prevalence of conceptually based art, there had developed "a keen feeling of loss...a sense that something absolutely essential to the life of art has been allowed to fall into a state of unendurable atrophy," as Hilton Kramer commented.[12] Kay Larson also felt this ache: "Artists are desperate to reconnect with feelng,"[13] and painting seemed the best way to do so.

Schnabel, Salle, Fischl, Clemente, and Cucchi became Katz's friends. They were attracted by the artistry, realism, bigness, and coolness of his painting. Clemente, for example, admired what Katz "does with the edges. of the paintings and the scale and the lines and the light, and a mysterious classical measure of his own that can't be defined, but it works."[14]

But it was not only Katz's paintings that attracted younger artists. They appreciated his sharp eye, quick intelligence, and critical demolition of grandiose and pretentious claims. As Sanford Schwartz wrote: "In surprising ways, Katz is a very theoretical person, and his theories and notions about success and failure, particularly in painting, literature and dance, which he shares freely with people, have quietly influenced many. For a wide variety of New York painters and writers about art, especially in the generation after his, Katz is a one-man testing ground for new ideas, and...he has become...as much of an influence as any other single painter or critic. [His] ideas, for all the concision with which they're delivered, aren't neat, self-contained packages. His ideas are always a shade iconoclastic; they're delivered in a flat, no-contest way, yet they invite a response."[15]

An excerpt from a talk Katz gave to the American Philosophical Society is typical of Katz's verbal style: "As a sixteen year old, when I first saw a

187

Mondrian painting, I thought it was great because the title was *Broadway Boogie Woogie* and the painting had a double boogie woogie bass in it. It was thrilling that an artist would do this... Years later, when I became interested in depth of color, Mondrian again looked sensational. The color has atmosphere, it spreads toward one and away, and horizontally and vertically." Katz went on to say that Mondrian's writings did not account for the obsessive passion of the painting, which was its strongest characteristic, He concluded that "in a sense, I think of Mondrian as expressionistic."[16]

Katz's painting has never been persuasively subsumed under any style. If anything, he is a one-man movement, which he once spoofed might. be labeled Katzism. And his independence has worked to his long-term advantage. Movements are always circumscribed by the time in which they are fashionable and thus become dated (although a few innovators continue to command attention). Unclassifiable art does not took dated. Katz then is one of the few artists of his generation to remain in the art world and the public eye. A painting by him was featured on the cover of *Parkett* (no. 29, 1989), and a commissioned portrait by him of novelist John Updike appeared on the cover of *Time* magazine.

In 1996 alone, a museum wing devoted to his art opened at Colby college, the leading international collector Charles Saatchi, who is noted for his acquisition of new art, purchased some thirty of Katz's pictures; and "hip" curators have included him in their shows, for example, *A/Drift* selected by Joshua Decter, a young critic, for the Center for Curatorial Studies Museum at Bard College, and *Views from Abroad, European Perspectives on American Art 2*, chosen by Rolf Lauter and Jean-Christophe Ammann, the director of the Museum für Moderne Kunst, Frankfurt, for the. Whitney Museum of American Art. In 1997, Bice Curiger, the editor of *Parkett*, included Katz in a show he curated for museums in Hamburg and Zurich. All three shows have featured young Conceptual. artists, yet the organizers felt obliged to include Katz. Young artists who are making their mark in the 1990s, among them painters Elizabeth Peyton. and John Currin, and photographer Beat Steuli, have looked to Katz for inspiration. As my book nears completion shows are scheduled in New York City, Frankfurt, and London.

Notes

1. Sidney Tillim, "The Present Outlook on Figurative Painting," *Perspective on the Arts* (*Arts Yearbook*), 1961, p. 59.

2. Alfred H. Barr, Jr., *Recent Painting USA: The Figure*, exh. cat. (New York: The Museum of Modern Art, 1962,

3. Jack Kroll, Introduction to *Figures*, exh. cat. (New York: Kornblee Gallery, 1962).

4. See Clement Greenberg, "Abstract and Representational," *Arts Digest* (November 1, 1954), p. 7.

5. Tillim, "The Present Outlook on Figurative Painting," pp. 44, 53-57.

6. Linda Nochlin, "The New Realists," In *Realism Now*, exh. cat. (Poughkeepsie, New York, Vassar College of Art, 1968), p.8.

7. Sidney Tillim, "Figurative Art in 1969: Aspects and Prospect," In *Aspects of a New Realism*, exh. cat. (Milwaukee: Milwaukee Art Center, 1969), p. 4.

8. Sidney Tillim, "A Variety of Realisms," *Artforum* (Summer, 1969), p. 42.

9. Robert Hughes, "The Most Living Artist," *Time* (November 29, 1976), p. 54.

10. "Painters Reply" *Artforum* (September 1975), p. 26.

11. Max Kozloff, "Painting and Anti-Painting: A Family Quarre," *Artforum* (September, 1975) p. 41.

12. Hilton Kramer, "The Art Scene of the '80s," *New Art Examiner* (October 1985), pp. 24-25.

13. Kay Larson, "Art Pressure Points," *New York* (June 28, 1982), p. 59.

14. Grace Glueck, "Alex Katz: Painting in the High Style," *New York Times Magazine*, March 2, 1986, pp. 38, 84.

15. Sanford Schwartz, *Alex Katz: Drawings 1944-1981*, exh. cat. (New York: Marlbrough Gallery, 1982), p. 5.

16. Alex Katz, "Talk on Signs and Symbols," p. 26.

1967 WAS A WATERSHED YEAR IN AMERICAN
AVANT-GARDE ART SINCE IT WAS THEN THAT
MINIMAL ART SPAWNED POSTMINIMAL ART. MY
CATALOGUE ESSAY WAS AN ANALYSIS OF THE
CONTENTS OF A SPECIAL ISSUE OF *ARTFORUM*
ON AMERICAN SCULPTURE. *ARTFORUM'S* EDITOR,
PHILIP LOIDER, THEN HAD HIS FINGER ON THE
OF 1960S AVANT-GARDE ART AND ITS
POLEMICS. AMONG OTHER SIGNIFICANT ESSAYS
HE INCLUDED WERE ROBERT MORRIS'S PRESEN-
TATION OF MINIMALIST AESTHETICS,
MICHAEL'S FRIED'S ATTACK ON MORRIS'S
POSITION, ROBERT SMITHSON'S SEMINAL ESSAY
ON EARTH ART, AND SOL LEWITT'S EQUALLY
SEMINAL ESSAY ON CONCEPTUAL ART. VERY FEW
SINGLE ISSUES, IF ANY, OF ANY ART MAGA-
ZINE MORE SUCCINCTLY SUMMED UP A MOMENT
IN ART THAN THIS NUMBER OF *ARTFORUM*.

1967: Out of Minimal Sculpture

W hy 1967? Why not 1959, the year Frank Stella's black-stripe paintings, exhibited in Dorothy Miller's "Sixteen Americans," at the Museum of Modern Art, stunned the New York art world and, in retrospect, would seem to mark the end of abstract expressionism as the avantgarde tendency? Or 1962, the controversial onset of pop art? Why not 1964, the year Clement Greenberg's "Post-Painterly Abstraction," at the Los Angeles County Museum of Art, heralded the recognition of stained color-field and hard-edge painting? Or 1966, when Kynaston McShine's "Primary Structures," at the Jewish Museum, featured minimal sculpture, or 1970, when his "Information," at the Museum of Modern Art, "established" conceptual art in America? Provocative shows might have been put together on the theme of 1959 or 1962 or 1964 or 1966 or 1970, or almost any year in between. Each would have looked different, so fast was the tempo of style change in the sixties. "Make it new" was truly the art slogan of that decade.

But why 1967? Because it was a watershed year. The minimal sculpture of Donald Judd, Robert Morris, Dan Flavin, and Carl Andre, and its premises, had become familiar, at least to the art world, through shows in private galleries and articles by Judd, Morris. Barbara Rose, Lucy Lippard, among others.

This is not to say that minimal sculpture of high quality was no longer being made. On the contrary, much of the best was yet to come. But it had ceased to be in the vanguard. That role was assumed by a number of innovative late-minimal artists, such as Eva Hesse, Richard Serra, Robert Smithson, and Bruce Nauman. I use the term "late minimal" rather than "postminimal" because minimal art remained the aesthetic context of late minimalism, whereas postminimalism aimed to cut its throat. As a watershed year, 1967 should not be too rigorously delimited; it should be allowed to reach back in time to 1966 and forward to 1968.

What then exemplified 1967? When I began this essay what jumped into mind—and stayed in mind—was the special issue on American sculpture of *Artforum* that appeared in the summer. At that moment, its editor, Philip Leider, had his finger on the pulse of the liveliest art in the United States and its issues, and he attracted many of the liveliest writers to deal with it: Robert Morris, Robert Smithson, and Sol LeWitt (who, as artists, are in the "1967" show), and critics Michael Fried, Barbara Rose, and Max Kozloff, among others. Leider himself introduced the issue with a critical article on Maurice Tuchman's "American Sculpture of the Sixties" survey at the Los Angeles County Museum of Art, which, as I recall, was the show of the year. It is fitting that the special issue featured sculpture, since it seemed to be the foremost art. So dominant was sculpture in 1967 that a hotly debated topic in the New York art world was, "Is painting dead?"

The basic premises of minimal art were recapitulated in the special issue by Morris, an innovator of minimal sculpture who had become its leading aesthetician. In his "Notes on Sculpture, Part 3: Notes and Nonsequiturs," he wrote that minimal sculpture had zeroed in on what made it sculpture-as-sculpture, namely its *literal* objecthood: "the shape becomes an actual object against the equally actual wall or ground." The common elements of minimal sculpture were "symmetry, lack of traces of process, abstractness, non-hierarchic distribution of parts, nonanthropamorphic orientations, general wholeness." Morris not only considered three-dimensional work fundamentally different from painting (or any other art, for that matter), but he dismissed painting as an "antique" mode. But what interested Morris more than the definition of minimal sculpture in 1967 were its unexpected conse-

quences: non sequiturs. Because a minimal object lacks internal relationships, it sets them up with its surroundings. In moving about, viewers become acutely aware of its "spatial setting." Glimpsing different views of the object in changing light alters their perception of the object and its and their environment or *situation*.[1]

Tony Smith was also speculating about the environment and art. In an interview about his sculpture in 1966, he digressed to talk about a drive he had taken one night on the unfinished New Jersey Turnpike. The road and its surroundings had overwhelmed him as no conventional art ever had. And yet, such phenomena were not designated as art. Smith remarked: "I thought to myself, it ought to be clear that's the end of art. Most painting looks pretty pictorial [meaning conventional] after that." But he could conceive of no way that his experience of the landscape could be translated into art.[2] Smith's problem was soon to be taken up as a challenge by Smithson (the sequence of names is coincidental, of course) and other artists of his generation.

Morris's text in *Artforum* was accompanied by reproductions of his own work and that of Judd, Flavin, Andre, LeWitt, Larry Bell (whose work was considered in an article by Fidel A. Danieli), and John McCracken. By 1967, their work had eclipsed formalist sculpture—that is, the welded metal construction of Anthony Caro and his followers. But construction sculpture continued to be very much admired for its quality in avant-garde art circles, and Leider featured it in articles on David Smith, by Jane Harrison Cone, and Mark di Suvero, by Kozloff.[3]

In response to the minimalist challenge, Fried took up the standard of formalist art, or modernist art as he called it, in the special issue, in an urgent polemic entitled "Art and Objecthood." Fried was not only concerned with the avant-garde's loss of interest in formalist art but with the way in which minimalist partisans used formalist premises, formulated by the leading formalist critic, Clement Greenberg, to justify minimal sculpture. Greenberg had stated that in the modern era each of the modernist arts had turned in on what made it autonomous and unique as an art. In painting, therefore, he preferred the work of Kenneth Noland and Jules Olitski, which asserted

the two dimensionality of the picture's rectangular surface and the opticality of color. In sculpture, however, he favored open, welded construction—the tradition that extended from Picasso and González through David Smith to Caro—which he claimed was essentially "pictorial" because it was based on "drawing" in space with linear and planar elements.

Morris viewed Greenberg's preference in sculpture as a denial of Greenberg's own formalist premises. Morris asserted that the nature of sculpture-as-sculpture was not to be pictorial as was painting-as-painting. Instead, sculpture-as-sculpture should approach the object, articulating its obdurate, physical mass. Because minimal sculpture did so, Morris declared that it was the legitimate latest stage of modernist sculpture. Fried met this argument by pointing to a contradiction in Morris's polemic: Minimal objects, which Fried called literalist objects, invariably directed the viewer's attention to the environment in which both the work and the viewer were located, thus subverting the autonomy of the art work. He found this situation inherently theatrical, since the viewer, now very conscious of him- or herself, became a kind of actor.

Fried went on to say that "there was a war going on...between the theatrical and the pictorial." As a formalist, he had come to value the pictorial, both in painting and in sculpture, above all else in art. As foes of the pictorial, the minimalists were enemies of "the authentic art of our time"; more than that, of *art* itself. The mission of both painting and sculpture, as Fried saw it, was to defeat objecthood. That, in his opinion, was what Caro had achieved in sculpture, and Noland, Olitski, and Stella in painting. Stella was of particular importance to Fried. His painting had been the primary influence on minimal sculpture, yet, in 1967, Stella verged toward stained color-field painting. Without abandoning his concern with *shape*, which had been the preoccupation of minimal sculpture and which, according to Fried, had become the main concern of recent formalist painting, he resorted to *illusionism*, which, by its nature, was antiliteralist. Painting could now have it both ways and was, therefore, not "antique" or outmoded, as Morris claimed, but, quite the contrary, superior to minimal objects. And so was construction sculpture, because it approached the pictorial.

194

So avid was Fried in his war against objecthood that he denied the old for-
malist distinctions between sculpture-as-sculpture and painting-as-painting.
Instead, he sought for a common denominator. of both, some quality found
in no other art, and discovered it in "presentness." An art that possessed pre-
sentness "has no duration...because at every moment the work is wholly
manifest." In contrast, minimal sculpture had "presence," a kind of stage
presence; it was experienced in time. Because it was "instantaneous," for-
malist paintings and sculptures had won out over minimal objects.[4] And
they would also vanquish theatrical "art" without the object, the kind of phe-
nomena that occurred to Tony Smith during his nocturnal automobile ride
on the New Jersey Turnpike.

Today, it is difficult to imagine how urgent such issues as formalism versus
literalism were in the sixties, certainly to the artists involved and their critic
and curator supporters. And the intensity of the polemics contributed to the
enterprise of all parties, although to outsiders it could seem esoteric and con-
voluted. In a letter to *Artforum* on Fried's article, Allan Kaprow, surely one
of the most sophisticated artists of the time, wrote: "All that talk about fight-
ing between 'literalists' and 'modernists.' First I heard of it. Maybe...[Fried
is] in on some plot or something. "[5]

Formalism did not win its war against minimalism, of course. Neither did it
lose. By 1967, both had won; they had become established. But it was liter-
alism in art that continued to engage the most interesting of emerging
artists. At the same time, they were doubtful that minimal sculpture could
be extended in fresh ways. Indeed, it was natural in a decade in which "make
it new" was a cardinal value for a reaction to have set in. In 1966, Lucy
Lippard, an advocate of minimal sculpture, acknowledged:

> The conventions of this mode are already established...It must have looked
> easy when Don Judd, then Robert Morris, and later Sol LeWitt and Carl
> Andre began to attract attention, but the mold hardened fast for their imi-
> tators. Monochrome, symmetry, single forms, stepped or graded color or
> shape, repetition of a standard unit, the box, the bar, the rod, the chain,
> the triangle or pyramid, are the new clichés.[6]

Lippard claimed that the rigors of minimalism had made her aware of what it precluded, namely "any aberrations toward the exotic."

> Yet in the last three years, an extensive group of artists on both East and West Coasts, largely unknown to each other, have evolved a...style that has a good deal in common with the primary structure as well as, surprisingly, with aspects of surrealism, [These artists] refuse to eschew...sensuous experience while they also refuse to sacrifice the solid formal basis demanded of the best in current nonobjective art.[7]

More specifically, Lippard had in mind such artists as Louise Bourgeois, Eva Hesse, Kenneth Price, Keith Sonnier, and H. C. Westermann, artists she included in a show entitled "Eccentric Abstraction" that she organized at the Fischbach Gallery in the fall of 1966. The central artists, such as Hesse, retained minimalism's rational modular or serial gridlike structure and literalist treatment of new, unexpected, often floppy materials, while giving rein to irrational, even absurd, autobiographical, psychological, erotic impulses—above all, erotic, because of the soft materials used—as well as other surrealist or expressionist impulses. Their late-minimal work was aptly characterized as minimalism with an eccentric edge, or a dada or surrealist edge, purist funk, or a sexy minimalism.

The special issue did not deal with any of Lippard's eccentric abstractionists, but Leider, responding to the same aesthetic stimuli as Lippard, published Barbara Rose's article on Claes Oldenburg's extravagant soft sculptures of common objects. In her introductory sentence, she proclaimed that "Oldenburg is the single pop artist to have added significantly to the history of form,"[8] Lippard stated that his "flowing, blowing, pokeable, pushable, lumpy surfaces and forms"[9] were the primary influence on eccentric abstraction. *Artforum*, in an article by James Monte, also featured eccentric abstraction's San Francisco counterpart, funk art. In opening up to surrealism and expressionism, eccentric abstraction and funk art eased the way for the recognition of sixties mavericks, among them Lucas Samaras, whose boxes, objects, and reliefs, studded with pins, razors, and other threatening phenomena, are autobiographical—and pervaded with pain. In 1967, Samaras turned benign and began to translate commonplace objects into fantastic

and witty works that evoked what the surrealists called the "marvelous."
Morris's work took a late-minimal eccentric or funky turn in 1967—in a
series of cut-felt pieces. The pattern of slits remained geometric and modu-
lar, as in his minimal sculptures, but the geometry was subverted by the ran-
dom sprawl of the soft materials, which called attention to the literal process
of sprawling. In 1968, Morris wrote an article in *Artforum* entitled "Anti-
Form." (The label was coined by Leider, not Morris, who objected to it.)
Morris claimed that minimal art was not as physical as art could be or should
be because the ordering of its modular or serial units was not inherent in the
materials themselves. To make the work more literal, the process of its "mak-
ing itself" had to be articulated. Morris, therefore, called for an art whose
focus was on variable matter itself and the action of gravity upon it. Such an
art could not be predetermined; its order was "casual and imprecise and
unemphasized. Random piling, loose stacking, hanging, give passing form to
the material. Chance is accepted and indeterminacy is implied since replac-
ing will result in another configuration."[10] Thus, Morris turned against his
minimalist preoccupation with preconceived, clearly defined, and durable
unitary volumes, but not with its stress on literalness.

The major process artist to emerge was Richard Serra. In 1967-68, he com-
piled a long list of verbs of action: "to roll, to crease, to fold, to store, to
bend, to shorten, to twist, to twine, to dapple,"[11] and so forth, a number of
which he soon would execute, as in his lead spatter pieces, prop pieces, and
scatter pieces. Process art would lead to filling interior spaces with a variety
of substances, often inchoate—for example, earth. From these indoor envi-
ronments, it was but a short step outside, into nature—into earth art.

Smithson, who emerged as a formidable polemicist in 1967, wrote a letter to
Artforum rebutting Fried's "Art and Objecthood," taking issue with, among
other matters, the attack on Tony Smith, whom Smithson hailed as "the
agent of endlessness."[12] Challenged by Smith's speculation about the aesthet-
ic potential of an "'abandoned airstrip' as an 'artificial landscape,'" lacking in
"'function' and 'tradition,'" Smithson had the opportunity of trying to find
a frame for the kind of amorphous sensations experienced by Smith when
Smithson himself became an artist-consultant to a firm of engineers and
architects developing an air terminal in Texas between Fort Worth and

Dallas. Smithson's observations appeared in the special issue in an article entitled "Towards the Development of an Air Terminal Site." In the process of investigating the site, auger borings and core borings were made. These soil samples intrigued Smithson, as did "pavements, holes, trenches, mounds, heaps, paths, ditches, roads, terraces, etc., [all of which] have an aesthetic potential" and are "becoming more and more important to artists." Instead of installing works of art in the airport, Smithson proposed to take the entire site itself into account, its physical and metaphysical dimensions beneath the earth, on the ground, and from the sky. "One does not impose, but rather exposes the site." Smithson envisioned other "art forms that would use the actual land as a medium"—in remote places, such as the Pine Barrens of New Jersey or the North and South Poles. "Television could transmit such activity all over the world."[13] Smithson concluded, prophetically, that site-specific earth art was just beginning.

And indeed it was—for Christo, Walter De Maria, Michael Heizer, Dennis Oppenheim, and Smithson. In 1967, Oldenburg had his notorious *The Hole*, a "grave", dug and filled by grave diggers in Central Park. This work was executed for "Sculpture in Environment," one of the early shows of works of art in public places in America. Oldenburg also exhibited his *Proposals for Monuments: Fagends and Drainpipe Variations*, at the Sidney Janis Galley, in New York, and *Giant Wiper* and other "Proposals," at the Museum of Contemporary Art, in Chicago. Both *The Hole* and the "Proposals" anticipated the renaissance of public art in the United States.

Smithson was particularly fascinated by the aesthetic potential of disintegrating matter—sediment, sludge, and the like—verging toward a state of entropy, which, as he saw it, was the destiny of the universe. Conceptual art was another kind of "dematerialization," to use Lippard's and John Chandler's term.[14] The seminal statement, "Paragraphs on Conceptual Art," by Sol LeWitt, appeared in the special issue. It is fitting that conceptual art should have been treated first in the context of sculpture, since, in its original late-minimal form, it is a dematerialization of the primary structure, taking it back to the original idea that generated it and presenting the idea itself in verbal form as an artwork.

LeWitt defined conceptual art as art that "is meant to engage the mind of the viewer rather than his eye or emotion." He went on to say that "the idea or concept is the most important aspect of the work. When an artist uses a conceptual form of art, it means that all of the planning and decisions are made beforehand and the execution is a perfunctory affair. The idea becomes a machine that makes the art." That did not mean that conceptual art was rational, "theoretical or illustrative of ideas." Quite the contrary, "It is intuitive...and it is purposeless." Conceptual artists "leap to conclusions that logic cannot reach...Irrational judgments lead to new experience." But conceptual art avoided the subjective process of art-making. "Once the idea of the piece is established in the artist's mind and the final form is decided, the process is carried out blindly."

Conceptual art was the antithesis of art "that is...perceptual rather than conceptual. "LeWitt's antipathy to the physical led him to entertain the idea of a purely conceptual art:

> If the artist carries through his idea and makes it into visible form, then all steps in the process are of importance. The idea itself, even if not made visual, is as much a work of art as any finished product. All intervening steps—scribbles, sketches, drawings, failed works, models, studies, thoughts, conversations—are of interest. Those that show the thought process of the artist are sometimes more interesting than the final product."[15]

Thus, conceptual art could range from an object generated by an idea to a written or verbal proposal, or it could exist in the gap between verbalization and visualization. Illustrations of his own works accompanied LeWitt's article, as well as those of Jo Baer, Ruth Vollmer, Flavin, Andre, Mel Bochner, Hesse, Jane Klein Marino, Paul Mogensen, Edward Ruscha (a detail from *Every Building on the Sunset Strip*), and Dan Graham (a photograph of steps). Conceptual works by LeWitt, Tony Smith, Bochner, and Brian O'Doherty were included in an issue of *Aspen Magazine*, no. 5 and 6, edited by O'Doherty, in 1967. This particular issue was a box that contained not only conceptual art but essays, fiction, recorded music and statements, interviews, documents, poetry, and films by Robert Morris, Stan VanDerBeek, Robert Rauschenberg, Marcel Duchamp, Samuel Beckett, William Burroughs,

Alain Robbe-Grillet, Roland Barthes, John Cage, Merce Cunningham, and Dan Graham, among others. Unlike Leider, O'Doherty dealt with broader intellectual issues that engaged artists in the late sixties, a topic too large to be dealt with in this essay. (Also illuminating was a series of statements by artists that Barbara Rose and I compiled and published in *Art in America*, in 1967.[16] 1 still feel it is the best summation of the sensibility of the sixties.)

With the advent of process art, earth art, and conceptual art around 1967, other tendencies—for example, the new realism of Alex Katz, Philip Pearlstein, and Alfred Leslie—began to vie successfully for recognition. Art became increasingly pluralistic. Leider's special issue contained articles on realist sculptors—George Segal, by Robert Pincus-Witten, and Richard A. Miller, by Sidney Tillim—and on Ellsworth Kelly as sculptor, by Barbara Rose. Even within minimal art there were diverse developments, notably the monumental primary structures of Tony Smith and Ronald Bladen that emerged with a strong profile in 1966-67, and the dematerialized minimal sculpture of Larry Bell. There was a general tendency toward complexity—exemplified in painting by Stella and Roy Lichtenstein and, even more, Al Held, and in sculpture by the polychromed, laminated wood constructions of George Sugarman. The new pluralism called into question the avant-garde imperative "make it new," an imperative that led artists to press to the limits of art, limits that were reached when art came close to looking like nonart, as process art, earth art, and conceptual art did when they first appeared. Perhaps the last word had been said by conceptual artists who "eliminated what may be irreducible conventions in art-the requirements that it be an object and visible."[17]

In retrospect, 1967 marked the beginning of the end of the sixties, of the avant-garde as a believable concept, perhaps even of modernism, and the ICA exhibition should be considered with this in mind.

Notes

1. Robert Morris, "Notes on Sculpture: Part 3, Notes and Nonsequiturs," *Artforum* (Summer 1967): 25-26.

2. Samuel Wagstaff, Jr., "Talking with Tony Smith," *Artforum* (December 1966): 19.

3. An article on Anthony Caro did not appear in the special issue of *Artforum*, presumably because his work was the subject of an article by Michael Fried in the February issue.

4. Michael Fried, "Art and Objecthood," *Artforum* (Summer 1967): 22.

5. Allan Kaprow, "Letters," *Artforum* (September 1967): 4.

6. Lucy R. Lippard, "New York Letter: Recent Sculpture as Escape," *Art International* (20 February 1966): 20.

7. Lucy R. Lippard, "Eccentric Abstraction," *Art International* (November 1966): 28.

8. Barbara Rose, "Claes Oldenburg's Soft Machines," *Artforum* (Summer 1967): 30.

9. Lippard, "Eccentric Abstraction," 36.

10. Robert Morris, "Anti-Form," *Artforum* (April 1968): 34-35,

11. Richard Serra, "Verb List Compilation 1967-1968," in Gregoire Muller (text) and Gianfranco Gorgoni (photographs), *The New Avant-Garde: Issues for the Art of the Seventies* (New York: Praeger Publishers, 1972), 94.

12. Robert Smithson, "Letters," *Artforum* (September 1967): 4.

13. Robert Smithson, "Towards the Development of an Air Terminal Site," *Artforum* (Summer 1967): 38, 40.

14. See John Chandler and Lucy R. Lippard, "The Dematerialization of Art," *Art International* (February 1968).

15. Sol Lewitt, "Paragraphs on Conceptual Art," *Artforum* (Summer 1967): 80, 83.

16, Barbara Rose and Irving Sandler, eds., "Sensibility of the Sixties," *Art in America* (January/February 1967): 44-57.

17. Irving Sandler, "Introduction," *Critics Choice 1969-70*, exhibition catalogue (New York: New York State Council on the Arts and State University of New York, 1969): n.p.

Toward the end of the 1960s I became increasingly aware of pervasive changes that were occurring in American art. At this moment, the idea of an avant-garde no longer seemed believable. Consequently, art seemed increasingly pluralistic. In 1969, at the very moment that the change in art was occurring, for a catalogue introduction for a show I curated, I decided to investigate the issue. In my essay, I announced that the art-conscious public would have to become open as never before to multiple tendencies in art. I had anticipated "the postmodern condition." I consider this essay one of my most significant.

202

Critic's Choice 1969-70

I n recent years one artistic style after another has monopolized the attention of the art-conscious public. The belief prevails that each successive style is avant-garde and that it constitutes an absolute standard (no matter how transitory) that renders all other styles obsolete. Value in art is thus made to depend on novelty. I am convinced that this point of view is outdated and that, increasingly, the uniqueness of an artist's vision and the artistry with which it is embodied in a work will count for more than the alleged up-to-date character of a style.

Prior to the nineteenth century, innovations in art were accepted readily by a small, sophisticated group that constituted the public for art. In modern times this public grew larger but became less knowledgeable in esthetic matters and, until very recently, refused to accept innovational styles. Thus generations of alienated artists conceived of themselves as avant-garde.

Although public hostility made life exceedingly difficult for advanced artists. they persevered, secure in the conviction that popular taste was philistine and stale. But more important, they became convinced that their urge to experiment with new ideas, no matter how unpalatable, was prompted by

the pervasive changes taking place in modern life. In the cause of reality, modernist artists felt compelled to question every existing norm and to experiment in order to discover new values and new forms with which to express them. So pressing was their need for the new that successive vanguards spurned as inauthentic any style that repeated what had been and did not transform or expand received conceptions of life and art.

Challenging of existing values goes on, as it must, for today the tempo of change speeds beyond anything imaginable in the past. Artists are still confronting revolutions (and they seem to occur daily) in every facet of life. The proof of this can be found in the number of new tendencies that have proliferated in the last decade or so, However, these tendencies, even the newest, can no longer be thought of as avant-garde, primarily because during the past half-century art has reached so many limits. Frontiers may remain, but the artists who discover them cannot be considered avant-garde since the impulse to press to the limits has become established as a tradition.

A limit in art is reached when an artist's work comes as close as possible to being non-art. This art does not go over the boundary because artists, critics, historians, museum curators, and a sizeable segment of the art-conscious audience treat every artist's work as art. Even dada objects, such as Duchamp's ready-mades, which were meant not only to be non-art but anti-art, have been elevated into art. More recently, the happenings artists have moved to other extremes, where art is scarcely distinguishable from our everyday environment and where it tends to resemble theatre more than painting or sculpture. Pop artists have broken what used to be the barrier between "high" art and "low" (that is, commercial, popular, etc.) art. Members of an organization called Experiments in Art and Technology have probed the edge between art and the new technology. Minimal artists have refined art to its pure essence by extracting any reference to image or any other of the arts. Process artists have reduced art to its materials and the means whereby it is made, calling attention solely to their inherent properties.

In the last two or three years, a number of artists have systematically demolished every notion of what art should be—to the extent that they have eliminated what may be irreducible conventions in art—the requirements that it

be an object and visible. Some are working in nature—digging holes in the earth or filling galleries and other spaces with ordinary "formless" substances that do not seem to add up to an object. Others merely think up ideas that need not result in anything visible.

The avant-garde has ceased to exist, not only because so many limits of art have been reached, but because there now exists a large and growing public that no longer responds in anger to the novel, and when not eager for it is at least permissive. Elitists may question the motives of the mass audience for art and the quality of its esthetic experiences—but not its sympathy. In response to this friendliness, artists have begun to feel less alienated and to think of themselves as integrated into society "—men of the world," as Allan Kaprow put it. This is a radical change in their condition which may strongly affect the course of art.

The demise of the avant-garde has prompted many who continue to yearn for new frontiers to look elsewhere (for example, to underground movies), justifying their shift of interest on the grounds that painting and sculpture are dead. This attitude cannot be accepted by those who need art objects, who live in varying degrees through them. But the audience for painting and sculpture may have to change some of its expectations. It may have to stop considering novelty in art a primary value. Rather it may have to attach greater importance to the quality of works of art and to the expressiveness and uniqueness with which artists mix visual ideas. The possibilities in art today are endless. There are areas of vast potential—scarcely tread by those artists who have jumped to extremes—that require fuller exploration. The audience for art objects may also have to become open as never before to multiple tendencies in art. Such openness is particularly contemporary, for the changes in all realms of human experience are so varied, radical, and rapid that to proclaim one direction as the "right" one has lost credibility.

As the 1960s progressed it became increasingly clear that a new sensibility was shaping American art. It came to be labeled Post-Modernism. I had anticipated its arrival in the introduction I wrote in the *Critic's Choice* show of 1969. In 1980, at the moment the discourse began to engage the art world, I further tried to define it in an introduction to an issue of the *Art Journal* titled *Modernism, Revisionism, Pluralism, and Post-Modernism*, which I edited. This issue would be seminal in the discourse on Post-Modernism.

206

Modernism, Revisionism, Pluralism,

and Post-Modernism

Recently, fundamental premises of modern architecture and the visual arts and of their history have been called into question. To put it directly, modernism has become problematic. Some artists, architects, historians, and critics have gone so far as to proclaim that modernism never even existed or that if it once had then it is now dead. We have entered the post-modern age, even though it often looks more like a regression to the pre-modernist era, or to put it positively, an attempt to reestablish ties with the past that modemism was supposed to have shattered and whose detritus it was supposed to have swept into the dustbin of history. Such claims might be shrugged off if they were made in one discipline—but several? And by respected authorities in each? Indeed, we seem to be in a moment of extreme intellectual and cultural ferment, a moment that I believe may last for a number of years to come.

To begin with, it is necessary to define the labels *modernism, revisionism, pluralism*, and *post-modemism*. For the sake of clarity, it is useful to distinguish two kinds of modernism, labeling one inclusive modernism and the other exclusive modernism. Modernism can be defined narrowly, arbitrarily limited to a single tendency proclaimed as mainstream and avant-garde. This is

exclusive modernism. But modernism can also be viewed broadly as unbounded, multiple, inclusive of every tendency that seems at all "progressive," that is, different from what has been. As H.W. Janson has remarked, the term avant-garde can be applied for different reasons to many styles at any moment.[1] The inclusive view of modernism tends to deny or belittle any conception of modernism as a single (or at most, double) stream or mainstream whose progression unfolds in qualitative leaps into the unknown, each made by the avant-garde of its time, leaps that in retrospect have often been considered as inexorable and irreversible.

The history of modem art has more often than not been viewed from the perspective of exclusive modernism, as a series of qualitative leaps into the new. However, depending on the criteria for what is new in art and difficult to accept, some historians prefer to treat any moment as a cross-section, a continuum from more to less, light to dark, rather than as a sharp break between the "good," forward-looking vanguard and the "bad," backward-looking academy. This alternate approach, which has even entailed the rehabilitation of "academic" art, has been called revisionism.

Pluralism is to contemporary art since 1970 what inclusive modernism is to modern art. It is the broad view, embracing every current tendency and considering each of equal value. Post-modernism needs to be dealt with in the same manner as modernism, that is, as either exclusive or inclusive. The definition of exclusive post-modemism depends on a conception of exclusive modernism. Exclusive postmodernism wants to invert exclusive modernism and, in the process, destroy it; it is patricidal. Inclusive post-modernism is merely the latest stage of inclusive modernism, that is, modernism that encompasses post-modernism. Thus, both exclusive post-modernism and pluralism are opposed to exclusive modernism. But pluralism is broader than exclusive postmodernism, since it views art as open in every direction, including that of exclusive modernism.

During the sixties, such purist tendencies as stained color-field abstraction and Minimalism—which aimed to reduce art to that which was intrinsic to its medium and to eliminate all that was not—were announced by critics to be modernist, avant-garde, or mainstream, the terms more or less inter-

changeable. Among these writers, many of whom were artists, who together began to dominate art critical discourse were painter Ad Reinhardt; Clement Greenberg and his followers such as Michael Fried (who was also influenced by painter Frank Stella) and Rosalind Krauss; and Minimalist sculptors Carl Andre, Donald Judd, and Robert Morris. It was the reductive, nonobjective styles championed by these writers that many pluralists and all post-modernists have identified as modernism. In order to simplify my account, I will accept their equation of modernism in the visual arts with purist abstraction.

The central form of modernism, perhaps its icon or emblem, as Rosalind Krauss has written, has come to be considered the Minimalist grid.[2] In architecture too, modular buildings—the extreme, functionalist, and commercially debased variants of the modular International Style—have been considered by post-modernists as equivalent to Minimalism. Modernism in the visual arts is thus symbolized at its most general by abstraction or, more accurately, by nonobjectivity. More specifically, modernism is identified with Minimalism. Indeed, post-modernism more often than not should be called post-Minimalism. Or perhaps Minimalism can be considered the latest (possibly final) stage of modernism. This kind of identification is clear in the following remark by John Perreault, a champion of decorative pattern painting: "Presently we need more than silent cubes, blank canvases and gleaming white walls. We are sick to death of cold plazas and monotonous 'curtain wall' skyscrapers...[and] interiors that are more like empty meat lockers than rooms to live in. "[3]

Purist styles and their justifications came under growing attack after 1970 when the notion of avant-garde ceased to be believable. I can be more specific about the very moment this occurred: the evening of July 1, when the *Information* show opened at the Museum of Modern Art, presenting Conceptual art in all of its varied manifestations as an established tendency in international art.

Pluralism as a label was used throughout the seventies. Post-modernism came into frequent use only at the end of the decade, after the emergence of several tendencies such as a so-called new imagism and decorative pattern

painting, which seemed to share an anti-Minimalist and thus anti-modernist aesthetic.

Pluralism was opposed to modernism, but it embraced every tendency and implied that each was of equal value. What remained to be argued was what was good, bad, or in between within each tendency, and that was more a matter of personal taste than an issue to debate. This made the polemics amorphous and flat. Indeed, the very notion of pluralism involved a flattening out of art. And to many the art itself seemed flat at the time, if less so in retrospect.

The introduction of the label post-modernism sharpened polemics because it could be opposed dialectically to modernism. The arguments became more focused and provocative. It appeared as if the concept of post-modernism could be used as a dialectical tool to examine in retrospect the art of the seventies and speculate about what might happen in the eighties. Art discourse livened and hotted up. (This can be good because it is lively, bad because it sloganizes and vulgarizes.) one could take sides as one had during the sixties for or against Pop Art, Op Art, Minimal art, or Conceptual art. Moreover, as I said, post-modernism seemed more consequential, because it connected with the most provocative controversy in architecture.

At the moment, the term post-modernism can better characterize a sensibility than a style or a complex of styles, although interesting claims of post-modernism have been made for the complex abstractions of Al Held and Frank Stella; the new imagism of such artists such as Joel Shapiro and Charles Simonds or Nicholas Africano and Lois Lane; the decorative pattern painting of Robert Zakanitch, Joyce Kozloff, Robert Kushner, Kim MacConnel, and Miriam Schapiro; the sculpture, based on premodern architecture, of Siah Armajani, George Trakas, and Mary Miss; new developments in photography, video, and performance art; and other recent and not-so-recent tendencies. In this short introduction I cannot deal with the specific claims, but I would like to suggest the sensibility of post-modernism.

Post-modernism has rejected modernism's purity and has instead welcomed impurity. Joyce Kozloff, a decorative pattern painter and mosaicist whose

way of working was inspired in part by her feminism, once listed 112 anti-modernist words in a polemic entitled "Negating the Negative (An Answer to Ad Reinhardt's 'On Negation')." Among them are: antipurist, anti-puritanical, anti-Minimalist, anti-reductivist, anti-formalist, anti-austere, anti-bare, anti-boring, anti-empty, anti-flat, anti-clean, anti-machine-made, anti-bauhauist, anti-mainstreamist, antisystemic, anti-cool, anti-absolutist, anti-dogmatic, anti-exclusivist, anti-programmatic, anti-dehumanized, anti-detached, anti-grandiose, anti-pedantic, and anti-heroic.[4] Kozloff affirmed "additive, subjective, romantic, imaginative, personal, autobiographical, whimsical, narrative, decorative, lyrical...primitive, eccentric, local, specific, spontaneous, irrational, private, impulsive, gestural, handwritten, hand-made, colorful, joyful, obsessive, fussy, funny, funky, vulgar, perverse, mannerist, tribal, rococo...self-referring, sumptuous, salacious, eclectic, exotic, messy, monstrous, complex, ornamental...delicate, warm."[5] I should like to stress the influence of feminism on the development of pluralism and post-modernism. Consciousness-raising played a vital role in the evolution of an introspective, personalist, anti-purist art, as did the brilliant proselytizing of feminist art critics such as Lucy Lippard.[6]

In art criticism too, the tendency has been to introduce new approaches—social, psychological, autobiographical, iconographic, and so forth. To use Kozloff's approach, the new criticism appears to involve a negation of Clement Greenberg's no-nos for art critics. In an article entitled "How Art Writing Earns Its Bad Name," Greenberg attacked "perversions and abortions of discourse: pseudo- description, pseudo-narrative, pseudo-exposition, pseudo-history, pseudo-psychology, andworst of all—pseudo-poetry (which represents the abortion, not of discourse, but of intuition and imagination)."[7] Art critics in increasing numbers are aspiring to he more than pseudo in the disciplines Greenberg mentioned, among others, and to connect these disciplines meaningfully to art.

Kim Levin put the sensibility that Kozloff delineated into a historic context:

> The '70s has been a decade which felt like it was waiting for something to happen. It was as if history was grinding to a halt. Its innovations were disguised as revivals. The question of imitation, the gestural look of Abstract

Expressionism, and all the words that had been hurled as insults for as long as we could remember—illusionistic, theatrical, decorative, literary—were resurrected as art became once again ornamental or moral, grandiose or miniaturized, anthropological, archeological, ecological, autobiographical or fictional. It was defying all the proscriptions of modernist purity. The mainstream trickled on, minimalizing and conceptualizing itself into oblivion, but we were finally bored with all that arctic purity. The fact is, it wasn't just another decade. Something did happen, something so momentous that it was ignored in disbelief: modernity had gone out of style.[8]

Post-modernism is filled with extraaesthetic references while modernism purged all that was not of the medium. Rackstraw Downes, who was one of the first to apply the term post-modernist to painting, remarked on this change: "Modernism deteriorated into a kind of pictorial narcissism—it became a painting capable only of admiring its own nature. Post-modernism has seized on these failings as its *raison d'être* and announced its existence by giving the act of painting something to do."[9]

Exactly what that is will surely be a major issue of the art of the eighties.

Notes

1. H.W. Janson, "The Myth of the AvantGarde," *Art Studies for an Editor-25 Essays in Memory of Milton S Fox*, New York, 1975.

2. Rosalind Krauss, *Grids*, New York, Pace Gallery, 1978.

3. John Perreault, "A Room with a Coup," *The Soho Weekly News*, 13 September 1979, 47.

4. Joyce Kozloff, "Negating the Negative (An Answer to Ad Reinhardt's 'On Negation')," mimeograhed typescript published by the Alessandra Gallery for its show *Ten Approaches to the Decorative*, 1976, pp. unnumbered.

5. Ibid.

6. See Lucy Lippard, *From the Center: Feminist Essays on Women's Art*. New York, 1976.

7. Clement Greenberg, "Art: How Art Writing Earns Its Bad Name," *Encounter* 19, December 1962, 70-71.

8. Kim Levin, "Farewell to Modernism," *Arts Magazine*, LIV, 1979, 90 — 92.

9. Rackstraw Downes, "Post-Modernist Painting," *Tracks*, Fall 1976, 72.

Chapter Four

The Changing
Art World

Beginning in 1956, 1 not only wrote art crit-icism and then art history but I took an active part in the New York art world as an on-the-spot observer, a participant, and chronicler. Most Friday nights, I was to be found at The Club. The Club was founded by the first-generation Abstract Expressionists in 1949 because they needed a place to meet, talk, and socialize, most of all to talk, since the ideas behind avant-garde painting were problematic. Consequently, The Club's primary function was the presentation of pan-els and lectures on aesthetic issues. The participants were limited to artists and a select number of art professionals. After the panels, there was drinking and dancing. Prior to the founding of The Club artists discussed aesthetic issues and each others' work via studio visits and meetings at the Cedar Street Tavern. The Club represented a move from private conversations to more public discourse, signalling the artists' bid for greater art-world and public recognition. After 1954, I attended The Club regularly and took notes of the proceedings which provided the source material of *The Triumph of American Painting: A History of Abstract Expressionism* and *The New York School: The Painters and Sculptors of the Fifties*. From 1956 to 1962, I arranged the programs and other events at The Club.

The Club

For nostalgia-prone artists who frequented the Waldorf Cafeteria, the lectures at the "Subjects of the Artist" School and Studio 35, the Club and the Cedar Street Tavern, the decade following the Second World. War was "the good old days." Uncontaminated by success, artists were supposed to have been purer then, more comradely and preoccupied with artistic matters. For others—the careerists—the social history of Abstract Expressionism, once it became important, has been something to rewrite. With. an eye to future position, they have tried to change the past. Both attitudes (aggravated by natural lapses of memory) have led to myth-making, which, like any distortion of past events, saps them. of authenticity. The following notes attempt to reconstruct what actually happened. They were culled from dozens of interviews, personal experiences, surviving records and printed memoirs.

Many of the artists who founded the Club met in the 1930s while on the Federal Art Project. Some got to know one-another at meetings of the Artists' Union and the American Abstract Artists, or in Hans Hofmann's school, or in such restaurants as Romany Marie, the San Remo, the Stewart Cafeteria on 23rd and 7th Avenue and the one on Sheridan Square. During

the war, the Waldorf Cafeteria on 6th Avenue off 8th Street became a popular late-at-night hangout for downtown artists. However, they were not comfortable there; whenever the weather permitted, they gathered in nearby Washington Square Park. The cafeteria was a cruddy place, full of Greenwich Village bums, delinquents and cops. The management did not want the artists; they were coffee drinkers who preferred to eat where the fare was better and cheaper (like the Riker's on 8th Street near University Place). To harass them, the Waldorf management allowed only four persons to sit at a table, forbade smoking, and, for a time, even locked the toilet. Therefore, a group of artists decided to get their own meeting place, and in the late fall of 1949, met at Ibram Lassaw's studio and organized the Club.

The Club was preceded a year earlier by the "Subjects of the Artist" School, but the School was not its parent body, as has often been claimed. The two were formed independently. The School was founded by William Baziotes, David Hare, Robert Motherwell and Mark Rothko, all of whom had had one-man shows at Peggy Guggenheim's Art of This Century Gallery between 1944 and 1946. With the exception of Rothko, the other three had been close to the Surrealist Government-in-Exile in New York during World War II. Clyfford Still participated in the initial planning of the School but did not teach; Barnett Newman joined the faculty somewhat later. To broaden the experience of the students, other advanced artists were invited to lecture on Friday evenings. These sessions were open to the public, and a number of the artists who organized the Club either spoke or attended.

After one semester the School closed and in the fall of 1949, Robert Iglehart, Tony Smith and Hale Woodruff—teachers at the New York University School of Art Education—and some of their students, notably Robert Goodnough, took over the loft, named it Studio 35, and continued the Friday evenings until April, 1950. Among those who lectured during the two seasons, 1948-49 and 1949-50, were Hans Arp, Baziotes, Nicholas Calas, John Cage, Joseph Cornell (who showed his films), Jimmy Ernst, Herbert Ferber, Fritz Glarner, Adolph Gottlieb, Harry Holtzman, John Hulsenbeck, Weldon Kees, Willem de Kooning, Levesque, Motherwell, Newman, Ad Reinhardt, Harold Rosenberg and Rothko. The final activity of Studio 35 was a three-day closed conference, April 21-23, 1950, some six months after

the inception of the Club. The proceedings were stenographically recorded, edited by Motherwell, Reinhardt and Goodnough, and published in "Modern Artists in America," 1951. In the introduction to this book, the reason for the decline of Studio 35 is given: "These meetings...tended to become repetitious at the end, partly because of the public asking the same questions at each meeting." The Club was to avoid this problem by limiting participation in its activities mainly to artists and by abstaining from any attempt at adult education.

According to a 1951 list, the, charter members of the Club were Lewin Alcopley, George Cavallon, Charles Egan, Gus Falk, Peter Grippe, Franz Kline, Willem de Kooning, Ibram Lassaw, Landes Lewitin, Conrad Marca-Relli., E. A. Navaretta, Phillip Pavia, Milton Resnick, Ad Reinhardt, Jan Roelants, James Rosati, Ludwig Sander, Joop Sanders, Aaron Ben Shmuel (who was at the first meeting but soon dropped out) and Jack Tworkov. They rented a loft at 39 E. 8th Street and fixed it up. The Club was governed by a voting committee, consisting of those charter, members who remained active and others it elected. By the end of 1952, some twenty more, were added including Leo Castelli, John Ferren, Philip Guston, Harry Holtzman, Elaine de Kooning, Al Kotin, Nicholas Marsicano, Mercedes Matter, Joseph Pollet, Robert Richenburg, Harold Rosenberg and Esteban Vicente. However, the dominant force in Club affairs was Phillip Pavia who made up any financial deficit and arranged the programs.

All Club rules were determined by the voting committee without recourse to the membership. No policy established by one voting meeting was deemed to limit the actions of subsequent meetings. In fact, no one seemed to remember just what decisions had been made from month to month, and minutes were kept only sporadically. For example, as late as 1955, a sub-committee was appointed to define what a charter member was. To become a member, one had to be sponsored by a voting member and approved by the committee. A black-ball method was used: two negative votes (it had to be two because Lewitin always voted no) and a candidate was rejected, but this was occasionally ignored. New members were selected because of their compatibility and not because of how they painted. In the beginning, there was an initiation fee of $10 (sometimes waived for poorer artists), presum-

ably to buy a chair, and monthly dues of $3; later, the dues was lowered to $10 or $12 annually.

Membership jumped quickly. By the summer of 1950, the original 20 had been tripled. An entry in the minutes a year later reads: "77 members + 11 deadheads." Most artists who came to be labeled Abstract Expressionists joined within a few months, including the faculty of the "Subjects of the Artist" School, Rothko excepted, although he appeared now and then at the beginning. Frequent attendance, however, was another matter. The regulars tended to be those who had met at the Waldorf and their friends who lived south of 14th Street. In 1955, a voting meeting limited total Club membership to 150. Each member in good standing was permitted to bring guests or to write them notes of admission. But few outsiders, if persistent, were denied entry; it was usually sufficient to announce the name of the member who was supposed to have invited you. At first, guests came in free; later, there was a 50 cent charge, presumably paid by the member, not his guest, to emphasize, the private character of the Club. Initially, only coffee was served. Drinking liquor was not the thing to do; besides, most members could not afford it. Subsequently, a bottle was bought to oil up the speakers, and still later, liquor was provided after the panels, the costs defrayed by passing a basket. Games were prohibited, but there was dancing.

The Club was formed to provide a place where artists could escape the loneliness of their studios, meet their peers to exchange ideas of every sort, including tips on good studios and bargains in art materials (a perpetual topic). But there was a more compelling, though not always conscious, reason: mutual support. Reacting against a public which, when not downright hostile to their work, was indifferent or misunderstanding, vanguard artists created their own audience, mostly of other artists—their own art world. Further, for many existing styles and their tradition's—social and magic realism, regionalism and geometric abstraction—had lost their meanings, and new ones had to be discovered. Therefore, artists gathered to consider what such new values might be and whether they constituted a common culture and to find ways of describing and interpreting them. Their needs were urgent enough to keep "these highly individualistic artists together, their ideas criss-crossing and overlapping in a conflict that would tear apart any

other togetherness," as Pavia put it. "They faced each other with curses mixed with affection, smiling and evil-eyed each week for years." (*It Is*, #5, Spring, 1960.)

The Club was meant to be private and informal. At first, every member had a key and came when he pleased. Meetings were generally prearranged by phone calls on the spur of the moment. However, the Club soon took on a more public and formal character, first by inviting speakers (prompted by the Studio 35 sessions), and then by arranging panels. (This move was strongly, but unsuccessfully, resisted.) In keeping with its dual purpose, free-wheeling Round Table Discussions, limited to members, were held on Wednesdays (until 1954); on Fridays, lectures, symposiums and concerts were presented which were open to guests who were mainly critics, historians, curators, collectors, dealers and avant-garde allies in the other arts. The programs, organized by Pavia until the spring of 1955, by Ferren the following year, and by a committee headed by myself from 1956 to the end of the Club in the spring of 1962, became the major activity.

In assuming a semi-public function, the Club, both reflected and contributed to the changed nature of the New York art scene. During the late forties shows by Pollock, de Kooning, Still, Rothko, Motherwell, Kline and other Abstract Expressionists in the galleries of Peggy Guggenheim, Howard Putzel, Betty Parsons, Sam Kootz and Charles Egan, received growing recognition. Such critics as Clement Greenberg, Harold Rosenberg, Thomas Hess, and Robert Goldwater called public attention to these exhibitions. What had been an underground movement came out into the open. Convinced that the art they were creating was more vital, radical and original than any being produced elsewhere, the artists themselves began to demand their just due from art officialdom, or, to put it more accurately, to denounce discrimination. In 1948, a meeting called by artists at the Museum of Modern Art censured hidebound art critics in general and a statement issued by the Boston Museum of Contemporary Art attacking modernism, Again, in 1950, at the three-day conference at Studio 35, Gottlieb suggested that a jury which had chosen a show entitled "American Art Today, 1950" for the Metropolitan Museum be repudiated as hostile to modern art. A letter, signed by 18 artists, was sent to New York newspapers;

this protest was widely publicized, and the signers labeled "The Irascible 18."

The fact that the Waldorf artists organized a club rather than choose a new restaurant, as had been the practice, indicates a change in attitude. However, it must be stressed that the Club never had a collective mission or promoted an esthetic program. It is true that the majority of its founders worked in abstract modes, but they were a diverse group with intents as irreconcilable as de Kooning's and Reinhardt's. It is also true that most of the abstract artists inclined to Expressionism. Naturally, their art became the main topic of discussion, particularly because each member insisted on talking about his own work and experience a novel turn in advanced New York art-talk which in the past had focused on the School of Paris. Moreover, the Abstract Expressionists generated a sense of excitement. As Goldwater remarked: "The consciousness of being on the frontier, of being ahead rather than behind, of having absolutely no models however immediate or illustrious, of being entirely and completely on one's own—this was a new and heady atmosphere," (*Quadrum*, No. 8, 1960.)

But the Abstract Expressionists abhorred all fixed systems, ideologies and categories—anything that might curb expressive possibilities. Extreme individualism was a passionate conviction: "We agree only to disagree" was the unwritten motto. Therefore, no manifestoes, no exhibitions, no pictures on the walls (size and placement might indicate a hierarchy), and, as much as possible, no names of contemporaries, less through iteration some be made heroes and, as Goldwater quipped, to prevent riots. Pavia deserves special mention for keeping the Club neutral and preventing it from becoming the platform for any individual or group.

The early lectures covered many facets of modern culture. Among the speakers were philosophers William Barrett, Hannah Arendt and Heinrich Bluecher, composer Edgard Varese, social critic Paul Goodman, Joseph Campbell, Father Flynn of Fordham University, and the art critic Thomas Hess. There were also parties held in honor of artists such as Alexander Calder, Marino Marini and Dylan Thomas. A selection of events in 1951-52 denotes the range of artists' interests and esthetic positions:

Sept. 28: Martin James led an Inquiry into Avant-Garde Art."

October 12: Peter Blake spoke on "The Collaboration of Art and Architecture."

Nov. 9: "An Evening with Max Ernst," introduced by Motherwell.

Nov. 23: Lionel Abel lectured on the "The Modernity of the Modern World."

Dec. 14: Abel again, on "Work or Free Work."

The following week, Hubert Kappel spoke on Heidegger.

Jan. 18: The symposiums on Abstract Expressionism, prompted by he publication of Thomas Hess' "Abstract Painting," began. The first panel, titled "Expressionism," consisted of Harold Rosenberg (moderator), Baziotes, Guston, Hess, Kline, Reinhardt and Tworkov.

Jan. 25: "Abstact Expressionism II": John Ferren (moderator), Peter Busa, Byrgoyne Diller, Perle Fine, Adolph Gottlieb, Harry Holtzman and Elaine de Kooning (who sent a paper which was read).

Feb.1: "Abstract Expressionism III": Martin James (moderator), George Amberg, Robert Goldwater, Ruth Field Iglehard, Ad Reinhardt and Kurt Seligmann.

Feb. 20: A conversation between Philip Guston, Franz Kline, Willem de Kooning, George McNeil and Jack Tworkov was moderated by Mercedes Matter.

March 7: A group of younger artists, Jane Freilicher, Grace Hartigan, Alfred Leslie, Joan Mitchell, Frank O'Hara and Larry Rivers was moderated by John Myers, continuing the discussion on Abstract Expressionism.

March 14: John Cage spoke on "Contemporary Music," introduced by Frederick Kiesler.

March 21: James Johnson Sweeney led a discussion on "Structural Concepts in Twentieth Century Art." The chairman was Peter Busa.

March 28: "The Purist Idea": Harry Holtzman (moderator), Paul Brach, John Ferren, James Fitzsimmons, Ad Reinhardt.

April 11: "The Image in Poetry and Painting: Nicholas Calas (moderator), Abel, Cage, Denby, Navaretta.

April 25: "The Problem of the Engaged Artist," John Ferren (moderator), Abel, Cage, Denby, Navaretta.

May 2: Dr. Frederick Perls spoke on "Creativeness in Art and Neurosis."

May 14: "New Poets": Larry Rivers (chairman), John Ashbery, Barbara Guest, Frank O'Hara, James Schuyler.

May 21: "Abstract Color Films": Lewin Alcopley (chairman), Ted Connant, Eldon Reed, Bill Sebring.

Of all the subjects discussed, the one that recurred most often and that created the hottest controversy was the problem of community, of defining shared ideas, interests and inclinations. Much as the Abstract Expressionists hated the thought of a collective style, its possible existence concerned them. Attempts to indicate a tendency had been made earlier, i.e., a show titled "The Intrasubjectives," with a foreward by Rosenberg, at the Kootz Gallery in the fall of 1949. The issue of group identity was also raised at the Studio

35 sessions in April, 1950. Gottlieb said, "I think, despite any individual differences, there is a basis of getting together on mutual respect and the feeling that painters here are not academic..." Newman picked up this point, "Do we artists really have a community? If so, what makes it a community?" This question was central to the symposiums on Abstract Expressionism (Pavia called it "The Unwanted Title") at the Club in 1952. Eight panels were entitled "Has The Situation Changed?" in April and May, 1954 and another series had the same heading in January, 1958 and February, 1959. Four panels, "What Is The New Academy?" in the spring of 1959 were continued in 17 statements by artists published in *Art News*, Summer and September, 1959. However, no consensus was ever arrived at.

Part of the difficulty in defining and clarifying shared ideas was the verbal style of the Club. Artists refused to begin with formal analysis, pictorial facts or the look of works. This approach might have implied that Abstract Expressionism was fixed and established style whose attributes could be identified. Further, the ideas of style assumed that making a certain kind of picture was a primary aim. This, the Abstract Expressionists denied. Indeed, most adopted an unpremeditated method to avoid style. The problem of how and why an artist involved himself in painting was more exciting to them than the mechanics of picture-making. The consciousness of being on the frontier, of being on one's own, produced a new and heady atmosphere, but without models to fall back on, the sense of possible failure was intensified. These mixed feelings of elation, doubt and anxiety had to be communicated, partly because they fed into the work, and partly because the talk about them reassured artists that their essays into uncharted areas were not delusional.

Club members supposed that their peers understood how a picture "worked" in formal terms. Therefore, they tended to talk about the function of art, the nature of the artist's moral commitment and his existential role (but with little reference to Existentialism). That is, they tried to transliterate their creative experience rather than the art object. Conversation was treated as the verbal counterpart of the painting activity, and artists tried to convey what they really felt in both. This created frustrating difficulties, because such ideas can rarely be checked against specific works. As Goldwater wrote:

"The proceedings always had a curious air of unreality. One had a terrible time following what was going on. The assumption was that everyone knew what everyone else meant, but it was never put to the test; no one ever pointed to an object and said, see, that's what I'm talking about (and like or don't like). Communication was always entirely verbal. For artists, whose first (if not final) concern is with the visible and the tangible, this custom assumed the proportions of an enormous hole at the center." Self-confession did lead artists to take liberties with, and to strain, language and logic, but there were compensations. What they had to say, they said directly (to the point of brutality), personally and passionately. At times, this resulted in incoherent and egotistic bombast, but more frequently, it led to original, trenchant and provocative insights. The verbal style of the Club also generated bitter personality conflicts, for, as Goldwater remarked, "Since the artist identified with his work, intention and result were fused, and he who questioned the work, in however humble a fashion, was taken to be doubting the man." (*Quadrum*, No. 8, 1960.)

Some of the special flavor of the Club was caught by Jack Tworkov in an entry in his journal of April 26, 1952: "The enthusiastic clash of ideas that takes place in the Club has one unexpected and, in my belief, salutary effect—it destroys, or at least reduces, the aggressiveness of all attitudes. One discovers that rectitude is the door one shuts on an open mind. The Club is a phenomenon—I was at first timid in admitting that I like it. Talking has been suspect. There was the prospect that the Club would be regarded either as bohemian or as a self aggrandizing clique. But now I'm consciously happy when I'm there. I enjoy the talk, the enthusiasm, the laughter, the dancing after the discussion. There is a strong sense of identification. I say to myself these are the people I love, that I love to be with. Here I understand everybody, however inarticulate they are. Here I forgive everyone their vices, and I'm learning to admire their virtues. How dull people are elsewhere by comparison. I think that 39 East 8th is an unexcelled university for an artist. Here we learn not only about all the possible ideas in art, but learn what we need to know about philosophy, physics, mathematics, mythology, religion, sociology, magic." (*It is*, No. 4.)

Despite the bluntness of the discourse at the Club, the panel format made it

somewhat self-conscious and inhibited. The place for more informal and private conversation came to be the Cedar Street Tavern. Artists began to go to the bar, when the panels got dull, or after them. Then, they started to gather there every night when the Club was not open. They arrived late and stayed late. In fact, there was an entirely different clientele in the daytime: New York University professors and students, and a group of horse racing enthusiasts.

Unlike the Waldorf Cafeteria, the Cedar catered to artists. But its owners knew better than to make it look like an artists' bar, for this would have attracted the public and would have driven out the artists. Therefore, there were no paintings on the walls, driftwood, travel posters and other arty emblems of Greenwich Village bohemia. Nor did the management turn it into a neighborhood bar by introducing television. Artists were also attracted by the food which was fair and inexpensive, and by the fact that credit was extended when one got to know the owner. However, the move to the Cedar did reflect a new affluence in the switch from coffee to alcohol. Like the Club, the Cedar's decor was neutral, interchangeable with thousands all over America, reflecting the artists' desire for anonymity. There was nothing to distinguish it as an artists' hangout; in the front, a bar; in the rear, tables. At one time a drab green, the bar was "remodeled" in the late fifties and painted an equally nondescript grey.

Lower middle-class colorlessness became protective coloration. It shielded the artists from the "creative-livers," and the Beats, from Madison Avenue types who posed as bohemians after five o'clock, from the chic of all varieties who came slumming, and from Brooklyn and Bronx tourists who came to gape at the way-out characters. To further discourage these interlopers, the artists tended to dress soberly. Indeed, the Cedar typified a "no-environment"—de Kooning's term for the milieu of contemporary man—no nostalgia, romance or picturesqueness. It may also be, as Harold Rosenberg has suggested, that an artist could best engage in finding his personality in as neutral an environment as possible. The very name, or more accurately, misname—the Cedar Street Tavern, for a bar located on University Place—symbolized, unintentionally of course, the refusal of its customers to accept fixed categories. An establishment that could not get its own name straight must

be the right place for a group that could never decide on a name for its club.

The idea of mounting an exhibition of the works of Club members—like a big salon—was raised many times, but was rejected because it might indicate a trend or position and curb the open character of the Club. However, in the spring of 1951, it was finally decided to have a show, but not under the direct auspices of the Club. A group of charter members with the help of Leo Castelli (who, among other things, put up the rent money) leased an empty store at 60 E. 9th Street (next door to the studios of Kline, Marca-Relli and Ferren), chose the artists and installed the show. Sixty-one artists were listed on the announcement of the 9th Street Show, which, in the main, read like a Who's Who of Abstract Expressionism. However, with the exception of Motherwell, painters who had been connected with, or close to, the "Subjects of the Artist" School (Baziotes, Gottlieb, Newman, Rothko and Still) did not submit canvases, a sign of their growing indifference to the Club by 1951. Most of the exhibitors did not think that the show would attract much attention, but it did. There was a large crowd on opening night, May 21, and the rest of the show was well attended (it closed on June 10). The 9th Street Show generated a sense of exultation, a feeling that something important had been achieved in American art.

After 1955, the year Pavia left the Club, the makeup of the Club changed. Older members began to attend less often, even though many continued to pay dues. The beginnings of this turn were evident as early as May, 1952, when a voting meeting was devoted to the topic of disbanding the Club because it had outlived its function. A younger generation took over, the "inheritors," as Rosenberg called them, but that is another matter.

During the 1950s, as an art critic and art historian, I was an advocate of Abstract Expressionism. Consequently, I was very interested in critical moments in the development of their painting and its art-world and public reception. In 1950, the Abstract Expressionists protested a show at the Metropolitan Museum of art which made front page news in newspapers and magazines. What had been an underground movement came out into the open and made a bid for public recognition. This was the turning point after which the new American painting was taken seriously by the art establishment. In choosing themselves, the Irascibles separated themselves from other Modernist artists in New York. As a group, they made a bid for recognition, and they succeeded, since, with several exceptions, the Irascibles Came to constitute the pantheon of Abstract Expressionism.

228

The Irascibles

I n 1950, it suddenly became intellectually disreputable to dismiss avant-garde art or ridicule it as a lunatic or infantile aberration. Exemplifying this dramatic change was a policy statement issued in March by the Museum of Modern Art, the Whitney Museum of American Art, and Boston's Institute of Contemporary Art proclaiming "the continuing vitality...of modern art:" that is, "art which is aesthetically an innovation." The three museums promised that in the future they would treat advanced art fairly, and their attitude came to be shared by American museums generally.

Avant-garde artists welcomed the three-museum statement, but they still believed with justification that they were being discriminated against by the art establishment. On May 20, eighteen painters, most of whom would soon be labeled Abstract Expressionists, supported by ten sculptors, sent a public letter to the president of the Metropolitan Museum of Art protesting a national juried exhibition titled *American Painting Today-1950*, organized by the Museum, even though several had been among the 18,000 artists who had been invited to submit. The protesters denounced the conservatism of the five regional juries, the national jury, and the jury of awards. The "choice of jurors:' they wrote, "does not warrant any hope that a just proportion of

advanced art will be included." Therefore, they would boycott this "monster" show.

In a later article on the affair (*Arts Magazine*, September 1978), B.H. Friedman remarked that the letter had been suggested by Adolph Gottlieb at a three-day closed conference of avant-garde artists at Studio 35 (April 21-22). In consultation with other artists, notably Barnett Newman, Robert Motherwell, and Ad Reinhardt, Gottlieb drafted the letter and had it approved and signed. Newman hand-delivered it to the *New York Times* on Sunday, May 21. Luckily, there was no major news, and on the following day, the *Times* ran the story on the front page under the heading: "18 Painters Boycott Metropolitan: Charge 'Hostility to Advanced Art.'" On May 23, the *New York Herald Tribune* published an editorial titled "The Irascible Eighteen" (giving the artists a label), which condemned the protesters and defended the Metropolitan Museum. So did a letter to its Director, signed by seventy-six artists, including Milton Avery, Byron Browne, and Philip Evergood, expressing confidence in the integrity of the jurors, but this letter hardly made any news. Entering the fray that summer, *Art News* agreed with the Irascibles' assessment of the Metropolitan's juries but nonetheless urged the artists to enter the competition. *Art Digest* scolded the dissenting artists for convicting the Museum before trial and spoke up for the fairness of the jurors.

Weldon Kees, one of the signers of the Irascibles' letter and at the time the art critic for *The Nation*, continued the attack on the Museum in his column on June 3. On June 5, *Time* reported on the controversy in the lead article of its art section, the story accompanied by reproductions of paintings by William Baziotes, Ad Reinhardt, and Hans Hofmann. Then *Life* decided to cover the protest, planning to publish a picture story after the winners of the Metropolitan competition were announced on December 5. Dorothy Seiberling, an art editor at *Life*, contacted Gottlieb and requested that a photograph of the Irascibles be taken. After considerable negotiation, the painters met with *Life* staff photographer Nina Leen who took her now famous group portrait.

In brief, these are the facts, but what did the affair signify? First of all, the

Irascibles had developed a new collective consciousness. In the early and middle forties, as Gottlieb put it: "We were all separated. All we knew was that we were isolated, alienated, and nobodies... However, by 1945-46, there suddenly seemed to be an awareness that something new was happening." The artists did not specify what that something new was; they never issued a manifesto, and they resisted the notion of a group. At the three-day conference at which the protest was proposed, Alfred Barr, the only non-artist participant, suggested that the artists decide on "the most acceptable name" for themselves before others did. "It has been called Abstract-Expressionist, Abstract-Symbolist, Intra-Subjectivist, etc." Willem de Kooning countered: "It is disastrous to name ourselves," and he spoke for the assembled painters as a whole. Jackson Pollock was particularly concerned lest the Irascibles be viewed as a group, and he would sign the letter only if it was clear that they were not.

If the Irascibles did not share an aesthetic or a style, they did imply in their selection of each other that they recognized the radicality. originality, and quality of one another's work. More than that, they believed that their art was different from and better than what other artists at the time were making, including colleagues of theirs in the avant-garde whom they left out, not only from the protest, but from the three-day conference. (For example, Janice Biala, Norman Lewis, and Ralph Rosenborg were at the conference but were not among the Irascibles.) The Irascibles also chose each other because, with three exceptions, they were represented by three galleries. Nine were in Betty Parsons, four in Samuel Kootz (although Kootz tried to dissuade them from signing the letter), and two in the Peridot. In retrospect, it appears that the eighteen painters had established, if not a group, then a group consensus about the superiority of their own painting. And it was perceived that way, although they stated in their protest letter: "We believe that all advanced artists of America will join us in our stand." One excluded artist wrote Gottlieb that he "was made very unhappy by not being invited to join this group—aren't I good enough for them?"

In their letter, the Irascibles assumed an aggressive stance, denouncing the Metropolitan's Director, who "on more than one occasion has publicly declared his contempt for modern painting," and the Associate Curator of

American Art for "accepting a jury notoriously hostile to advanced art." "We draw to the attention of those gentlemen the historical fact that, for roughly a hundred years, only advanced art has made any consequential contribution to civilization." Nonetheless, Gottlieb viewed The Irascibles' action as a defensive one. "If there was any sense of solidarity, it was just out of a sense of mutual self-protection, like everybody else was against us, so we had to stick together a little bit." There was much to be mutually self-protective about, as Kees wrote in *The Nation* at the beginning of 1950: "One is continually astounded that art persists at all in the face of so much indifference, failure and isolation." But there was hope; Stuart Preston commented in the *New York Times*, September 17, on the forthcoming confrontation between advanced and conservative artists in military terms: "One sure thing about the new art season is that the nonfigurative forces will be stronger. They have regrouped; their commanders are older and more seasoned."

The photograph of the Irascibles in Life has been reproduced so often and has been disseminated so widely that today it has become the image whereby we envision the artists who achieved the triumph of American painting. But in 1950, having their photograph appear in a mass culture magazine raised troublesome questions. At first, *Life* asked the artists to pose holding up their paintings on the front steps of the Metropolitan Museum. The artists refused out of hand, because, as Gottlieb recalled, "that would look as if we were trying to get into the Metropolitan and we were being turned down on the steps." Gottlieb went on to say that the art editors "were very surprised at this, because nobody refuses anything to *Life* magazine." But the artists would not permit *Life* to make them look ridiculous. Newman, Motherwell, and Bradley Walker Tomlin then met with the art editors and proposed that the photograph be taken in a neutral space, and *Life's* photographic studio was agreed upon.

There was a deeper problem in collaborating with *Life*, namely the avant-garde's hatred of mass culture. As the leading purveyor of kitsch, *Life* was the enemy. What was equally distressing, *Life* had long proselytized against new art and had actively promoted retrogressive representational styles. Nevertheless, the magazine could not ignore modern art. On October 11, 1948, it presented "A Life Round Table on Modern Art," a section of which

was devoted to "Young American Extremists," and on August 8, 1949, an article on Pollock with the provocative subtitle: "Is he the greatest living painter in the United States?" But more characteristically, on February 21, 1949, *Life* condemned modern art as "a silly and secretive faddism" and lauded "the main trends in U.S. art of this century which are rooted in native traditions that are romantic and realistic."

At a meeting of the artists called by Newman, Motherwell, and Tomlin at which they reported on their negotiations with *Life,* Mark Rothko and Richard Pousette-Dart voiced strong reservations about having anything at all to do with the magazine; Rothko because it epitomized mass culture, Pousette-Dart because it represented the Establishment. But other artists argued that because the photograph would be "honest," meaning dignified, it would be permissible to pose, and they prevailed.

Friedman reported that fourteen of the artists met on November 24. "Brooks and Pollock took the train in from East Hampton and arrived early. Hedda Sterne arrived late and went directly to the studio. Bultman was in Rome...Kees had gone to San Francisco...And Hofmann had remained in Provincetown, Massachusetts, from which he sent a telegram to Newman: 'Sorry not to be with you all on the foto. With my sympathy for our cause!'"

Annalee Newman recalled that "Barney kept insisting that the group be photographed like bankers" The painters all wore suit jackets and ties. Yet even a cursory glance at the Leen photograph reveals that the artists did not look at all like bankers; certainly any banker or artist could have told the difference. The artists looked too intense. However, they did resemble businessmen more than bohemians. They did not dress up for the *Life* portrait; that was how they generally appeared in public. Even when they met among themselves, they wore suit jackets and ties, as at the three-day conference at Studio 35 (see photograph in Modern Artists in America, edited by Motherwell and Reinhardt) or at other meeting places (see Fred McDarrah's *The Artist's World in Pictures*). Although they were alienated outsiders, contemptuous of the middle class, the Abstract Expressionists did not want to be taken for Greenwich Village bohemians who lived the life of art without creating much of it. The Irascibles' appearance calls to mind Degas' remark

to the flamboyant Whistler: "You dress as if you had no talent."

The Leen photograph which appeared on January 15, 1951, not only did not make the artists look ridiculous, it made them look monumental. It is indeed a remarkable image. The eye first perceives the artists as a massive block (of genius); then is pulled into the triangular space formed by Stamos, Newman, and Rothko; then drawn in a slow spiral movement toward Hedda Sterne at its apex, turning the rectangle into a heroic triangle. Moreover, Leen opened up the mass, creating spaces. Each artist occupies his or her own space and emerges as an individual, indeed, as the individualist each was. The Irascibles were people with faces—and Leen captured that brilliantly.

The text that accompanied the photograph, titled "The Metropolitan and Modern Art" was brief and mainly factual. Instead of illustrations of paintings by the Irascibles it included eight color plates of pictures in the Metropolitan show, four by winners Karl Knaths, Rico Lebrun, Yasuo Kuniyoshi, and Joseph Hirsch. Incidentally, in that same week *Life* also contained an article on Gerald McBoing-Boing, an animated cartoon character who spoke in sound effects instead of words, and made a million bucks doing so.

The Irascibles' letter became significant because it was featured not only in art magazines but in the mass media. That it was indicates that the painters had become well known enough in 1950 to warrant an article on the front page of the *Times*, an editorial in the *Tribune*, and stories in *Time* and *Life*. Even the *Daily News* ran a three-and-one-half inch item on May 22. (A protest two years earlier by artists at the Museum of Modern Art against the anti-modernist policies of Boston's Institute of Contemporary Art received comparatively little attention.) The new status of the avant-garde was commented on by Motherwell and Reinhardt in 1951. "From East to West numerous galleries and museums, colleges and art schools, private and regional demonstrations display their mounting interest in original plastic efforts." Indeed, the Irascibles so commanded the attention of the media that most reports and reviews of the Metropolitan show noted their absence and recapitulated the reasons for it. In fact, they may well have influenced the selection of the 307 artists shown at the Museum. The Irascibles' protest, as

Life stated, "did appear to have needled the Metropolitan's juries into turning more than half the show into a free-for-all of modern art."

Avant-garde artists did not achieve widespread public acceptance and success until well into the fifties. For most of the decade advanced artists were alienated, neglected, and embattled. For example, Pollock did not sell a single large picture from his show in 1951. However, the three-museum statement and the Irascibles' protest in 1950 signalled a critical change in art world attitudes toward avant-garde art. In their aftermath, the Museum of Modern Art mounted in 1951 *Abstract Painting and Sculpture in America*, including twelve Irascibles, and in 1952, Fifteen Americans, which featured five, putting MoMA's stamp of approval on first-generation Abstract Expressionism. It is also noteworthy that in 1950, *Art News*, whose managing editor was Thomas Hess, began to publish articles on the Abstract Expressionists, and that in the following year, there appeared Hess's *Abstract Painting*, the first book to feature the Abstract Expressionists.

The Metropolitan Museum's attitude toward American avant-garde art changed within a half dozen years after the Irascibles' protest. In 1957, the Museum acquired Pollock's *Autumn Rhythm*, a daring purchase at the time. In 1969, the Museum celebrated its centennial by mounting an exhibition, *New York Painting and Sculpture 1940-1970*. The show consisted of 410 works by forty-three advanced artists, ten of whom had been Irascibles, artists its curator Henry Geldzahler proclaimed had "significantly deflected the course of recent art" installed in 50,000 square feet of gallery space, the show was one of the biggest ever put on by the Metropolitan and attracted a quarter of a million viewers. The Museum's sympathy for advanced American art continues; it is clearly manifest in the collection on display in its new wing selected by William Lieberman, Chairman of Twentieth Century Art, in which most of the Irascibles are prominently displayed.

FOR THE CATALOGUE OF A SHOW ON THE EAST
VILLAGE SCENE OF THE EARLY AND MIDDLE
1980s, I WAS ASKED TO WRITE AN ESSAY ON
THE HISTORY OF EARLIER ART INSTITUTIONS IN
WHICH ARTISTS PLAYED A MAJOR ROLE IN NEW
YORK CITY SOUTH OF 14TH STREET. I BEGAN
WITH THE TENTH STREET STUDIO BUILDING,
FOUNDED IN 1857 AND DEMOLISHED IN 1956 AT
THE VERY MOMENT THAT THE COOPERATIVES SET
UP BY YOUNG PAINTERS AND SCULPTORS OF THE
NEW YORK SCHOOL ON ANOTHER PART OF TENTH
STREET WENT INTO HIGH GEAR. WE ON TENTH
STREET HAD THE APLOMB—WITH JUSTIFICATION—
TO BELIEVE THAT WE WERE AT THE HUB OF THE
INTERNATIONAL AVANT-GARDE. MY ARTICLE
CONCLUDED WITH REMARKS ON THE ARTISTS'
EXHIBITION SPACES THAT WERE FOUNDED IN THE
1970s.

Tenth Street Then and Now

Unaccountably, at different times certain places—Paris's Left Bank, New York's Tenth Street—have an aura of art that attracts painters and sculptors. Tenth Street's appeal extends back in time to 1857, the year in which the Tenth Street Studio Building between Fifth and Sixth Avenues was opened. The idea was James Boorman Johnson's. He recognized that American artists needed comfortable, live-in studios at reasonable rents, and he decided to do something about it. Johnson commissioned Richard Morris Hunt, who designed a three-story brick building containing some twenty-five studios, airy and ample (by standards then)—some, fifteen by twenty feet, others, twenty by thirty feet. The list of tenants reads like a Who's Who of American art in the second half of the nineteenth century: John La Farge (from the opening of the Studio until his death in 1910), Winslow Homer (for eight years), Frederick E. Church, William Merritt Chase, Sanford R. Gifford, Martin J. Heade, and Albert Bierstadt, among others.

With so many artists in one building, there was a continual exchange of ideas—some of it more than verbal. Apparently, "at least once, Church painted half of one of Martin J. Heade's canvases in the latter's absence."

There was also "a constant coming-and-going of buyers, sightseers, pupils and arbiters of taste from the press." The Studio Building included a large exhibition space, which, at a time when there were very few galleries, served as a kind of salesroom. It became the setting for openings as well. Indeed, artists' receptions became the center of social life. As Mary Sayre Haverstock wrote, they "were the rage [and] no effort was spared to make them gala affairs." Yet, "the atmosphere was much more like that of an established gentlemen's club."[1]

The Studio was not the only art institution on Tenth Street. From 1858 to 1861, the National Academy of Design, many of whose leading artists lived and worked in the Studio, was situated on the corner of Fourth Avenue; its annual salons were major artistic and social events. Mathew Brady's New Photographic Gallery, a popular attraction at the time, was close by. Chase's studio was the meeting place of a number of other artists' groups: the Society of American Artists, which resisted successfully the hegemony of the Academy; an Art Club, with Walter Shirlaw, James Beckwith, Frederick Dielman, and Augustus St. Gaudens among its members; and later, the Society of American Painters in Pastel, which included John La Farge, John Henry Twachtman, J. Alden Weir, and Edwin Blashfield.[2]

The Tenth Street Studio Building was not demolished until 1956. In that year the Tenth Street artists' cooperative galleries entered into their most active phase, anticipating the international recognition of *The New American Painting*, the name of a show of Abstract Expressionist or New York School painting, organized by the Museum of Modern Art and shown in eight European countries, 1958-1959. Fifties artists no longer lived in one building but in a low-rent neighborhood centered on Tenth Street, a few blocks to the east of the old Studio. Indeed, on this street alone in 1956 were the lofts of more than twenty-five painters and sculptors, including Willem de Kooning, Philip Guston, Giorgio Cavallon, Esteban Vicente, Milton Resnick, James Rosati, William King, Michael Goldberg, and Gabriel Kohn.[3] Tenth Street was also within walking distance of other focal points of the New York School: the Cedar Street Tavern, on University Place just to the north of Eighth Street, and the Club, a cafe-forum founded by the first generation Abstract Expressionists in 1949 and taken over by the second

around 1956. The Club moved from loft to loft, like some floating dice-game, as one wit quipped; for two years or so in the late fifties it was located on the corner of Tenth Street and Fourth Avenue.

Galleries were relative late-comers on Tenth Street. Most were founded by artists of the New York School's second generation[4] who believed that their work merited exhibition but could find no uptown gallery willing to take the risk. It was natural that most—five of the eight cooperative[5]—should be located between Third and Fourth Avenues, since that was the geographic hub of the avant-garde art world, in the neighborhood where most of the audience, composed primarily of painters and sculptors, lived.

The first of the Tenth Street cooperatives was the Tanager which opened in 1952 in a former barbershop on East Fourth Street and in the following year moved to Tenth Street. Among its better- known members during the ten years of its existence were Alex Katz, Philip Pearlstein, William King, and Tom Wesselmann. During the fifties, the Tanager exhibited more than 130 artists, half for the first time in New York, and gave 21 nonmembers their first New York shows, including Alfred Jensen and Gabriel Kohn. The other major galleries, because of the stature of the artists who belonged, were the Brata Gallery, which numbered among its members Al Held, George Sugarman, and Ronald Bladen, and the Reuben Gallery; which was private but whose owners relied heavily on the ideas of artists they exhibited, mostly Environment- and Happening-makers, notably Allan Kaprow, George Brecht, Robert Whitman, Red Grooms, Claes Oldenburg, Jim Dine, Simone Forti, and related artists George Segal and Lucas Samaras.

It was natural that the Tenth Street galleries, with a few exceptions, should be cooperative, financed, managed and for the most part manned by their members, because sales were not expected and, in fact, were rare. In the three years that I ran the Tanager Gallery,[6] I sold only one work, to a woman who walked up to the desk at which I was writing a review for *Art News*. She announced that she wanted to buy a sculpture, which must have put me in a state of shock. Our conversation went somewhat as follows:

How much is it?

One hundred and twenty-five dollars.

I'll purchase it.
Will you leave a deposit?
No, I will write a check for the entire amount.
Where shall we deliver it?
To the Museum of Modem Art.
What is your name?
Mrs. Mellon.
How do you spell that?

But selling did not matter very much then, for artists made a virtue out of their poverty. What counted most was the approval of other artists. The members of Tenth Street cooperatives conceived of their mission as showing art that they found worthy to their peers; they thought of the galleries as public extensions of the artists' studios.[7] It should be stressed that Tenth Street painting was varied—the commonly held notion, first advanced by Clement Greenberg, if memory holds, that most of it was School of de Kooning, was not correct. Yet, with a few exceptions, it was painterly or gestural to some degree, and in this sense there was a common style.

The Tanager statement's seriousness of tone reflected the life-style of fifties artists. Their primary social activity was talking about art in each other's studios, the Cedar Street Tavern, the Club, and even at parties, although there was also drinking and dancing. The artist-run storefront galleries became centers of communal activities, places where artists could always find other artists to converse with, and on the joint Friday night openings of all of the galleries, where they could participate in festivities that resembled big block parties. In public, artists wore suits and ties, aiming to appear anonymously unike generations to come. Colorlessness was taken as a sign of seriousness, the manifestation of a self-image of the artist as creator rather than as creative liver, either in the style of Bohemia or the world of fashion. Artists spurned both worlds.

What caused Tenth Street to decline? Elsewhere, I have written that innovative artists who emerged in the sixties found the scene "hostile and avoided it. More specifically accountable was the success of a significant number of Tenth Street artists generally considered the best success in that they were

asked to join prestigious commercial galleries uptown [and the artists joined willingly)... As the best artists began to exhibit away from Tenth Street, what remained to be seen there was of decreasing interest. Aggravating this situation was the increase of mediocre, derivative, and eclectic work produced by the influx of newcomers who could show their work with greater ease—and did. This glut of inferior art drove away the audience and discouraged lively and ambitious young artists from exhibiting downtown. To state it bluntly, it was no longer important to show on Tenth Street-or to be [or even visit] there-and when this occurred, the scene declined."[8] To put it another way, the energy that generated the Tenth Street galleries and, for that matter, the Club, dissipated by 1962. 1 cannot specify what this energy was, what generated or dissipated it (and no one else has done so, to my satisfaction), but when it was gone, most everybody knew.

Artists did not need to found galleries in the sixties. There occurred a tremendous growth of the art market, and many new commercial galleries, such as Richard Bellamy's Green Gallery, and old ones, such as Leo Castelli's, took on avant-garde newcomers. Toward the end of the decade, artists did organize the Art Workers Coalition and other groups to protest the Vietnam War and social and art world "evils," including the art boom. In part, because of the distaste for art-as-a-commodity, artists focused on the conceptual component of their work at the expense of its physicality. There was a concomitant interest in hard-to-market earth, process, site-specific, multimedia, performance, body, and video art. Traditional studio media were widely rejected; in fact, a recurring topic of debate was: Is Painting Dead?

Works of art that were not objects did not appear to be salable and thus to require conventional gallery spaces, particularly commercial ones. But in the early seventies, artists working in new media increasingly sought to exhibit their work and/or its documentation in galleries that would allow them to do pretty much what they wanted to in the space. Moreover, there emerged a new generation of painters and sculptors, more numerous than ever before, that had difficulty finding dealers willing to show its work. At this moment, public agencies, such as the National Endowment for the Arts and the New York State Council on the Arts, made sizable sums of money available for the arts. These grants could only be awarded to not-for-profit organizations; in

response, so-called alternative spaces for the display of contemporary art arose to meet the needs of artists.[9] There also emerged a number of artist-run galleries, most of them with a feminist or realist mission, which, because they represented causes, were combative in a way that fifties cooperatives were not.[10]

The alternative space in New York that was most committed to exhibiting a broad range of artists unaffiliated with commercial galleries, and thus for the most part young, was Artists Space, founded in 1973 by Trudie Grace and myself with a grant from the New York State Council on the Arts. In the first three years of its existence, each unaffiliated artist shown there was selected by a relatively well-known artist on a one-to-one basis. Among the dozens of artists who were given their first major display in New York in the seventies were Laurie Anderson, Jonathan Borofsky, Scott Burton, Louisa Chase, Barbara Kruger, Ree Morton, Judy Pfaff, Ellen Phelan, Charles Simonds, David Salle, and John Torreano.[11] Helene Winer became the director of Artists Space in 1976 and changed its orientation somewhat, assuming more of a curatorial role, that is a "more active role in identifying, explicating, and supporting art that is genuinely new, usually unfamiliar and otherwise con-troversial,"[12] frequently inviting guest curators to organize shows. But the gallery's fundamental mission-benefiting unafiliated artists—did not change.

It was widely hoped that alternative spaces might constitute a new art sup-port network, alternative to the commercial one. This did not occur. Much as they tried, their administrators did not succeed in selling much art. To blame were their inexperience in salesmanship and their populist policy of showing an artist only once, or infrequently. Thus, they could not represent the artist as a commercial gallery would have; nor could they inspire the con-fidence collectors seem to require and dealers seem able to provide because of their knowledge of the art market and their commitment in time, monies spent for rent, staff, advertisement, etc. It is noteworthy that Helene Winer could not sell much of the works of artists she had exhibited at Artists Space until she left and opened a private gallery together with Janelle Reiring. Dealers, such as Holly Solomon, followed the shows at Artists Space closely and invited participating artists to join their stables, and they did.

Since Artists Space and other alternative organizations turned out to serve primarily as conduits to commercial galleries, many of them new, and because of the success of these galleries, it occurred to members of a new generation that emerged around 1980, most of them artists, that they could open private galleries in order to exhibit their own work and that of their friends in whom they believed. A number took the risk with relatively little investment, transforming hole-in-the-wall storefronts in dilapidated tenements in and around East Tenth Street into exhibition spaces. There had already developed a community, composed of a significant number of young artists who, in search of low rents, were attracted to the East Village—an area bounded on three sides by Third Avenue, the East River, and Fourteenth Street, and stretching below Houston Street into the Lower East Side. These artists became friends, visited each other's studios, exchanged ideas and partied together, and frequented the same bars and clubs, such as Club 57 on St. Marks Place, conceived by its denizens as a kind of Club Voltaire, and the Limbo Lounge on Tenth Street, to name two of many.[13] As Rene Ricard remarked: "One doesn't open a gallery to attract artists, one opens a gallery because one has them already. The Fun wasn't started because Patti Astor [an underground film star] wanted to become an art dealer, she knew artists who'd already made themselves noticed and wanted 'to give them their first show.'"[14] in a sense, the East Village galleries evolved from the need of a generation of artists to find public outlets for its energies.

The role of communal life, notably what Edit DeAk once termed "Clubism," must be stressed. As Krystina Kitsis wrote: "The essence of the club has always been the meeting point of image, music and dance in a confined space, dedicated to social cohesion and self-awareness. A sense of euphoria induced through drink, drugs and dance, culminating in an atmosphere and social ambience that shifts between fantasy and reality."[15] The East Village community was based not only on geographic proximity and generational and social ties, but also on shared expectations of what new art should be. This sensibility did not yield a single style but a kind of common denominator of greatly heterogeneous styles—and that variety should be stressed. Nonetheless, much of East Village art is small in scale, because of the size of studios and galleries, and figurative, often alluding to the neighborhood's mean but ethnically diverse street life and its art (graffiti), and/or

to Pop Art and mass media imagery. It is also influenced by "bad" art, as it used to be called in the late seventies, including Neo-Expressionism and other variants of New Image or New Wave painting, and more recently Surrealism. It is blatantly eclectic, cannibalistic, frequently quoting its sources directly, either in irony, nostalgia, fantasy or futility. If East Village art has any claim to being avant-garde, it is because it has muscled into "high" art such "low" art forms as ghetto-spawned spray-can writing, the trashiest of mass media kitsch, and the crudest of "bad" painting exacerbating an abrasive tendency in modern art that goes back to the Unfinished looking pictures of Delacroix, Courbet and Manet.

The first East Village gallery, the Fun, was opened by Patti Astor in 1981 on Tenth Street near First Avenue; it was followed within months by 51X, Nature Morte, Civilian Warfare, and Gracie Mansion, and, over the course of the next two years or so, by some three dozen. others, perhaps by now even more.[16] Why did Astor and the dealers who followed her lead opt for commercial rather than alternative galleries? One reason was that they would not have been free to show their friends only, lest they seem to be diverting public funds from serving the many, which is governmental policy, for the profit of the few. Moreover, as Astor pointed out: "I just wanted a place to show art and didn't want to bother with. filling out grant forms"[17]—the interminable administrative chore of not-for-profit institutions.

New commercial galleries in large numbers could only have arisen at a time when painting and sculpture—works of art as salable objects—were valued. And the art world in the seventies had become "canvas-happy," as Edit DeAk put it,[18] as it had not been for over a decade; art became chic again, and sales and prices skyrocketed. This led young artists and their friends to accept as role models rich and fashionable artists, many of the most celebrated in their early thirties, and their counterparts in gallery business, such as Mary Boone, Leo Castelli, Paula Cooper, Barbara Gladstone, Miani Johnson, Robert Miller, Janelle Reiring, Holly Solomon, Angela Westwater, and Helene Winer (not in her former role as director of Artists Space but as a co-owner of Metro Pictures). (ironically, at the same time, East Village dealers were inspired by the "poor" look of ghetto-based alternative spaces, which were both anti-commercial and anti-art world alternative galleries, such as

Fashion Moda, founded in 1978; ABC No Rio, 1980; and Group Material, 1981.) Eighties artists seek celebritythe kind of fame and glamor achieved by rock or movie stars and the tangible rewards it yields.[19] Even those artists who create political protest art demand that their galleries sell it, and understandably. Rents today are astronomical compared with what they were in the fifties. It costs much more, relatively, to survive as an artist in New York now than it did then. But on the whole, as Rene Ricard summed It up: "Everybody wants to be the next Andy Warhol.... Patti uses art to star in."[20]

By now, the East Village galleries are Established with a capital "E." Helene Winer has written:

> They have been enthusiastically embraced by the full complement of the art world-public and private institutions, journalists, collectors and artists. This is evident in art magazine articles, The New York Times coverage, guest exhibitions in established galleries, a map in the ubiquitous Gallery Guide, avid coverage in...The East Village Eye and New York Beat, enormous artist-attended openings, and the heavy visitor traffic on Sunday afternoons. This development affirms the perpetual renewal of the artists' community.[21]

It also signifies its institutionalization, as Walter Robinson and Carlo McCormick remarked: "Last summer [1983], after a year and a half of incubation, press attention and sales began to take off, to the surprise of almost everyone. In effect, the area's artists and dealers became accomplices in an unspoken conspiracy to forge a collective identity and use it as a marketing tool." And it appears that the "private, economic entrepreneurship" of the East Village art scene "suits the Reaganite zeitgeist remarkably well."[22] (Lest what I have written imply that the new galleries have supplanted alternative spaces in New York, they have not. Their number notwithstanding, they are too narrow, drawing too heavily on neighborhood artists who produce salable art. Alternative art will continue to require alternative spaces. Moreover, despite the market-consciousness of East Village galleries, many are not likely to show a profit and thus will turn out to resemble not-for-profit organizations, although they will go bust, of course.)[23]

What of the future of the East Village galleries? Because they developed into "a miniature replica of the contemporary art market," as Craig Owens remarked[24] they will have to prove themselves commercially and it appears that several will, becoming a kind of Soho East. If they do not, their best artists will be skimmed by more successful Soho and uptown galleries, and a number have been. Zooming rents are a threat to the existence of the new galleries and of the community of artists, many of whom are already being forced out, and their departure will lead to the dissipation of collective energies. (Ironically, the emergence of the East Village art scene is a major cause of the gentrification or Sohoization of the neighborhood.) The relative success of a few "winners" will probably sour relations with their less recognized friends and further weaken communal spirit. It always has in the past. Be all that as it may, at the moment there are a number of lively artists identified with the East Village, as this show amply illustrates, and that's the bottom line.

Notes

1. Mary Sayre Haverstock, "The Tenth Street Studio," *Art in America*, September-October 1966, pp. 50-51.

2. Ibid., p. 55.

3. In 1956, the Tanager Gallery organized a show titled *Painters and Sculptors on Tenth Street*, composed of the works of twenty-five artists living on the street. The artists were Ruth Abrams, Robert Bek-Gran, Charles Cajori, Giorgio Cavallon, Martin Craig, Michael Goldberg, Philip Guston, Angelo Ippolito, Alfred Jensen, William King, Gabriel Kohn, Willem de Kooning, A; Kotin, Saul Leiter, Linda Lindeberg, Pat Passloff, Howard Petersen, Vita Petersen, Milton Resnick, James Rosati, Ludwig Sander, George Spaventa, Albert Swinden, Esteban Vicente, and Steve Wheeler.

4. The members of the Tenth Street Cooperatives were not the earliest second-generation artists on the New York art scene. They were preceded by Nell Blaine, Helen Frankenthaler, Michael Goldberg, Robert Goodnough, Grace Hartigan, Alfred Leslie, Joan Mitchell, Robert Rauschenberg, Larry Rivers, and others. A number had shown at the artist-run Jane Street Gallery, during its existence from 1944 to 1949.

5. The artists' cooperatives in and around Tenth Street were the Tanager and the Hansa, founded in 1952; the James, 1954; the Camino, 1956; the March and the Brata, 1957; and the Phoenix and the Area, 1958. More than 200 artists were members of these galleries. (The Hansa Gallery moved uptown in 1954 and generally is not counted among Tenth

Street galleries.)

There were also a number of private galleries whose owners were so close to the artists they exhibited as to be coupled with the cooperatives. Among them were the Fleischman, 1956; the Nonagon and the Great Jones, 1957; and the Reuben, 1959.

6. I was hired by the Tanager Gallery to sit for three afternoons a week when the parents of one of its members provided a small grant. All decision-making was made by the Tanager's artist-members.

7. Irving Sandler, Statement, *Tanager Gallery* exhibition catalogue, October 16-November 5, 1959, n.p.

8. Irving Sandler, *The New York School: The Painters and Sculptors of the Fifties* (New York: Harper & Row, 1978), p. 42.

9. Leading not-for-profit alternative exhibition spaces organized in New York during the seventies were 112 Greene and the Kitchen, opened in 1971-72; the Clocktower and Artists Space, 1973; the Alternative Museum, 1975; P.S. 1 and Franklin Furnace Archive, 1976. See Phil Patton, "Other Voices, Other Rooms: The Rise of the Alternative Space," *Art in America*, July-August 1977, and Kay Larson, "Rooms with a Point of View," *Art News*, October 1977.

10. AIR and Soho 20 are the leading Feminist cooperatives. The artist-run Bowery, First Street and Prince Street galleries are devoted to realism.

11. For accounts of the organization of Artists Space and its first three years, see Trudie Grace, "Artists Space," *Art Journal*, Summer 1975, and Irving Sandler, "Artists Space," *10 Artists/Artists Space*, exhibition catalogue, Neuberger Museum, State University of New York at Purchase, September 9-October, 15, 1979.

12. Helene Winer, "Ten Artists," *10 Artists/Artists Space*, p. 7.

13. See John Howell, "Nightlife 1984," *New York Beat*, November 1983.

14. Rene Ricard, "The Pledge of Allegiance," *Artforum*, November 1982, p. 43.

15. Krystina Kitsis, "Nightlife: Subcultural Sexuality," *ZG*, Number 7, 1982, P. 15. Howell, in "Nightlife 1984," p. 10, remarked: "At their best, clubs are not merely entertainment tonight, but influential centers of fashion, social mores, music, and cross-cultural networking.

16. Helene Winer, curator, *New Galleries of the Lower East side*, Artists Space, January 21-February 18, 1984, included artists from seventeen galleries: Cash, Christminster, Civilian Warfare, East 7th Street, Executive, 51X, Fun, Tracy Caret, International with Monument, Gracie Mansion, Nature Morte, New Math, Oggi Domani, Pat Hearn, Piezo Efectric, P.P.O.W., and Sharpe. Walter Robinson and Carlo McCormick, in "Report from the East Village: Slouching toward Avenue D," *Art in America*, Summer 1984, p. 137, add

Area X, Art City, Arts & Commerce, Caidoz, Facchetti-Burk, La Gaileria, Max, MO David, M-13, Public Image, St. Mark's, Sensory Evolution, Lily van der Stoker, and Virtual Garrison. For information on the East Village art scene and art, I am in debt to Walter Robinson and Edit DeAk for our many conversations over the years, and to Carlo McCormick, for an interview, New York, June 6, 1984.

17. Robinson and McCormick, "Report from the East Village," p. 138.

18. Interview with Edit DeAk, Washington-New York, March 6, 1984.

19. Robinson and McCormick, in "Report from the East Village," p. 181, wrote: "[Ted] Rosenthal recently made the news-and may have legal charges pending against him-after an alarmed observer reacted to one of his sculptural interventions with a call to the bomb squad, who say he's a public nuisance..., *The Daily News* reports that he's told his dealer, Gracie Mansion, to double his prices."

20. Rene Ricard, "The Pledge of Allegiance," p. 43.

21. Helene Winer, Statement, *New Galleries of the Lower East Side*, exhibition catalogue, n.p.

22. Robinson and McCormick, "Report from the East Village," pp. 135, 137.

23. it is noteworthy that Artists Space and P.S. 1 should have mounted shows of East Village art, as if in recognition of this situation.

24. Craig Owens, "East Village'84: Commentary: The Problem with Puerilism," *Art in America*, Summer 1984, p. 163.

THE TANAGER GALLERY WAS THE FIRST ARTIST
COOPERATIVE ON TENTH STREET. IT SHOWED THE
WAY TO SOME EIGHT OTHER ARTIST-RUN GAL-
LERIES IN THE VICINITY. THE TENTH STREET
GALLERIES WERE AT THE CENTER OF THE NEIGH-
BORHOOD WHERE MOST OF THE PAINTERS AND
SCULPTORS OF THE NEW YORK SCHOOL LIVED AND
WORKED. I MANAGED THE TANAGER FROM ROUGHLY
1956 TO 1959 AND WROTE THE FOLLOWING STATE-
MENT OF ITS MISSION.

250

Statement

Tanager Gallery

The Tanager Gallery, from its beginning in 1952, has been a public extension of the artist's studio. Its shows have reflected the intimate artistic problems that painters and sculptors face and have proved a means of defining, clarifying and evaluating them. Artists, simultaneously participants and spectators, have responded to the openness of the gallery and have enthusiastically supported it.

The members of the Tanager have been particularly suited for this role. A diverse group with irreconcilable artistic differences, they are unreservedly outspoken on behalf of their individual viewpoints, yet they respect one another as artists.

Aside from its singular function, there is a flavor about the gallery that inspires the devotion of its members and accounts, in part, for its longevity (it is the oldest existing artists' cooperative in New York).

The Tanager intends to continue as a barometer of the New York art scene. Living wholly in the changeable present, its unique personality lies in its immediacy.

Irving Sandler

251

LOIS DODD PERLE FINE SIDNEY
GEIST SALLY HAZELET ANGELO
IPPOLITO ALEX KATZ NICHOLAS
MARSICANO PHILIP PEARLSTEIN
RAYMOND ROCKLIN

TANAGER GALLERY

EXHIBITION OF PAINTINGS AND
SCULPTURE OPENING FRIDAY
EVENING, OCTOBER 16, 8-11 P. M.
THROUGH NOVEMBER 5, 1959.

PROVINCETOWN WAS MY TENTH STREET IN THE
SUMMERS FROM 1955 TO 1958. THE SUN GALLERY
FROM 1955 TO 1959 WAS THE LIVELIEST GALLERY
THERE AND MOST LIKELY ANYWHERE AT THE TIME.
ITS OWNERS AND THE ARTISTS THEY EXHIBITED
WERE BOHEMIANS WHO REJECTED THE "ESTABLISH-
MENT" WHEREVER THEY FOUND IT. AS DOMINIC
FALCONE, ITS CO-FOUNDER, WHO SUBSIDIZED THE
GALLERY BY WASHING DISHES, WROTE: "THE SUN
IS OPEN TO ALL THE NEW VOICES." EVEN
ABSTRACT EXPRESSIONISM WAS SUSPECT, AND THE
SUN GALLERY TENDED TO FEATURE THE WORK OF
YOUNG ARTISTS WHO WERE MOVING IN OTHER
DIRECTIONS, SUCH AS ALLEN KAPROW'S AND RED
GROOMS'S HAPPENINGS AND ALEX KATZ'S NEW
REALISM. THE INTRODUCTION TO THE CATALOGUE
WAS A QUOTE FROM WORDSWORTH: "BLISS WAS IT
IN THAT DAWN TO BE ALIVE,/BUT TO BE YOUNG
WAS VERY HEAVEN!"

Provincetown in the Fifties:

A Memoir

Franz Kline once said that when he was young he was nineteen. When I think of my youth, I involuntarily think of Provincetown and the summers of 1955, 1956, and 1957 (and part of 1958) that I stayed there, even though the artist friends I made on the Cape and I were a decade or so older than nineteen at the time.

These summers were a germinal period in my life. I had already decided to become a writer on art even though I knew relatively little about painting and sculpture. I learned a great deal in Provincetown.

While working as a dishwasher at the Moors Restaurant, I met Angelo Ippolito, who was a waiter. He was my primary "teacher." I also sneaked into Hans Hofmann's Friday critiques and listened closely to the perpetual artists' conversations in studios, parties, and on the beaches, jotting them down in longhand. Having been a student of American history, I decided to go on doing research, but now on contemporary art, and I interviewed Milton Avery, Robert Motherwell, Adolph Gottlieb, Jack Tworkov, George McNeil, Fritz Bultman, and other artists. These notes would later become an important source for my books on the New York School.

I believe that because I spent only three summers in Provincetown it remains so vivid in my memory. What it had been then, or rather, what I remember it as, has not been revised by anything that happened to it since. My P-town is of the fifties—part oasis, part mirage.

What I recall most strongly is the awareness of potential, of promise, of the clear and present possibility of future greatness. As Frank O'Hara wrote, "there was then a sense of genius. Or what Kline used to call 'the dream'." And there were living in Provincetown artists who appeared well on their way to achieving it—a number already had, for example, Avery, Kline, Hofmann, Gottlieb, to mention only a few of those no longer living.

Hofmann, with whom most of the young artists I knew were studying or had studied, made "the dream" seem attainable. What made Hofmann even more attractive to art students was his ability to demonstrate before your eyes, as it were, how a picture should work and when it did work. Moreover, he was a historic figure; he had lived in Paris from 1904 to 1914—the heroic decade of twentieth century art; had been a friend of the innovators of Fauvism and Cubism; had learned of their ideas at first hand, possibly even contributing some of this own; and as early as 1915, had opened an art school, in time to become world famous.

Everybody *knew* that Hofmann was the best teacher anywhere (and they were right). Moreover, his students in the late forties and fifties knew they would be the painters and sculptors to succeed the first generation Abstract Expressionists (and many turned out to be.) And a few, Jan Muller, for example, had already created remarkable bodies of work. It was elating to be in their company.

Provincetown itself enhanced "the dream." With its dunes, ocean, and sun, and its light—as Motherwell wrote, "exactly the same kind of light that Matisse loved or Miro loved or the Greek sculptors loved," it was just the place to believe in unlimited horizons and a shining future. It was far enough removed from the "real" world for a young person to invent his or her identity in "life" and, if serious, to aspire to it in art.

256

And there was a great deal of leisure time. Those who could take a summer off in Provincetown either could afford to do so, or could easily earn enough to live on by working part time. One summer, I managed by washing the kitchen floor every night after closing and the refrigerator once a week at the newly opened Ciro and Sal's Restaurant, and by sitting in the HCE Gallery daily during lunch hours to relieve Ivan Karp who worked there. My work week was under fifteen hours. The following season, I shared the cellar of a fishing captain's house on the bay with a painter and a writer. We each paid $33.33 for the summer's rent.

The Sun Gallery, aptly named, was the showplace of the young. As an "institution," it reflected those who exhibited in and frequented it. It was serious, as the work on view testified. Like the artists, the Sun Gallery existed on a shoestring, largely supported by the earnings of its founders, Dominic Falcone, who, among other jobs, washed dishes at the Moors, and Yvonne Anderson, who worked at the Studio Shop.

The gallery had nothing to do with the Establishment (whatever that was.) As Falcone wrote in its credo in 1955: "The Sun is open to all the new voices, always listening for the new sounds, lifting them from the darkness into the light." Even the prevailing avant-garde, Abstract Expressionism, or more accurately, the gestural or painterly or "action" tendency within it, was suspect as being too established. Lester Johnson and Jan Muller, who were given five and two one-person shows respectively between 1955 and 1959, were turning away from abstraction toward figuration, and Alex Katz, who was given two shows, was a figurative painter who was reacting against Expressionism and venturing toward specific portraiture.

At the time, both tendencies shocked many. Dorothy Gees Seckler remarked: "Surprising, at least to Alex Katz...was the outrage expressed by some viewers—they brandished fists from outside the windows—over some paintings of his in the window of his first show [1958] there...they included a flat simplified figure of his wife, Ada, and a collage of the lighthouse at the point."

A number of artists who exhibited at the Sun Gallery were moving in the radical direction of what was called the Happening by Allan Kaprow, himself given a one-person show at the gallery in 1957. Red Grooms, who had met Falcone when they were fellow dishwashers at the Moors, presented one such early theater piece titled *A Play Called Fire* at the Sun in 1958. 1 remember vividly how unprecedented its crudeness seemed and the furor it created.

Although most of the artists shown at the Sun Gallery were figurative, their styles, even at the beginning of their careers, were distinctive. Their personalities were as individual as their work. Of the artists I knew best, I recall Ippolito's inspired and elegant wit; Katz's fast one-liners about art, as coolly incisive as they were provocative; Kaprow's iconoclasm in making art and his logic in talking about it; and Grooms' exuberance and charisma. (When he turned his out-of-the-way studio on Delancey Street in lower Manhattan into a "museum," the art world trekked to visit it.) I did not get to know Muller well, but I was aware that he was a role, model for many of his fellow artists.

P-town stands for my youth in art. It also marks the end of my formative years. That occurred in the summer of 1958 at the Provincetown Arts Festival, a juried show of works by nearly 400 artists from across America. The show was a boon to the art colony, attracting large numbers of art world professionals and tourists. For me, it gave rise to the suspicion that the gestural tendency in Abstract Expressionism—the first art to have stunned and inspired me and the best of which I still love—had become too common and accepted to remain avant-garde.

In 1973, I co-founded Artists Space, a not-for-profit gallery whose primary mission was to provide exhibitions for artists who were not affiliated with commercial galleries. It was one of the first so-called alternative galleries and a precursor to some 300 more that in the 1970s were formed across the United States, some of which used Artists Space as a model. In 1979, the Neuberger Museum showed ten of the better-known artists who had their first one-person shows in the gallery. I took this occasion to write a short history of Artists Space. Artists Space remains an active and lively gallery in New York.

Artists Space

rtists Space was conceived in 1973 by Trudi Grace and me. Trudi was then the director of the Visual Arts Projects Program of the New York State Council on the Arts. Working closely with Trudi, I had administered a couple of programs for the Council. At the time, both of us became increasingly sensitive to an inadvertent inequity in the Council's funding policy (as mandated by state legislation), namely that the Council could subsidize only non-profit organizations. That suited dancers, actors, and other performers who, because of the nature of their art, founded companies, and it also suited film and videotape-makers, who banded together because they needed to share the high cost of their equipment. But visual artists rarely set up organizations; they work privately in their own studios. It was simply unfair, doubly so because painters and sculptors on the whole have been the most vital of all creative artists in New York City, indeed, turning the city into the capital of world art.

Trudi and I raised this issue within the Council. Its administrators responded sympathetically and asked us to formulate projects that would be of general use to artists—general in that they did not provide grants to individuals since that was the function of the Creative Artists Public Service program

(CAPS). We then invited small groups of artists of diverse ages, aesthetics, and positions within the art world to meet with us in order to identify the needs of artists and to design programs to meet them. The artists we called together agreed that a distressing problem facing many excellent New York artists was the lack of opportunity to exhibit their work. The existing galleries were not able or willing to offer shows to the large number of artists who merited them. An alternate gallery—perhaps even an alternate art support system—seemed necessary.

At first, it was suggested that artists who were not affiliated with commercial and cooperative galleries be awarded grants to mount shows in their own studios. This plan was quickly rejected because the privacy that most artists require would be invaded, because often artists' lofts are not easily accessible, and because studio-shows would not possess the authority to attract a significant public. Even those regular gallery-goers most sympathetic to unrecognized artists would not have the time to visit many dispersed lofts.

It soon became evident to us that a permanent exhibition space in a good location was needed. Furthermore, such a gallery would have to screen the artists shown in it. This was a troublesome problem to solve, but after lengthy discussion, we decided that each unaffiliated artist to be shown would be selected by a relatively well-known or established artist on a one-to-one basis. This procedure had the advantages of turning over decision-making powers to artists, of being public, because the names of the selectors would be announced, of avoiding the compromises and tedium of a committee process, and of generating interest in the shows. If the art-conscious public on the whole would not go out of its way to visit an unknown artist's show, it might, if only out of curiosity, wish to see what new work a known artist believed to be significant, particularly if the work was readily available.

We also agreed that each selecting artist would have only a single choice and that an unaffiliated artist would be shown only once. Thus, no person or group could dominate the gallery. Moreover, the element of unpredictability and surprise would be guaranteed. We also decided that certain costs of the exhibitions, such as for the transportation of works, for printing and mailing announcements, and for advertising, would be borne by the gallery.

If works were sold, all of the proceeds would go to the artist. The gallery would take upon itself the burden of funding its operations in ways other than by collecting commissions from those it was established to serve. It all made good sense, but I must admit that we were fearful that the Council would balk at being closely identified with a program of such high visibility whose primary decision-making authority was to be delegated to individual artists. That, however, was a risk that we were convinced should be taken, and the Council subsequently concurred.

Trudi and I asked Jerome Hausman to join us in presenting the plan for a new gallery and for half a dozen other projects to the Council, and then we assumed that our job was done. The Council accepted our proposals but decided that its function was not to administer programs, but to fund organizations in the field of the arts. It then asked us to incorporate ourselves as a non-profit organization and, with a grant from the Council, to put into effect the projects we had devised. We agreed to do this, and the Committee for the Visual Arts (CVA), as we called ourselves, was inaugurated. Trudi left the Council to become the CVA's Executive Director, and I became a part-time employee for the first year and the President of the Board of Directors.

Half of the members of the Board were artists who were widely respected by other artists. I should like to emphasize the point that to give artists major decision-making powers was a deliberate policy of the CVA. This made us, in our opinion, different from, and perhaps an alternative to, typical arts organizations which are controlled by non-artist administrators, trustees, and curators. But we also recognized the need for tough-minded administration. Indeed, the CVA succeeded largely because it was able to join the imaginativeness of artists when they face the problems of their own community with the skill of a trained staff adept at bookkeeping and writing the elaborate and stringent grant proposals which are demanded by public and private funding organizations.

Having received our go-ahead from the Council in the late spring of 1973, Trudi single-handedly found a spacious, well-lit loft on Wooster Street near Houston Street in the heart of Soho and during the summer had the floor-to-ceiling junk removed and the space fixed up so that three one-person

shows could be mounted simultaneously. The result of her effort was one of the handsomest galleries in New York. We named it, simply, Artists Space. I had chosen the initial roster of selecting artists, making sure that all aesthetic positions were represented. While the gallery was being prepared, the selectors chose artists to be exhibited from among those who were not affiliated with another gallery. A number of them were ready to show immediately, and Artists Space opened in the early fall. The artists who did the choosing the first year were Vito Acconci, Peter Agostini, Carl Andre, Romare Bearden, Peter Campus, Chuck Close, Dan Flavin, Nancy Graves, Michael Heizer, Donald Judd, Jane Kaufman, Sol LeWitt, Richard Nonas, Philip Pearlstein, Dorothea Rockburne, Edwin Ruda, Lucas Samaras, Richard Serra, Jackie Winsor, and Jack Youngerman.

The response to Artists Space by the artists who exhibited there, by the gallery-going public, and by critics and curators was enthusiastic. Even commercial dealers welcomed us, recognizing that we were fulfilling a need that they could not. To make the gallery even more useful to the community of artists, we made the space available after gallery hours to performing artists, poets, multi-media artists, and film and video-makers in or close to the art world. In the first three years of our existence we averaged two or three nighttime events a week. We also arranged panel discussions and lectures on issues of interest to our constituency of artists.

We soon faced two problems. One, that it was I who had chosen the selecting artists. Why me? There was no longer any necessity for haste, and we had two new staff members to help us: Susan Wyatt and Edit deAk, who had ties with young artists. We solved this problem by drawing up a list of names of more than 650 artists, most of whom were represented by New York galleries. Then we mailed the list to all the artists on the list, inviting them to vote for the ten artists whom they believed would make the best selectors, excepting those who had already served in this capacity. More than 400 artists returned the ballots—the large number a tribute to the role that Artists Space was already playing. The artists who led the tally became the selectors of the exhibiting artists for the following two years. The selectors chosen by this process were: Darby Barmard, Jack Beal, Lynda Benghs, Mel Bochner, Louise Bourgeois, Christo, Mel Edwards, Rafael Ferrer, Audrey

Flack, Mary Frank, Red Grooms, Nancy Grossman, Al Held, Brice Marden, Robert Ryman, Joan Snyder, Julius Tobias, and Richard Tuttle.

Our second problem was that we were not convinced that our selectors, even with their broad knowledge of unrecognized artists, knew them all. Our solution was to set up a file, listing unaffiliated artists. Any New York State artist who submitted slides and, preferably, a short biography was included. The file was used in a variety of ways. Selectors were urged to consult it. To vary the selection procedure, groups of artists who had had one-person shows at Artists Space were asked to choose group shows from the file. Also, all of the artists in the file were invited to serve as a jury-of-the-whole the first time, to my knowledge, that such a method was used to select a show. All who were interested, and most were, assembled one or two evenings, viewed all the slides and, by voting, selected a group show. The file was also made available to curators, dealers, critics, heads of college art departments, collectors, and, indeed, anyone who wanted to see it.

Artists Space was formed as an alternate gallery—it was one of the first—and we thought that it might lead to an alternative to the commercial galleries. It did not—then. Much as we tried, we did not succeed in selling very much art. To blame was our inexperience in salesmanship and our policy of showing an artist only once. Thus, we could not represent an artist, as a commercial gallery would have. Furthermore, dealers followed our shows closely and invited many of the artists we exhibited to join their galleries. The artists did. Much as they continued to be friendly to Artists Space, they were not interested in establishing an alternate art-support system. Their willingness to do so was a necessary precondition to the success of such a venture. But now this situation seems to be changing. Many of today's promising young artists seem to be more committed to alternate spaces than were artists of the generation that preceded them. As for Artists Space in its first three years, it helped initiate the careers of dozens of fine artists, ten of whom are represented in this show at the Neuberger Museum.

I HAD SPENT ALMOST HALF A CENTURY WRITING THE HISTORY OF CONTEMPORARY ART. IT APPEARED IN FOUR VOLUMES, BEGINNING WITH *THE TRIUMPH OF AMERICAN PAINTING: A HISTORY OF ABSTRACT EXPRESSICNISM*, PUBLISHED IN 1970, AND ENDING WITH *ART OF THE POST-MODERN ERA: FROM THE LATE 1960S INTO THE EARLY 1990S*, WHICH APPEARED IN 1996. IN THIS LAST SURVEY OF THE SERIES, THE FINAL CHAPTER SUMMARIZED THE PERIOD, FOCUSING ON TENDENCIES THAT HAD BECOME ESTABLISHED AND THOSE THAT APPEARED TO REMAIN VIABLE. IT CONCLUDED THAT ART HAD ENTERED A PLURALIST ERA. ON THE WHOLE, THIS CHAPTER REMAINS AS RELEVANT NOW AS IT DID A DECADE AGO. ·

Into the 1990s

Art of the Postmodern Era

B y the end of the 1980s the question of whether painting was dead or alive ceased to be debated in the art world, except by the *October* coterie. Painting was simply accepted as a viable artistic option. After all, it had been around since cave days, and on the evidence of the current interest, it looked as if it would just keep going on and on. Even many of its previous detractors came to view it as capable of certain kinds of expression that no other art form could deliver. Painters, both those established early in the eighties, such as Francesco Clemente, Eric Fischl, Anselm Kiefer, Elizabeth Murray, Sigmar Polke, Gerhard Richter, Susan Rothenberg, David Salle, and Julian Schnabel, and, later in the decade, Peter Halley, Philip Taaffe and David Reed, continued to command art-world attention.

So did the work of media and deconstruction artists, notably John Baldessari, Richard Prince, Cindy Sherman, Jenny Holzer, Barbara Kruger, and Hans Haacke, but not their younger contemporaries, since images appropriated from the mass media, captioned photographs, advertising-like layouts, and so on, had become all too common. A huge survey, titled *Image World: Art and Media*, held at the Whitney Museum in the late fall of 1989, met with art-world indifference. So did a related show, *A Forest of Signs: Art*

in the Crisis of Representation at the Museum of Contemporary Art in Los Angeles. Peter Plagens of Newsweek wrote of Image World: "The news that artists, as curator Lisa Phillips writes [in the catalog], 'have had to confront the fact that this new visual mass communication system has in some way surpassed art's power to communicate' is hardly heartstopping."[1] Commenting on a wall label in the show, which read, "Why are media images so powerful and persuasive?" Peter Schjeldahl remarked: "It's funny. I had just been wondering why media images (including verbal ones on wall labels) are so weak and unpersuasive. Maybe it's because like most people, I've spent my life in intimate, daily, love-hate combat with such images, acquiring a certain immunity in the process." Schjeldahl concluded: "The sophisticated groan, a vernacular locution that most Americans pick up around he age of 8, is a defense against the mental and spiritual depredations of media... The [show's] effort to reproduce the media's supposedly soul-shattering glut is almost touching, it's so resistible."[2] *The New Yorker* critic reported that the *Image World's* premise... "that the overpowering presence of the media has produced an 'image, world' is about as sprightly today as the Oldest Living Confederate Widow could expect to be. Come on, kids! Screw your thinking caps on a little tighter."[3] As Andy Grundberg summed it up, *Image World* and *A Forest of Signs* exuded "a valedictory air. One felt not that they were describing current events in the art world but rather that they were encapsulating an era and transforming it into art history. This effect was heightened by their appearing in 1989, the decade's last year. "[4] Even middlebrow and lowbrow periodicals dismissed it as old hat.

The deconstructionist rationale that supported the work of such artists as Levine, Kruger, and Haacke seemed equally old hat. Moreover their work had been embraced by the art market and consequently had lost much of its polemical edge. Its own commodification called into question its critique of commodification. And what was more damning, it could be co-opted by consumer society, as Kruger's "look" was in Smirnoff Vodka advertisements. Above all Baudrillard's neo-Marxist idea that people were unable to distinguish between reality and media imagery and that they were seduced by the "spectacle" of consumer society and reduced to passiveness struck growing numbers of art professionals as humdrum and/or unbelievable. This idea had been popularized by deconstruction, commodity, and neogeo artists to the

extent that it had become "the critical lingua franca," as David Rimanelli observed. By 1990 it had gone "out of fashion... Few knowing people in the art world still speak of simulacra, the hyperreal, or the ecstasy of communication."[5]

Events in Eastern Europe revealed just how resistible propaganda was, no matter how massive. After the Russian Revolution in 1917, the Soviet Union had inaugurated a "great experiment," namely to produce a "new Communist man." For seventy years the Leninist and Stalinist dictatorships had monopolized public discourse and had engaged in the most exhaustive indoctrination supported by unspeakable terror. Then, in a matter of weeks in August 1989, the masses overthrew Communism and tore down the Iron Curtain. If totalitarian societies could not control thought, how much less likely was it in the democratic West.

Art theory in general seemed exhausted by the end of the 1980s. The names of the intellectual gurus of that decade—Derrida, Barthes, Foucault, Lacan—were referred to with decreasing frequency, and when their ideas did come up, they were more often than not challenged. With the demise of Communism, Marxism lost much of its cachet. In retrospect a great deal of what had been published in *October* appeared to be specious. Schjeldahl quipped: "Amid the clatter of toppling Lenin statues, the plight of...*October* becomes touching. Will they change the name to *August?*"[6] The idea promoted by the left that capitalism had entered the stage of "late capitalism," and was on its last legs, now seemed to be the hangover of obsolete wishful thinking more than the present reality. As Robert Storr pointed out,

> We are in fact in a period of high capitalism. And, for all its structural debility and all the misery and fraud it propagates, capitalism has no rivals, only economic cycles and internal competition. In fact, rather than collapsing of its own weight—although partial collapses always threaten—capitalism is about to reabsorb the still weaker socialist systems that have so long been its political adversaries.[7]

The proof of how tired *October* had become was a symposium organized by Rosalind Krauss at the Dia Foundation in the fall of 1990. The topic was the

High & Low: Modern Art and Popular Culture show at the Museum of Modern Art. The show's purpose was to reveal that "high" artists had borrowed freely not only from the mass media but from every kind of "low" art and that this practice had become an established part of the tradition of modern art. This premise appealed to the general public but had become too familiar to be of interest to the art world, except as the inaugural show of Kirk Varnedoe, the museum's new director of painting and sculpture. Krauss and the other speakers announced that they would provide theoretical alternatives to the methodology of Varnedoe and his associate Adam Gopnik, but they did little more than deliver short talks on historical subjects, most of them concerning Duchamp, talks no different from those common at the annual meetings of the College Art Association. Art theory had become, in a word, academic, and indeed, it remained influential only in graduate art history programs, in which unregenerate tenured ideologues taught that scholarship meant choosing and mastering a dogma; poking through works of art for evidence supporting it; and evaluating the work on the basis of the dogma .[8]

Deconstruction artists who had been promoted by art theorists began to repudiate art theory because they felt that it limited the interpretation of their art, confining the discourse and closing it off. Such artists as Sarah Charlesworth and Laurie Simmons began to voice their objections publicly.[9] Commenting on Charlesworth's statement that she was sick of deconstruction, Robert Pincus-Witten said: "She was, as Suzanne Joelson whispered into my ear, Theory Weary... Or, as Jerry Saltz rhymed later, Theory Leery, to which I could not help but affix the final couplet, Theory Bleary."[10]

Many deconstruction artists turned from unmasking the media to new subjects, as Andy Grundberg observed. "Levine's last show...consisted of sculptured glass objects that took their cue from Duchamp. Prince's current shows...consist of paintings and sculptures that in appearance seem eager to evoke Minimalist styles of the late 1960's. Sherman's next show...will include portraits redolent of Old Master painting. [These artists'] images now seem less mediated than personal, and they are tinged with no small measure of nostalgia. Today, memory seems a more potent subject than the media." Grundberg concluded that these artists as well as Laurie Simmons and

Louise Lawler "have broadened their focus beyond the media to address how contemporary consciousness is shaped by images of all sorts."[11]

Commodity artists and the neogeos achieved art-world recognition in 1986. They were the last group of artists to command art-world attention in the eighties. But if no new "ism" emerged at the end of the 1980s, certain individuals dominated art discourse, for example, the Starn twins in 1987, Koons in 1988, Mike Kelley and David Hammons in 1990. All were neo-Duchampian appropriation artists, but the art world did not link them together; instead it focused on the distinctive qualities of each, in the case of the Starn twins, the postmodernist nostalgia for the past; Koons, the apotheosis of consumer society—and of Warhol;[12] Kelley, the psychological and social underbelly of consumer society; and Hammons, the growing consciousness of the African-American experience, and by extension, of a multicultural America.

Art of the end of the 1980s took three diverse directions. The first extended available twentieth-century styles in personal ways, disregarding social issues. The second—which commanded the most art—world attention-dealt directly with newly urgent social problems, and the third was aptly labeled abject or pathetic art. Extending available styles had become too traditional and expected an approach to generate much comment in the art world, although a number of individual artists did. On the other hand, abject and socially conscious tendencies were much discussed.

Abject art was surveyed in a show titled *Just Pathetic* (1990) that included Mike Kelley, William Wegman, and David Hammons. As a whole the work was the end product of a countercultural tendency toward "badness" in art prevalent since the late 1960s. Ralph Rugoff wrote in the catalog that "pathetic art settles for an undignified ridiculousness. Constructed with preterite materials, this work often seems laughably awkward; its gawkiness, both conceptually and physically, frequently gives it an adolescent appearance...A typical characteristic of pathetic art is its low-grade construction." Pathetic art is so pathetic that it even lacks irony:

> Bereft of irony's protective distance, pathetic art invites you to identify with

the artist as someone [not] in control of his or her culture...

So no tongue-in-cheek critiques. No policing actions. No devastating salvoes hurled at the art establishment. Pathetic art knows it doesn't have the strength; its position of articulation is already disabled and impaired...

Pathetic art is sad but also funny, and the sadder it gets, the funnier it seems.

Rugoff concluded that pathetic art was a reflection of a society and a culture that were disfunctional and out-of-gas and whose future did not seem to offer any improvement. The essay ended with a paradox that many of the pathetic artists in the show had achieved success. But there's no failure like success."[13]

Arthur Danto was also struck by the prevalence of what he called "demotic art," characterized by a "zero degree of draftsmanship. [Its drawing is] the kind that finds its way into tattoo parlors, prison wall graffiti, leaflets advertising garage sales." It is "derisive, sullen, hostile, punk...charmless, expressionless, flat, mechanical, smeared, logogrammatic." Responsible was what he termed "a convulsion in culture." "We are not dealing with the work of marginal figures but with mainstream art;...massively mainstream," at that. Danto concluded that works of art that are "antiaesthetic, palimpsestic, fragmented, chaotic, layered, hybridized" may be "a mirror of our times."[14] By 1990 the major practitioners of pathetic art were established. Although they attracted dozens of followers who presented ludicrous readymades, cartoon-like parodies, and the like, the tendency had gotten stale.

Danto's suggestion that pathetic art was influenced by the sorry state of the world was well-taken. But there was much to celebrate in the 1990s. The Cold War had. ended and with it the threat of nuclear holocaust. Western liberalism had triumphed—its emblem, the heady news photograph of Germans tearing down the hated Berlin wall. Still, there was much to be pessimistic about: the AIDS epidemic; rampant nationalism and genocide; famine and the oncoming environmental catastrophe generated by the excesses of the consumer society and the population explosion; and in addition the deterioration of the inner cities and accompanying homelessness, increasing racial tensions, and drug and crime problems; the poor condition

of education; the antiabortion movement; growing homophobia; and censorship."[15] The problems that beset Americans were omnipresent. As Laurie Anderson commented: "I just walk out my door and there it is. Every night there are four men trying to sleep in 30-degree weather in a new loading dock dormitory... Old women are rifling through garbage bags hunting for scraps. Delivery boys ring all 10 doorbells at once, which was really irritating until one day I realized: they can't read."[16]

If pathetic artists seemed caught up in a fin-de-siécle gloom, socially conscious artists were hardly less pessimistic. Those on the political left asserted "that the Western liberal democracies are repressive and imperialistic and maintain their hegemony [by] convincing the majority...to live their own domination as freedom"[17]—a highy questionable hypothesis. But whether socially minded artists believed this or not, they recognized that capitalism was here to stay. Lacking a vision of a future good society, they understood that they could only hope to ameliorate existing society, not revolutionize it. All that art could be was, as Storr wrote with as much optimism as he could muster:

> [for] worse and for better ... a fever graph of the enthusiasms, discontents, bad conscience, and bad faith of its patrons' and practitioners' class... Its contradictions are ours, from which no revolution has saved us in the past and none seems likely to do so in the future. Resistance of any meaningful kind to the constraints and crimes of bourgeois society must therefore begin with the admission and constantly updated appraisal of our compromised position within it. For if, in its crisis-ridden and frequently brutal unfolding, that reality seems intolerable, nevertheless we cannot stand apart from it and tell the truth.
>
> The prospect before us is to reenter [existing society) in the fullness of its enduring ambiguity, magnificence, and corruption. To that end we must acknowledge and surrender to the complete if sometimes tragic fascination with contemporary life."[18]

If the art market was any indication, capitalism was hardly on its last legs. Indeed, the market reigned over all of the art activities of the 1980s. As Schjeldahl observed: "Money and contemporary art got married in the '80s. The couple was obnoxious and happy."[19] And Robert Pincus-Witten wrote

in the last months of the decade: "The talk of art and money is ceaseless; however much one says No to the subject, it asserts itself."[20] In November, 1989, a billion dollars' worth of art was sold at auction. And in May two records were broken; $82.5 million was paid for van Gogh's *Portrait of Dr Gachet* and $78.1 million for Renoir's *Au Moulin de la Galette*. But that month marked the end of the binge.[21] Confidence in the market was shaken by shocking revelations that much of Japanese buying that fueled the boom had to do not with appreciation of art and aesthetic values but with moving money around unlawfully for the benefit of organized crime and corrupt politicians.[22] Another shock was the report in October that trend-setter Charles Saatchi was selling large numbers of works from his collection. Most important, the art world was finally convinced that art was overpriced, most of all contemporary art. In November the bottom of the art market dropped out.[23]

Contemplating the precipitous fall in auction prices, Schieldahl wrote: "For almost everything of the '80s, it was strictly from bloodbath." still, "no one was going to jump out a window on account of an unbought Julian Schnabel... Here was a market, still vastly lusher than that of a decade ago." But, the "long feeding frenzy whose insults to common sense could seem to traumatize even some of its beneficiaries" was over. Schjeldahl concluded: "The recession ahead should foster a desperately needed rethinking of what art is and what art is good for."[24]

Socially committed artists were appalled by the excesses of the burgeoning ail market. Its collapse added to their belief that boom-and-bust capitalism was evil. Nevertheless whether they acknowledged it or not, they accepted Storr's assumption that capitalism would persevere. Still, gripped by a sense of social urgency and anxiety, they would deal with social issues in their art. And the best faced perpetually nagging problems: If art was to have social content, how to avoid the reduction of issues to simplistic one-dimensional propagandizing or abstract illustration of theoretical premises, and instead embody the complexities of being and existence, its joys, miseries, and challenges, on the one hand and on the other hand, to do so in an aesthetically compelling manner.

Socially committed art was hardly new at the end of the 1980s. Indeed, that decade had had a plethora of such artists ranging from Golub to Haacke to Kruger and Holzer. But a new group of artists with a multicultural message had come to the fore: African-Americans, Latino and Chicano-Americans, Asian Americans, and Native Americans. In the summer of 1990 *The Decade Show* was mounted at the New Museum, the Studio Museum in Harlem, and the Museum of Contemporary Hispanic Art. In a lengthy review in *New York*, Kay Larson wrote that the exhibition "means to enlist the peripheries—the people who feel 'marginalized' and who are often very angry about it." She emphasized the efforts of the three museum directors who organized the show: Marcia Tucker, Kinshasha Holman Conwill, and Nilda Peraza,

> ambitious and socially conscious women who have all experienced marginalism in their own lives and whose allegiances point [to] the emerging identity of the nineties....
>
> "The Decade Show" describes the growing consciousness of "otherness" in American society... Multiculturalism is the buzzword among groups trying to position themselves for the day when whites of European derivation become a minority in America."[25]

Roughly one-third of the artists in *The Decade Show* had achieved art-world recognition in that they had been shown in prestigious galleries, had received art critical and, in many cases, museum attention. (Some twenty-five of the ninety-three artists in the show have been dealt with in this survey.) Tucker, herself, realized this; she suggested in the catalog that rather than viewing the show in terms of "oppositional thinking," "branch thinking" might be more appropriate, "because it's not about 'us versus the mainstream.'"[26] The year 1990 saw the publication of Lucy Lippard's book, *Mixed Blessings: New Art in a Multicultural America*, one of a growing number of books on the subject .[27]

Art theoreticians on the left embraced multiculturalism, but they had to do some ideological flip-flops. In the 1980s they had proclaimed the death of the author, exemplified by the white, Western, heterosexual male. Multiculturalism required the rebirth of the author since the marginalized

artist had to be identified as African-American, Latino-American, and so on, and as a genuine representative of his or her culture. Authenticity made a comeback. Multiculturalism raised serious social questions. Would it lead to the empowerment of marginalized people and hence to a more just society, or to a new tribalism that would fragment society?

Multiculturalism was only one of the social issues that engaged growing numbers of artists, both in their art and their activities as citizens. The terrible toll of the AIDS epidemic on the art community made it an issue of the first priority. The concern over AIDS intensified an interest in the theme of the body, an issue long raised by feminists and growing in urgency because of the controversy over abortion or, to put it more generally, who controlled a woman's body. The question raised by the work of such artists as Kiki Smith and David Wojnarowicz was how do we apprehend the body, and in whose image? The media's? Ours? And whose body is it: male, female, gay, straight, white, colored, aged, working class, middle class? What is private; what is public?

Art about the naked body was often branded pornography and censored. The cause cèlébre was the cancellation in 1989 of the Robert thorpe retrospective of photographs at the Corcoran Gallery of Art in Washington, D.C., some of naked people, children with their genitals exposed, and homoerotic practices. The show had been funded in part by the National Endowment for the Arts, and that was used as a pretext by Senator Jesse Helms to introduce an amendment to an appropriations bill, which the Senate approved by voice vote, prohibiting use of public money to "promote, disseminate, or produce obscene or indecent materials." Helms's primary target was the NEA, which he hoped to eliminate entirely, and with reauthorization coming up in 1990, he was preparing the ground. In the 1990s he would achieve his goal.

The threat to freedom of artistic expression was serious. The most worrisome incident was the indictment in 1990 of Dennis Barrie, the director of the Cincinnati Art Center, for mounting the Mapplethorpe retrospective. The charge was pandering obscenity and exhibiting naked minors. Barrie stood trial before an unsympathetic judge and a jury whose members were select-

ed primarily because they knew nothing about art. He was saved from jail only by the ineptness of the prosecution's case.

It was not only the Mapplethorpe controversy but the growing agitation of gays for increased governmental attention to the AIDS crisis and on behalf of themselves as a discriminated-against minority that intensified homophobia and attacks on the NEA in Congress. The butt was a NEA-funded show titled *Witnesses: Against Our Vanishing*, scheduled to open at Artists Space in New York, in November 1989. Curated by Nan Goldin, the exhibition was meant to be a "collective memorial" in which twenty-three artists would represent "their personal responses to AIDS."[28] Susan Wyatt, the director of Artists Space, was fearful that the catalog of the show, which contained an essay by Wojnarowicz attacking Helms, California Representative William Dannemeyer, and New York's Cardinal John O'Connor, might embarrass the agency. She alerted the NEA so that it might be prepared for any adverse criticism. Believing that Helms was his main problem, Chairman John Frohnmeyer asked Artists Space to return the ten thousand dollar grant it had been awarded. Artists Space refused, and the grant was canceled. The art world was outraged by the NEA's stance, and it rallied in support of Artists Space. Within days unsolicited contributions of more than eighty thousand dollars arrived in the mail, including checks of ten thousand dollars each from Roy Lichtenstein and the Pace Gallery. Accompanying a contribution of ten thousand dollars from the Art Dealers Association of America was a statement by R. Frederick Woolworth and Gilbert S. Edelson on behalf of its board of directors, pointing out that

> of the approximately 85,000 grants made by the NEA since [its inception in] 1965, only some twenty odd (one-quarter of one percent) have generated public controversy. This is, a small price to pay for the freedom of expression that is essential to creativity and a core value of a democratic society...

> The issue is not whether the nation's tax dollars should go to fund "pornography" or art that is "offensive" to a minority or even a majority of its citizenry. The issue is whether we, as a nation, have the courage to seek out the best and to leave for posterity the richest cultural patrimony that contem-

porary society can produce. To do so, we must rely upon a system of judgment by experts in the various fields of artistic endeavor.[29]

Stunned by the art-world response, Frohnmeyer traveled to New York to meet leaders of the artists' community at Artists Space. Aware that the loss of his artist constituency would be more damaging than the antipathy of Helms, Frohnmeyer restored the grant to Artists Space—one battle won in the war for freedom of expression, but not the last by any means.

Activist organizations, such as Act-Up (AIDS Coalition to Unleash Power) and Gran Fury created works condemning homophobia and the public neglect of the AIDS epidemic. For example, at the Venice Biennale of 1990, Gran Fury mounted billboardlike works in which a portrait of the Pope was paired with a quote by Cardinal O'Connor from the Vatican's Conference on AIDS: "The truth is not in condoms or clean needles. These are lies... Good morality is good medicine." An accompanying text read in part: "By holding medicine hostage to Catholic morality and withholding information which allows people to protect themselves and each other from acquiring the Human Immunodeficiency Virus, the church seeks to punish all who do not share in its peculiar vision of human experience and makes clear its preference for living saints and dead sinners." On another wall an image of an erect penis was paired with the sentences "Men Use Condoms Or Beat It," "AIDS Kills Women," and "Sexism Rears Its Unprotected Head." The Gran Fury work created a furor over whether it violated Italian obscenity laws and should be censored. After a brief shutdown, the venue was allowed to remain open.[30]

In keeping with the social concerns of artists, there was a growing interest in installation and performance art, particularly of a political nature. Such works lent themselves to a direct presentation of topical political issues, not only the AIDS epidemic but freedom of artistic expression, violence against women, abortion rights, racism, homelessness, and the protection of the environment.

Peter Schjeldahl, as good a prognosticator as any, sized up the situation in 1991 and predicted "a major shift" caused, if by no other factors, by boredom.

We are bored with auctions. We are bored with dealers as celebrities and collectors as celebrities. We are bored also with celebrated theories. Politically corrective critique bores us with its forever unexamined Utopian fatuities...

> We are bored with auctions. We are bored with dealers as celebrities and collectors as celebrities. We are bored also with celebrated theories. Politically corrective critique bores us with its forever unexmined Utopian fatuities...

> What we want this season...is shakedown simplification of the art culture, reduced as much as possible to communions of artists and newly self-conscious audiences. As a practical matter, the favored mode of the art will be installational.... We want to walk into spaces temporarily transformed by particular artists to trigger particular thoughts, feelings, and reflections bearing on who they are and who we are.[31]

Robert Storr's *DISlocations* at the Museum of Modern Art and Lynne Cooke's and Mark Francis's Carnegie International in Pittsburgh, both in 1991, exemplified this attitude. In their anti-art-as-object attitude, installation and performance art at the beginning of the 1990s seemed to resume postminimalism of the late sixties. Thus, ironically, much of the art with which I end this book circles back to the countercultural art that began it.

Socially oriented art was anointed in the Whitney Biennial of 1993, curated by Elisabeth Sussman. The introductory wall text stated that the works of the eighty-two artists selected, of whom only eight were painters, "confront critical issues that are altering the fabric of American life." it continued:

> In particular, the artists raise important questions about the changing role of the artist in society; the politics of representing racial and sexual difference; the boundaries between art and pornography; the function of art as a sociopolitical critique; the interrelationships of self, family, and community; and the influence of new technologies.[32]

Most of the critical responses to the show were negative, a sign of the waning interest in socially oriented art. Elizabeth Hess, who generally supported social art, wrote a mildly favorable review, finding the work "uneven" but

containing enough "smashing objects" to make the show "worthwhile."[33] Roberta Smith damned it as "a pious, often arrid show that frequently substitutes didactic moralizing for genuine visual communications" but went on to say that "this Biennial is a watershed. In some ways it is actually a better show than usual because it sticks its neck out." However, Smith concluded: "While the exhibition dwells at length on the problems that face fin de siecle America, it does not often demonstrate their conversion into convincing works of art."[34] Peter Schjeldahl wrote that the show was "the most coherent biennial ever" which "accurately reflect[s] the dominant trend of the last two years in American art culture." But he found it baleful and concluded: "The episode will last until a generation emerges that is tired of it or until universal justice occurs on Earth, whichever comes first. Neither can come too quickly for me."[35] Kay Larson singled out works by Gary Hill, Glenn Ligon, Sue Williams, and Robert Gober, and commented that on the whole the "work—even when grim—is at least passionately energized," but she was taken aback by works whose political correctness "pushed you past endurance."[36] Robert Hughes branded the show "A Fiesta of Whining: Preachy and political, [it] celebrates sodden cant and cliché."[37] Peter Plagens agreed that the show was "mostly preachy. and glum. a Salon of the Other ...which ends up more a dyspeptically sad show than a radically feisty one."[38]

With the decline of art-world interest in socially oriented art as a tendency, and with no "new" tendency in evidence, art entered into a pluralist condition. In 1995 the Whitney mounted "A Polite Biennial," as Mark Stevens dubbed it. "The assorted currents of contemporary art are invariably presented in their most polite and handsome forms." Its politics was of politesse. Stevens concluded "no commanding style or attitude now rules the art world."[39] Although the 1970s is commonly thought to be the pluralist era, the label more accurately applies to the 1990s, or at least so it seems at mid- decade.

NOTES

1. Peter Plagens, "Art: MassComm 101: the Media vs. Modernism," *Newsweek*, Nov. 27, 1989, p. 88.

2. Peter Schjeldahl, "Art: Tomorrowland," 7 Days, Nov. 29, 1989, p. 63. Kirk Varnedoe and

Adam Gopnik, *High & Low*, agreed that a large public had "a hardened knowingness about the value-emptied amorality of media culture. [Far] from being the preserve of a small cadre of vanguard thinkers, [it was] the sour, commonplace cynicism of the whole commercial culture" (p. 375).

3. "Art," *The New Yorker* Nov. 27, 1989, p. 16.

4. Andy Grundberg, "As It Must to All, Death Comes to Postmodemism," *New York Times*, Sept. 16, 1990, sec. 2, p. 47. Marzorati, in "Picture Puzzles: The Whitney Biennial," *Art News*, Summer 1985, recognzed as early as 1985 that "the moment, one in which art has, been about pictures, is nearly played out. [A] certain edge has been rubbed smooth" (p. 77).

5. Rimanelli, "Cumulus from America": 146-47.

6. Peter Schjeldahl, "Art: Art Trust," *Village Voice*, Sept, 17, 1991, p. 97.

7. Storr, "No Joy In Mudville," p. 182.

8. See Michael Brenson, 'Art View: A Concern With, Painting the Unpaintable," *New York Times*, Mar. 25, 1990, sec. 2, p. 35.

9. Sarah Charlesworth openly condemned deconstruction at a panel at the School of Visual Arts, *New York*, Mar. 1990.

10. Robert Pincus-Witten, "Theory Weary," in Collins an& Milazzo, *The Last Decade: American Artists the 80s* (New York: Tony Shafrazi Gallery, 1990), p. 46.

11. Andy Grundbert, "Photographic View: The mellowing of the Post-Modernists," *New York Times,* Dec. 17 1989, sec. 2, p. 43.

12. Warhol's name was ubiquitous, healed in a vas retrospective (second in size only o the Picasso) at the Museum of Modern Art in 1989, the huge catalog, the publication of many books, and on and on. Brian Wallis, In "Review of Books: Absolute Warhol," *Art in America*, Mar. 1989, wrote that "two years after his death, Andy Warhol continues to loom over the contemporary art scene like a silver specter. Everywhere his influence is evident; in the kitschy readymades that critique consumerism; in the easy passage between art-making and fasion, rock music, entertainment or films; in the celebration of artists as celebrities or stars; and in the endless fascination of the mass media wit the art world as a rather bizarre and freewheeling sideshow: (p.25).

13. Ralph Rugoff, "Just Pathetic," *Just Pathetic* (Los Angeles: Rosamund Felsen Gallery, 1990), pp.3-4,19.

14. Arthur C. Danto, "Books & The Arts, What Happened to Beauty?" *The nation*, Mar. 30, 1992, pp. 418, 420-21.

15. Dan Cameron, "Changing Priorites in American Art,: *Art Inernational*, Spring 1990,

p. 89.

16. Laurie Anderson, "1980-1989, R.I.P.: Strange Angels: Flying Into the Next Century," *Village Voice*, Jan. 2, 1990, P. 44.

17. Louis Menand, "Articles of Oppositional Faith," *Times Literary Supplement*, Jly 21-27, 1989, p.796.

18. Storr, "No Joy In Mudville," p. 182.

Arthur C. Danto, in "Are We Cracking Under the Strain," New York Time Book Review, Dec. 23, 1990, wrote that we live in a time in which God, democracy, socialism, art, sex, the family, and economic growth have become problematic as never before, Change is occuring with such rapidity that "the world is...so different from what it was nly recently that thetere are no useful lessons to be drawn from the past–except that lesson. [We] have to learn to live without solutions and make do instead with a few human values and some tentaive norms" (p.22).

19. Peter Schjeldahl, "Art:Art Gavel Comes Down Hard,: *Village Voice*, Nov. 27, 1990, p. 123.

20. Robert Pincus-Witten, "Entries: Geist, Zeitgeist & Breaking the Zero Barrier," *Arts Magazine*, Oct. 1989, p. 60.

21. Peter Watson, in *From manet to Manhattan, The Rise of the Modern Art Market* (New York: Random House, 1992), wrote:

At the beginning of may in New York the contemporary auction at Christie's fell $10 million below the firm's worst expectations ($50 milion), and twenty-six of the seventy-seven pictures failed to sell. AT the Sotheby's sale two nights later, thirty-three out of eighty-seven works did not meet their reserve, and the total of $55.9 million was well short of the expected $87-113 milion...

At the sales of contemporary art that autumn [1990], works by Dubuffet, Warhl, Schnabel and Stella all went unsld.... By the end of the year, David Nash, Sotheby's head of Impressionists in New ork, was talking about a return to 1988 levels. By the middle of 1991, a return to 1986 levels was being contemplated. (pp. 457-59)

22. Art was used to circumvent the law in jaan in the following manner. As Watson reported in *From Manet to Manhattan*, pp. 443, 459, to buy a property whose price was controlled by law, the buyer would "sell" a painting to the seller for one price and buy it back in a few months at an agreed-upon price many times higher. Every time this was done, the price of art rose, Then major Japanese companies dealing in art went bankrupt. If the thousands of paintings they acquired were put up for sale, the art market would collapse. They were held back, but confidence in the market was



shattered.

23. Speculation was nothing new in American economic life. In Alexis Gregory, "Economics:Art as Money:An Interview with John Kenneth Galbraith," *Journal of Art* (Oct. 1990), Galbraith said:

Some part of the art market, perhas a large part, is now a manifestation of the classical character of inflation on the speculative level. That is to say, prices have gone up for whateer reason. This causes other people to think they're going up more, andn so they buy on that expectation and that sends the prices up. That, in turn, attracts other people to buy and the price goes up even more. This is the pure speculative situation that occurs most often in the securities markets, but it also occurs in real estate and is now manifesting itself in the art market. (p. 59)

But what went up came down.

24. Schjeldahl, "Art: Art Gavel Comes Down, Hard," p. 123. Judd Tully reported in "Passed!" *Journal of Art* (De. 1990):

The speculative boom in contemporary art that triggered an artbreak of auction fever in the salesrooms of Christie's and Sotheby's in the late '80s passed away in early November, leaving behind a long list of high-priced casualties. The bad news began at Sotheby's evening sale of November 6, realizing a pun $19.8 million with 43 of the 77 lots failing to find buyers. The shocking buy-in rate of 56%, and a sales total that was exactly half of the lowest pre-sale estimate, constituted an outright disaster" (1).

James Servin, in "SoHo Stares at Hard Times," *New York Times Magazine*, Janu 20, 1991, wrote:

The most glaring sign of an overinflated art boom came in November 1989, when two paintings at Sotheby's, a Jasper Johns and a Willem de Kooning, netted a total of $38 million, $5.6 million more than Sotheby's total contemporary sales in all of 1986. As the spring of 1990 approached, the financial world turned its attention to the S&L crisis, the falling dollar and an uneven Japanese stock martket, all of which contributed to pull the rug from under the art world, with the erosion of confidence of those in the financial world, the art market unraveled with astonishing speed. Around the time of th May 1990 contempoarary art auctions, Christie's and Sotheyby's brought in only half of an expected $100 million. Six months later, the gloom persisted. Of 554 art works expected to sell at the two auction houses, only 332 did, at $49.6 million below their combined lowest estimate. At Sotheby's, a Julian Schnabel canvas failed to elicit a single bid. After some silence cynical laughter and a round of applause followed. (p. 27)

25. Kay Larson, "Art: Three's Company," *New York*, June 11, 1990, p. 84. In the last

week of 1990, in an issue, title "Age of Anxiety," devoted to predictions of the 1990s, Newsweek featured Marcia Tucker in sidebar because of her "vision of a poitically engaged, multi-cultural art." (Editors, "People for the 90s: Marcia Tucker," *Newsweek*, Dec. 31, 1990, p. 39.)

Among te better-known artists in the show were Hans Haacke, Leon Golub, Robert Colescott, Jenny Holzer, Komar & Melamid, Martin Puryer, Mel Edwards, Erick Fischl, Barbara Kruger, Cindy Sherman, Richard Prince and Bruce Nauman.

26. Nilda Peraza, Marcia Tucker, and Kinshasha Holman Conwill, "Directors' Introduction: A Conversation," *The Decade Show* (New York: Museum of Contemporary Hispanic Art, New Museum of Contemporary Art, Studio Museum in Harlem, 1990), p. 12. The artists in the show who are dealt with in this book are Applebroog, Basquiat, colescott, coplans, Durham, Edwards, Fischl, Golub, haacke, Hammons, Holzer, Kelly, Komar & Melamid, Kruger, Lawler, Nauman, Prince, uryear, Rollins & K.O.S., Sherman, Simmons, Sperio, Steinbach, and Wojnarowicz

27. Lucy R. Lippard, *Mixed Blessings: New Art in a Multicultural America* (New York: Pantheon Books, 1990).

28. Nan Goldin, "In the Valley of the Shadow," *Witnesses:Against Our Vanising* (New York: Artists Space, 1989), p. 5.

29. Art Dealers Association of America, press release, Nov. 13, 1989, p. 3.

30. Robert Nickas, "That Sinking Feeling," *Flash Art* (Oct. 1990): 139.

31. Peter Schjeldahl, "Art: Art Trust," *Village Voice*, Sept. 17, 1991, p. 97.

32. *1993 Biennial Exhibition Introductory Wall Text* (New York: Whitney Museum of American Art, 1993), mineographed sheet.

33. Elizabeth Hess, "Art + Politics = Biennial: Up Against the Wall," *Village Voice*, Mar. 16, 1993, p. 35.

34. Roberta Smith, "At the Whitney, a Biennial with a Social Conscience," *New York Times*, Mar. 5, 1993. sec. C. pp. 1, 27.

35. Peter Schjeldahl, "Art + Politics = Biennial: Up Against the Wall," *Village Voice*, Mar. 22, 1993, p. 72.

36. Kay Larson, "Art: What a Long Strange Trip,: *New York*, Mar. 22, 1993, p. 72.

37. Robert Hughes, "A Fiesta of Whining," *Time*, Mar. 22, 1993, p. 68.

38. Peter Plagens, "Fade from White: The Whitney Biennial Gives Center Stage to Women, Gays, and Artists of Color," *Newsweek*, Mar. 15, 1993, pp. 72-73.

39. Mark Stevens, "Art: A Polite Biennial," *New York*, Apr. 3, 1995, p. 56.

EPILOGUE

As art entered into the twenty-first century, it grew even more pluralist than it had been. Art-world discourse centered more than ever on the burgeoning art market, the unheard of prices paid for art, and the growing power of collectors—many invited to join museum boards—as well as the role of market pressures in shaping the art-world consensus. In their buying, collectors followed collectors, foremost of whom was Charles Saatchi. This was accompanied by an increasing internationalization of art, generated by a proliferation of art fairs and extravaganzas emulating the Venice and Sao Paulo biennials. It is not clear whether the mushrooming of the art market has resulted in a qualitative change in the art world or, more important, has affected what artists create in their studios. I predict that this will be a major question for years to come.

In thinking about my art critical and art historical practice for over 50 years, I find myself at odds with the most fashionable art criticism, art history, and art theory of the last three decades. The leading art critics, historians and theorists have had a tendency to deal with art in abstract terms, as the illustration of any number of theories—formalist, neo-Marxist, psychoanalytic, linguistic, and so forth, into

WHICH THEY FIT ART WORKS, OFTEN CHOPPING THEM INTO PIECES SO THAT THEY FIT THEIR THEORIES. BUT I HAVE ALWAYS BELIEVED THAT SIGNIFICANT ART IS THE ISSUE OF THE VISIONS AND EXPERIENCES OF INDIVIDUAL ARTISTS. IT IS MY CONVICTION THAT ARTISTS WHOSE WORKS I ADMIRE ARE PRIVILEGED AND SO ARE THE WORKS THEY CREATE. CONSEQUENTLY, MY WRITING ON ART HAS ALWAYS DEPENDED ON WHAT ARTISTS THEMSELVES THINK. NOW, EVEN MORE THAN BEFORE, I AIM TO TAKE A 180 DEGREE TURN AWAY FROM ART THEORETICAL CEREBRATION, IN ORDER TO BRING CONTEMPORARY ART CRITICISM AND HISTORY BACK INTO THE ARTISTS' STUDIOS, IN WHICH ART IS CONCEIVED AND REALIZED.

MY OWN ART THEORY, IF ONE CAN CALL IT THAT, HAS ITS SOURCE IN THE PROTO-EXISTENTIALIST IDEAS OF MIGUEL DE UNAMUNO, A PHILOSOPHER-NOVELIST-POET, WHO HATED GENERALIZATIONS. HE WROTE "THAT WHEN A MAN AFFIRMS HIS 'I,' HIS PERSONAL CONSCIOUSNESS, HE AFFIRMS MAN, MAN CONCRETE AND REAL, AFFIRMS THE TRUE HUMANISM...AND IN AFFIRMING MAN HE AFFIRMS CONSCIOUSNESS." AS I LOOK BACK, IT APPEARS TO ME THAT I SHARE HIS DISLIKE OF GENERALIZATIONS, PARTICULARLY GLITTERING GENERALIZATION, WHAT THOMAS HESS TERMED "GLIDGE"; ALTHOUGH I MUST ADMIT THAT I HAVE OFTEN BEEN GUILTY IN PRACTICE. LIKE UNAMUNO, MY PRIMARY CONCERN HAS ALWAYS BEEN FOR THE CONCRETE INDIVIDUAL—IN MY CASE, INDIVIDUAL ARTISTS AND THEIR SPECIFIC CREATIONS. THE THREAD THAT RUNS THROUGH MY WRITING IS A CONCERN FOR THE INTENTIONS, VISIONS, AND EXPERIENCES OF ARTISTS.

THE PAINTER PHILIP PEARLSTEIN REINFORCED MY
THINKING. HE CAUTIONED ME—AND CRITICS IN GENER-
AL—AGAINST USING ART AS THE RAW MATERIAL FOR MY
OWN ENDS. "DON'T ASSUME," HE SAID, "THAT ARTISTS
ARE DUMB AND DON'T KNOW WHAT THEY ARE REALLY
DOING AND THAT THE CRITICS KNOW BETTER BECAUSE
THEY PRESUMABLY HAVE A FULLER GRASP OF THEIR TIME
AND THEREFORE CAN PRESUME THAT THEIR PRIMARY PUR-
POSE IS TO DEFINE WHAT ARTISTS DID." PEARLSTEIN
WENT ON TO SAY: "AND DON'T SUPPOSE THAT YOUR
EMOTIONAL AND SUBJECTIVE RESPONSES TO THE WORK
ARE SUFFICIENT OR RELIABLE." I BELIEVE THAT CRIT-
ICS OUGHT TO TRY TO FIND OUT WHAT AN ARTIST'S
INTENTIONS ARE AND WHY HE OR SHE CHOOSES TO WORK
IN A CERTAIN WAY—AND COME TO TERMS WITH THAT
INFORMATION.

ARTISTS DO NOT FORMULATE THEIR INTENTIONS IN A
VACUUM. THEY DO SO IN INTERACTION WITH OTHER
ARTISTS AND THEIR INTENTIONS. CONSEQUENTLY, AT
ANY ONE MOMENT MODERN ART CAN BE CONSIDERED AS A
FIELD OF INTERACTING ARTISTS WITH INTENTIONS
THAT ARE IN ACCORD OR IN CONFLICT WITH EACH
OTHER.

IN MY EFFORT TO CONVEY THE INTENTIONS OF THE
ARTISTS I ADMIRE, I HAVE HAD TO MAINTAIN CLOSE
CONTACT WITH THEM IN ORDER TO LEARN ABOUT THEIR
MOTIVES. IF YOU WANT TO FIND OUT ABOUT NEW AND
DIFFICULT ART, YOU TALK TO ARTISTS FIRST. JOHN
CANADAY, A FORMER CHIEF CRITIC OF THE NEW YORK
TIMES, WARNED AGAINST FRATERNIZATION WITH
ARTISTS, ALLEGING THAT IT WOULD TAINT OR COMPRO-

MISE AN ART WRITER'S CRITICAL EYE. BUT HIS
REVIEWS, AND THOSE OF OTHER CRITICS WHO KEEP
THEIR DISTANCE FROM ARTISTS, HAVE ALWAYS STRUCK
ME AS IRRELEVANT. STILL, CANADAY HAD A POINT. IN
COUSIN BETTE, BALZAC WROTE OF MEDIOCRE ARTISTS
WHO CHARMED PEOPLE; HE LABELED THEM DEMI-
ARTISTS. "THE WORLD IS FOND OF THEM, AND TURNS
THEIR HEADS WITH APPLAUSE. THEY SEEM TO BE SUPE-
RIOR TO REAL ARTISTS, WHO ARE OBJECTED TO ON THE
GROUNDS OF THEIR ALLEGED EGOISM, BAD MANNERS, AND
REBELLION AGAINST THE RULES OF SOCIETY. THIS IS
BECAUSE GREAT MEN BELONG TO THEIR WORK." IN MY
WORLD, IF THE REAL ARTISTS WERE ECLIPSED BY THE
DEMI-ARTISTS, IT WAS NOT FOR LONG. WE KNEW WHO
WAS WHO. AND IN FACT, MANY OF THE ARTISTS I HAVE
KNOWN ARE BOTH PERSONABLE AND SIGNIFICANT.

AT THE SAME TIME THAT I HAVE DEALT WITH ART AS
THE ISSUE OF CONCRETE INDIVIDUALS, I HAVE TRIED
TO DEAL WITH MYSELF AS ONE TOO. INDEED, JUST AS
ARTISTS CREATE OF OF THEIR INNER NEED, SO DO
CRITICS WRITE ABOUT ART. CONSEQUENTLY, I HAVE
MATCHED MY OWN EXPERIENCE OF THE WORK OF ARTISTS
AGAINST MY UNDERSTANDING OF THEIR ASPIRATIONS. I
HAVE ASKED, WHAT IS THE ARTIST'S VISION, HOW IS
IT EXPRESSED, AND IS THE WORK A SINGULAR ACHIEVE-
MENT? IN THE END, THIS IS WHAT COUNTS.

I HAVE REFUSED TO RESTRICT MY CRITICISM TO FOR-
MAL CONSIDERATIONS, AS CLEMENT GREENBERG URGED
ART CRITICS TO DO. NOR HAVE I MADE IT A PRIMARY
GOAL TO TELL GOOD FROM BAD. GREENBERG CLAIMED
THAT A CRITIC HAD TO DECLARE HIS OR HER LIKES AND

DISLIKES IN ORDER TO ESTABLISH HIS OR HER CRE-
DENTIALS. STANDOFFISHLY GIVING GRADES TO ART,
AS IT WERE, GOES AGAINST MY NATURE WHICH IS TO
BE AN ENTHUSIAST. I WANT TO EXPOSE MYSELF TO NEW
ART AND TRY TO UNDERSTAND IT—AND MY RESPONSE TO
IT.

FROM THE FIRST, I HAVE CONSIDERED ART CRITICISM
SECONDARY TO ART. THIS IDEA HAS NOT BEEN VERY
POPULAR IN THE LAST QUARTER CENTURY. ART THEO-
RETICIANS WHO EMERGED IN THE 1980'S, PARROTING
BARTHES, HERALDED THE DEATH OF THE ARTISTS AND
THE BIRTH OF THE SPECTATOR, BY WHICH THEY MEANT
THEMSELVES. WHAT COUNTED WAS INTERPRETATION NOT
CREATION. I FIND THIS ATTITUDE SELF-AGGRANDIZ-
ING. TO BE SURE, SUCH SELF-PROMOTION HAS HAD A
LONG HISTORY, MORE SO IN LITERATURE THAN THE
VISUAL ARTS. IT WAS PUT OVER BY CRITICS WHO SUC-
CEEDED IN SETTING THEMSELVES UP AS AUTHORITIES
OF INTELLECTUAL AND CULTURAL LIFE. THESE WRITERS
FOCUSED ON IDEAS ABOUT ART RATHER THAN ON ACTU-
AL WORKS.

RECENT ART CRITICS HAVE EVEN MAINTAINED THAT
THEIR WRITING IS SUPERIOR TO THE ART IT IS ABOUT,
BECAUSE OF THEIR PRESUMABLY GREATER UNDERSTAND-
ING OF PHILOSOPHY, PSYCHOANALYSIS, AND SOCIAL
ISSUES. THEY MAINTAIN THAT CRITICS WHO EXPLI-
CATE OUR AGE ARE EXTRAORDINARILY CREATIVE. THEIR
ENTERPRISE IS SO HEROIC THAT IT OUGHT TO BE INDE-
PENDENT AND NOT SUBMISSIVE TO ANY WORK OF ART.
BUT WOULD NOT THIS INVENTED SENSE OF OUR AGE
BECOME A BIAS WITH WHICH TO PREJUDGE ART? TO ME,

IT IS ART THAT OUGHT TO DETERMINE A CRITIC'S SENSE
OF HIS OR HER TIME OR THEORIES. IF A CRITIC WON'T
SUBMIT TO THE ART, THEN THE CRITIC IS IN THE WRONG
FIELD, AND HIS OR HER CRITICISM OUGHT TO BE TRULY
INDEPENDENT OF ART, THAT IS, LEAVE ART OUT OF IT.
IT IS MY BELIEF THAT ART CRITICS, HISTORIANS AND
THEORISTS WHO CAN'T ACCEPT THE PRIMACY OF ARTISTS
AND ART ARE GUILTY OF THE SIN OF ENVY.

I DO BELIEVE THAT THERE IS A PLACE FOR MORE GENER-
AL QUESTIONS IN ART CRITICISM AND HISTORY, NAMELY
WHY, IF WE PUT ISSUES OF QUALITY ASIDE TEMPORARILY,
DO CERTAIN ARTISTS AND CERTAIN STYLES ACHIEVE
RECOGNITION WHEN THEY DO AND OTHER ARTISTS AND
STYLES DO NOT. AND WHY CERTAIN ARTISTS AND CERTAIN
STYLES CONTINUE TO CLAIM ART-WORLD ATTENTION AND
OTHERS DO NOT. THESE QUESTIONS WILL INCREASINGLY
ENGAGE ME IN THE FUTURE.